The Theory and Craft of Digital Preservation

Trevor Owens

Johns Hopkins Universit

Baltimore

Johns Hopkins University Press
2715 North Charles Street
Baltimore, Maryland 21218-4363
www.press.jhu.edu

Library of Congress Cataloging-in-Publication Data

Names: Owens, Trevor, author.
Title: The theory and craft of digital preservation / Trevor Owens.
Description: Baltimore : Johns Hopkins University Press, 2018. | Includes
 bibliographical references and index.
Identifiers: LCCN 2018010715 | ISBN 9781421426976 (paperback : alk. paper) |
 ISBN 1421426978 (paperback : alk. paper) | ISBN 9781421426983 (electronic) |
 ISBN 1421426986 (electronic)
Subjects: LCSH: Digital preservation. | Digital libraries—Management.
Classification: LCC Z701.3.C65 O94 2018 | DDC 025.8/4—dc23
LC record available at https://lccn.loc.gov/2018010715

A catalog record for this book is available from the British Library.

*Special discounts are available for bulk purchases of this book. For more information,
please contact Special Sales at 410-516-6936 or specialsales@press.jhu.edu.*

Johns Hopkins University Press uses environmentally friendly book materials, including
recycled text paper that is composed of at least 30 percent post-consumer waste,
whenever possible.

The Theory and Craft of Digital Preservation

--

DISCARD

Contents

--

Acknowledgments

--

I spent a year working on this book, but it represents the culmination of about a decade of trying to make my own sense of digital preservation. As such, I have a lot of people to acknowledge. The strengths of this book come from the international digital preservation community I've been welcomed into. Its weaknesses are my own.

I was introduced to digital preservation in my time at the Roy Rosenzweig Center for History and New Media. Before he passed away, Roy made an extensive and lasting impression on those of us lucky enough to work for him. My constant hope is that the compassion, dedication, and pragmatism Roy brought into every day of his work at the Center comes through in my own. My understanding and appreciation for issues in digital history and digital preservation were sparked by four years of discussion and collaboration with colleagues there: Dan Cohen, Josh Greenberg, Sean Takats, Tom Scheinfeldt, Sharon Leon, Sheila Brennan, Dave Lester, Jeremy Boggs, Jim Safley, Kari Kraus, Connie Moon Sehat, Miles Kelly, Mindy Lawrence, Jon Lesser, Kris Kelly, Ken Albers, Faolan Cheslack-Postava, John Flatness, and Christopher Hamner. It was in Dan's

digital history graduate seminar that I first heard about things like bit rot, graceful degradation, and digital preservation in any formal way. When Sharon couldn't make it to a Library of Congress meeting of the National Digital Information Infrastructure and Preservation Program (NDIIPP), I went instead and ended up getting introduced to many of my future colleagues. Josh generously offered substantive edits on my undergraduate thesis, was always happy to chat about science and technology studies, and ultimately served as a reference when I applied to work for the NDIIPP.

When I joined the NDIIPP team in 2010, I had no idea how lucky I was. I was able to join some of the smartest folks in the world working on digital preservation. The best part was that they were surprisingly down to earth. On my first day, Dan Chudnov (whose "Emperor's New Repository" article remains one of the best pieces of writing on digital preservation) told me something like, "You can love the Library of Congress but it won't ever love you back." It's true. Massive institutions like the LC can feel like cold bureaucracies. However, those challenges can create bonds and friendships that last. The best treasures of the Library of Congress are found in its staff. The colleagues I connected with in NDIIPP, and across the institution, are the people who taught me both what digital preservation is and how it actually happens. To that end, I owe a considerable thanks to Martha Anderson, Abbey Potter, Michelle Gallinger, Jane Mandelbaum, Dan Chudnov, Butch Lazorcheck, Erin Engle, Leslie Johnston, Jefferson Bailey, Abbie Grotke, Ed Summers, Nicholas Taylor, Chris Thatcher, Nicki Saylor, Chris Adams, Thomas Padilla, Emily Reynolds, Gloria Gonzalez, Jimi Jones, Bertram Lyons, Kate Murray, Caroline Arms, Carl Fleischhauer, Caitlin Hammer, Andrew Cassidy-Amstutz, Kathleen O'Neill, Meg McAleer, Moryma Aydelott, Beth Dulabahn, Kate Zwaard, David Brunton, and many others.

While working for NDIIPP I was able to serve as the first co-chair of the National Digital Stewardship Alliance's (NDSA) digital preservation working group. The monthly conference calls and discussions of what was and wasn't working factored heavily into shaping the ideas behind this book. Although everyone involved in NDSA-

related meetings and events has had an impact on my thinking, I would like to specifically mention Micah Altmen, Andrea Goethals, Andy Johnson, Lori Emmerson, Jason Eppink, Amanda Brennan, Euan Cochran, Megan Phillips, Karen Carani, Dragan Espenschied, Cal Lee, David Rosenthal, Vicky Reich, Katherine Skinner, Nick Krabbenhoeft, Robin Ruggaber, Cory Snavely, Peter Krogh, Micheal Edson, Mike Giarlo, David Pearson, Bethany Nowviskie, Robert Horton, Chris Lacinak, Kara Van Malssen, Abby Smith Rumsey, Howard Besser, Don Watters, Doug Reside, Ian Bogost, Henry Lowood, Jason Scott, Richard Pierce-Moses, Mark Matienzo, Maureen Callahan, Jaime Schumacher, Stacey Erdman, Seb Chan, and Aaron Straup Cope.

I would also like to thank people who took the time to comment on the public drafts of this book that I shared on my blog: Bertram Lyons, Alan Liu, Chris Adams, Karl-Rainer Blumenthal, Porter Olsen, Matthew Kirschenbaum, Jon Ippolito, Thomas Padilla, Jessica Tieman, Glynn Edwards, Andrew Jackson, Euan Cochrane, Shira Peltzman, Clarissa Ceglio, Annie Johnson, and Steven Lubar. The book is significantly stronger as a result of their input.

Across all of these places and spaces I've been lucky to have a set of mentors who have taught me so much about how cultural institutions work: Roy Rosenzweig, Dan Cohen, Josh Greenberg, Martha Anderson, Carl Fleischhauer, Kim Sheridan, Richard Staley, and Maura Marx.

I must also thank my editor, Matt McAdam. We first discussed the idea of this book over coffee at the Library of Congress in 2014. I ended up going off to write an entirely different book, but that whole time I kept thinking about what the present book might be. Matt and the entire Johns Hopkins University Press team have been ideal to work with throughout the project. In particular, the book has benefited significantly from edits from Managing Editor Juliana McCarthy and Laura Dewey.

Lastly, and most importantly, I would like to thank and acknowledge Marjee Chmiel. My wife. My constant companion. You read the often incoherent first drafts of sections of this book and helped

me make them less so. You did that just as you did with my cover letters and resumés for each of the jobs I've mentioned. You brought me to DC from Wisconsin. You are so present in my life and in my work that it is impossible to articulate specific things to attribute to you. I do know that I really have no idea who I would be or what I would be doing outside of the life we live together. We did our dissertations together. Each taking turns powering through writing and research while the other would make dinner, wash the dishes, and walk the dogs. Your accomplishments inspire me. Your insights refine my thinking. Your thoughtfulness and compassion invigorate me to work to be a better person.

The Theory and Craft of Digital Preservation

--

- - - - - - - - - -

Beyond Digital Hype and Digital Anxiety

A summit on digital preservation at the Library of Congress in the early 2000s brought together leaders from industry and the cultural heritage sector to work through the mounting challenges in ensuring long-term access to digital information. One participant from a technology company proposed something like, "Why don't we just hoover it all up and shoot it into space?" The "it" in this case being any and all historically significant digital content. Many participants laughed, but it wasn't intended as a joke. Many individuals have sought, and continue to seek, similar (although generally not quite as literal) "moon-shots," singular technical solutions to the problem of enduring access to digital information.

Almost two decades later, we find ourselves amid the same stories and imagined solutions that we have heard for (at least) the past twenty years. For the public, there is a belief (and worry) that if something is on the Internet, it will be around forever. At the same time, warnings of an impending "digital dark age," where records of the recent past become completely lost or inaccessible, frequently appear in the popular press. It is as if digital information will last forever

1

but also, somehow, disappear dramatically all at once. The hype cycles of digital technology, combined with a basic lack of understanding about digital media, leave us ill-equipped to sort through the hype and anxiety. Yet, I've found that when I tell people I work on digital preservation and explain what I mean by that, most respond something along the lines of, "Gosh! I never even thought about that!"

For many executives, policy makers, and administrators new to digital preservation, it seems like the world needs someone to design a super system that can "solve" the problem of digital preservation. The wisdom of the cohort of digital preservation practitioners in libraries, archives, museums, and other institutions of cultural memory who have been doing this work for half a century suggests this solution is an illusory dream. To them, the recurring idea of the singular technological super system that "solves the problem" is a distraction not worth chasing. It's also something that diverts resources from those doing the work. Ensuring long-term access to digital information is not a problem for a singular tool to solve. Rather, it is a complex field with a significant set of ethical dimensions. It's a vocation. It is only possible through the consistent dedication of resources from our cultural institutions. This book is intended as a point of entry into the theory and craft of digital preservation as it has emerged in practice.

I offer a path here for getting beyond the hyperbole and the anxiety of "the digital" to establish a baseline of practice. To do this, one needs to first unpack what we mean by "preservation." It is then critical to establish a basic knowledge of the nature of digital media and digital information. Anyone can then make significant and practical advances toward mitigating the most pressing risks of digital loss.

As a guidebook and an introduction, this text is a synthesis of extensive reading, research, writing, and speaking on the subject of digital preservation. It is grounded in my work on digital preservation at the Library of Congress and, before that, work on digital humanities projects at the Roy Rosenzweig Center for History and

New Media at George Mason University. The first section of the book synthesizes research on the history of preservation in a range of areas (archives, manuscripts, recorded sound, etc.) and sets that history in dialogue with new media studies, platform studies, and media archeology. The later chapters build from this theoretical framework as a basis for an iterative process for the practice of doing digital preservation.

This book serves as both a basic introduction to the issues and practices of digital preservation and a conceptual framework for deliberately and intentionally approaching digital preservation as a field with multiple lineages. The intended audience is current and emerging library, archive, and museum professionals as well as the scholars and researchers who interact with them. I hope that it can have use more broadly as well to anyone interested in beginning to practice the craft of digital preservation in any other field. While the issues are complex, I have done my best to make the book useful to someone working for a massive institution or as a lone arranger in a small historical society or community archive.

The book has a practical bent, but it is not a how-to book, as such a thing would quickly become outdated. The book is not a set of step-by-step instructions. It is intended more as a point of reference for developing and honing one's own craft as a digital preservation practitioner. It's worth remembering that the opposite of practical isn't theoretical, it's impractical. As such, good practice is developed and refined in dialogue with theory, which I have attempted to accomplish in this book.[1] I delve into a range of scholarship in media theory as well as archival and library science theory. To this end, I'm working to anchor digital preservation craft in an understanding of the traditions of preservation and the nature of digital objects and media.

So, with that in mind, I use the next part of this introduction to get into a set of principles I've developed over my time working in this field that I think help push back against some of the problematic assumptions that crop up in digital preservation. These are not a road map for the book. These are not what I am going to argue for.

They are more of a point of reference for where I am coming from and where I think we need to go.

Sixteen Guiding Digital Preservation Axioms

As a point of entry to the book, I have distilled a set of sixteen guiding axioms. I realize that sounds a little pretentious, but "axiom" is the right word for what these are: points that I think should serve as the basis for digital preservation work. They are also a useful way to help define what exactly digital preservation is and isn't. Some of them are unstated assumptions that undergird orthodox digital preservation perspectives; some are at odds with that orthodoxy. These axioms are things to take forward as you read. Some are also points that I argue for and demonstrate throughout the book. All are things I see as central to the craft of digital preservation.

1. *A repository is not a piece of software.* Software cannot preserve anything. Software cannot be a repository in itself. A repository is the sum of financial resources, hardware, staff time, and ongoing implementation of policies and planning to ensure long-term access to content. Any software system you use to enable you to preserve and provide access to digital content is by necessity temporary. You need to be able to get your stuff out of it because it likely will not last forever. Similarly, there is no software that "does" digital preservation.

2. *Institutions make preservation possible.* Each of us will die. Without care and management, the things that mattered to us will persist for some period of time related to the durability of their media. The primary enablers of preservation for the long term are our institutions (libraries, archives, museums, families, religious organizations, governments, etc.). As such, the possibility of preservation is enabled through the design and function of those institutions. Their org charts, hiring

practices, funding, credibility, and so forth are all key parts of the cultural machinery that makes preservation possible.

3. *Tools can get in the way just as much as they can help.* Specialized digital preservation tools and software are just as likely to get in the way of solving your digital preservation problems as they are to help. In many cases, it's much more straightforward to start small and implement simple and discrete tools and practices to keep track of your digital information using nothing more than the file system you happen to be working in. It's better to start simple and then introduce tools that help you improve your process than to simply buy into some complex system without having gotten your house in order first.

4. *Nothing* has been *preserved, there are only things* being *preserved.* Preservation is the result of ongoing work of people and commitments of resources. The work is never finished. This is true of all forms of preservation; it's just that the time scales for digital preservation actions are significantly shorter than they tend to be with the conservation of things like books or oil paintings. Try to avoid talking about what *has been* preserved; there is only what we *are* preserving. This has significant ramifications for how we think about staffing and resourcing preservation work. If you want to evaluate how serious an organization is about digital preservation, don't start by looking at their code, their storage architecture, or talking to their developers. Start by talking to their finance people. See where digital preservation shows up in the budget. If an organization is serious about digital preservation, it should be evident from how they spend their money. Preservation is ongoing work. It is not something that can be thought of as a one-time cost.

5. *Hoarding is not preservation.* It is very easy to start grabbing lots of digital objects and making copies of them. This is not

preservation. To really be preserving something you need to be able to make it discoverable and accessible, and this will require that you have a clear and coherent approach to collection development, arrangement, description, and methods and approaches to provide access.

6. *Backing up data is not digital preservation.* If you start talking about digital preservation and someone tells you, "Oh, don't worry about it, we back everything up nightly," you need to be prepared to explain how and why that is not digital preservation. This book can help you develop your explanation. Many of the aspects that go into backing up data for current use are similar to aspects of digital preservation work, but the near-term concerns of being able to restore data are significantly different from the long-term issues related to ensuring access to content in the future.

7. *The boundaries of digital objects are fuzzy.* Individual objects reference, incorporate, and use aspects of other objects as part of their everyday function. You might think you have a copy of a piece of software by keeping a copy of its installer, but that installer might call a web service to start downloading files, in which case you can't install and run that software unless you have the files it depends on. You may need a set of fonts, a particular video codec, or any number of other things to be able to use something in the future; it is challenging to articulate what is actually inside your object and what is external to it.

8. *One person's digital collection is another's digital object is another's data set.* In some cases the contents of a hard drive can be managed as a single item, in others they are a collection of items. In the analog world, the boundaries of objects were a little bit more straightforward or at least taken for granted. The fuzziness of boundaries of digital objects means that the concept of "item" and "collection" is less clear than with analog items. For example, a website might be an item in

a web archive, but it is also functionally a serial publication that changes over time, as well as a collection of files.

9. *Digital preservation is about making the best use of your resources to mitigate the most pressing preservation threats and risks.* You are never done with digital preservation. It is not something that can be accomplished or finished. Digital preservation is a continual process of understanding the risks you face for losing content or losing the ability to render and interact with it and making use of whatever resources you have to mitigate those risks.

10. *The answer to nearly all digital preservation questions is "it depends."* In almost every case, the details matter. Deciding what matters about an object or a set of objects is largely contingent on what their future use might be. Similarly, a preservation approach to a massive and rapidly growing collection of high-resolution video will end up being fundamentally different from the approach an organization would take to ensure long-term access to a collection of digitized texts.

11. *It's long past time to start taking actions.* You can read and ponder complicated data models, schemas for tracking and logging preservation actions, and a range of other complex and interesting topics for years, but it's not going to help "get the boxes off the floor." There are practical and pragmatic things everyone can and should do now to mitigate many of the most pressing risks of loss. I tried to highlight those "get the boxes off the floor" points throughout the second part of the book. So be sure to prioritize doing those things first before delving into many of the more open-ended areas of digital preservation work and research.

12. *Highly technical definitions of digital preservation are complicit in silencing the past.* Much of the language and specifications of digital preservation have developed into complex sets of requirements that obfuscate many of the practical things

anyone and any organization can do to increase the likelihood of access to content in the future. As such, a highly technical framing of digital preservation has resulted in many smaller and less resource-rich institutions feeling like they just can't do digital preservation, or that they need to hire consultants to tell them about complex preservation metadata standards when what they need to do first is make a copy of their files.

13. *The affordances of digital media prompt a need for digital preservation to be entangled in digital collection development.* Digital media affords significant new opportunities for engaging communities with the development of digital collections. When digital preservationists take for granted that their job is to preserve what they are given, they fail to help an organization rethink what it is possible to collect. Digital preservation policy should increasingly be directly connected to and involved in collection development policy. That is, the affordances of what can be easily preserved should inform decisions about what an organization wants to go out and collect and preserve.

14. *Accept and embrace the archival sliver.* We've never saved everything. We've never saved most things. When we start from the understanding that most things are temporary and likely to be lost to history, we can shift our focus and energy to making sure we line up the resources necessary to protect the things that matter the most. The ideology of "the digital" makes it seem like we could or should attempt to save everything. However, this comes from the mistaken thinking that digital preservation is primarily a technical challenge instead of a social and ethical one. We need to also realize that there are varying levels of effort that should be put toward future proofing different kinds of material.

15. *The scale and inherent structures of digital information suggest working more with a shovel than with tweezers.* While we need to embrace the fact that we can't collect and

preserve everything, we also need to realize that in many cases the time and resources it takes to make decisions about individual things could be better used elsewhere. It's often best to focus digital preservation decision making at scale. This is particularly true in cases where you are dealing with content that isn't particularly large. Similarly, in many cases it makes sense to normalize content or to process any number of derivative files from it and keep the originals. In all of these cases, the computability of digital information and the realities of digital files' containing significant amounts of contextual metadata mean that we can run these actions in batch and not one at a time.

16. *Doing digital preservation requires thinking like a futurist.* We don't know the tools and systems that people will have and use in the future to access digital content. So, if we want to ensure long-term access to digital information, we need to, at least on some level, think about and be aware of trends in the development of digital technologies. This is a key consideration for risk mitigation. Our preservation risks and threats are based on the technology stack we currently have and the stack we will have in the future, so we need to look to the future in a way that we didn't need to with previous media and formats.

Digital Preservation Is People: Notes on Voice and Style

- -

With those sixteen points out of the way, I can make a few more points on style and language to close out this introduction. Given that nothing is preserved, that there are only things that some people in some institution are preserving, a core conceit of my approach and writing is to bring out the people who are doing the work. Much of the book involves describing individual objects or collections that

people working in an institutional context have established a commitment to preserve. I think it's inappropriate to decontextualize the work of digital preservation. As a result, throughout the text I have attempted to keep those people and their work as elements to drive the narrative. Recognizing that much of digital preservation to date has been situated as a highly technical field largely pursued by the most elite of elite cultural institutions, this ends up meaning that many of these stories are about a privileged class of mostly white men working to preserve the work and legacies of other privileged white men.

Given the pressing need for our history and our collections to genuinely represent the diversity of our world, I have consciously tried to draw attention to work that counters this pattern. My hope is that in doing so, the field can further move toward more equitable approaches to collecting, preserving, and providing access to the past. With that noted, the stories of objects and organizations are not as diverse as I would like them to be. At the very least, by acknowledging this up front I want to underscore that the problems that exist around getting our institutions to reflect the diversity of the communities they serve are very real and that despite best efforts they will continue to play out, to an extent, in the examples I describe.

This focus on people, on relationships between the people documented in collections, and the people doing the work to preserve and provide access to digital information is also reflected in the language I use to engage with you, the reader. I have attempted to model this text on the digital preservation graduate seminars I teach. So when I use "you" to refer to you, the reader, it is important to clarify what assumptions I am making about you. My assumption is that you want to learn about digital preservation, which I hope is accurate, given the fact that you are reading this book. In that sense, I am assuming that you are interested in engaging in what I am calling the craft of digital preservation. I am not assuming that you are a librarian, archivist, or a curator or that you are a student aspiring to become one. First and foremost, I imagine the book will be use-

ful to people working or who want to work in cultural institutions. However, I have attempted to make the book useful to a wider audience.

My hope is that this book will be of use to activists who want to start practices to ensure long-term access to their records, or scholars who are serious about trying to make sure that their work has a life beyond them, or those working in large or small nonprofits or government organizations, or to people who are particularly serious about their family's or community's history. So while I do hope that this book is of use to individuals in formal roles as keepers of culture and history, I also aspire to make this rather complex topic accessible to as many people as possible. To some extent, my hope is that this reframing of digital preservation to a broader audience can offer some potential opportunities to change some of the issues I earlier identified regarding the historical role of privileged classes as the gatekeepers of preservation.

Along with that, throughout the book I will presume some minimal level of rapport between you and me when I talk about us as "we." In picking up and reading this book, you have expressed at least some level of concern and desire to ensure long-term access to information. As such, you have become part of a long-standing and worldwide tradition of memory keepers that is a part of all human cultures and societies. So throughout, "we" is intended to be an inclusive term referring to anyone who, in keeping with the values of librarians and archivists, is committed to work toward ethical, socially responsible, and enduring access to accurate records of communities, cultures, and societies.

- - - - - - - - - -

Preservation's Divergent Lineages

There is no such thing as digital preservation, there is only the conservation of digital media." This, I am told, was one of the opening remarks at the initial meeting of a digital preservation task force at the Library of Congress. Library of Congress digital preservation program staff were taken aback. In one comment, a colleague had seemingly dismissed decades of their work and the work of others around the world focused on digital preservation. A yearlong effort to define digital preservation strategy for the world's largest library began with dismissal of digital preservation as an idea made of whole cloth. Through sustained and extensive dialogue, members of this task force eventually came to understand each other and were able to develop an institutional framework for digital preservation. This, however, prompts a few major questions. How could it have been that in a field with decades of work and scholarship, colleagues couldn't collectively acknowledge some of the most basic concepts of the field? This chapter offers an answer. All too often core assumptions about what exactly preservation is remain unstated.

I have heard many stories like this, where interdisciplinary dialogue about digital preservation has broken down when an individual protests, "But *that's* not preservation." Discussions of digital preservation often start from the tacit assumption that we have resolved what preservation entails in the old analog world. We have not. It's often taken for granted that before "the digital" there was a nice and tidy singular notion of what preservation was. There was not. This mistaken assumption is part of a general problematic tendency in digital hype to separate the universe into things that came before and after computing. Before pinning down what digital preservation is, it's critical to establish its context in a range of long-standing and divergent lineages of preservation.

Preservation means different things in different contexts. Discussions of digital preservation are particularly vexed because these contexts have largely collapsed. Digital media formats have proliferated into nearly every area in which one might think about preservation. Each of these contexts has a history. These histories are tied up in the changing nature of the mediums and objects for which conceptions of preservation and conservation were developed. Understanding a little about the divergent lineages of preservation helps establish the competing notions at play in defining what counts as preservation in which contexts.

What counts as preservation in a particular tradition or lineage is complicated. This, however, is a relatively short book, so I will attempt to simplify. To that end, I have clustered divergent and historically contingent preservation traditions into three distinct frameworks: *artifactual*, *informational*, and *folkloric*. These preservation frameworks are accurate only to the extent they are useful. What I present is less a history of preservation than a mobilization of that history to sort out how divergent ideas coexist under the idea of preservation.

To make sure this approach is broad enough, I explore these notions of preservation in areas as diverse as the development of preservation of the built environment; art conservation; the manuscript

tradition; approaches to managing butterfly gardens; the advent of recorded sound technology and the development of oral history; and the development of photography, microfilming, and preservation reformatting. Each episode and tradition offers a mental model to consider and deploy for different contexts in digital preservation. Each case provides a means to test and check our own assumptions about what exactly preservation is. Understanding these contexts and meanings of preservation establishes a vocabulary to articulate what aspects of an object must persist for a given intention for future use.

The histories of preservation are grounded in a negotiation between what people want to do and what the material world will allow them to do. In this context, the history of mediums and formats must also be understood as contributing to our conceptualization of preservation. The materiality and affordances of our forms, media, and platforms set the limits on what preservation can be.[1]

I've come to believe that the lineages of preservation are best understood as one half of a dialogue with the material and formal nature of the things we want to preserve. Building on work in media archeology, a field of media research focused on understanding how various new media have shaped thinking and knowing, I will explain how digital media should be understood as part of a continual process of remediation embedded in the new mediums and formats that afford distinct communication and preservation potential. In this case, we need to think broadly about anything that shapes the things we want to preserve. This includes but is not limited to the affordances of the spoken word, human memory, written languages, clay tablets, sandstone, papyrus, vellum, woodcuts, movable type, typewriters, daguerreotypes, dictaphones, film, gramophones, microfilm, PDFs, CD-Rs, and MP3 files. Given this cacophony of media, formats, and mediums, it becomes clear that preservation cannot be a single conceptual area of work. Instead, preservation is best understood as a kind of juggling act in which preservation professionals—librarians, archivists, curators, conservators, folklorists, historians, archeologists, scholars, records managers, anthropologists, numismatists, and philatelists (among others)—work to

carry folkloric, informational, and artifactual objects into the future. But I'm getting ahead of myself; before we get into issues of media and mediums, it's important to roughly articulate these three divergent traditions of preservation.

The Historic House, the Specific Words, or the Gist of the Story? Three Frames for Preservation

This *is* George Washington's Mount Vernon. This *is* Mary Shelley's *Frankenstein*. This *is* the story of Rama and Sita. Each statement uses the same verb, *is*, but *is* means something fundamentally different in each context. Each of the three previous statements makes a claim about the identity of some object we might want to preserve. Each statement makes a different claim about what would constitute the authenticity or integrality of the object.

In the first case the identity is *artifactual*; it is based on a notion of historical contiguity of a tangible physical object. It has to be that specific house to count as Washington's house. In the second case identity is *informational*, based on the idea that any copy with identical information is the same. Any copy of *Frankenstein* will do as long as it has the same words in it. The third case is *folkloric*; as long as the key elements of the story are present, every word or phrase doesn't have to be the same. Someone might tell the story differently, but it's still the same story. Each of these provides a frame for forms of preservation grounded in the affordances of material objects.

Historical Contiguity and the Artifactual Object

In the case of Mount Vernon, we are talking about a place, a historical site, a plantation owned by the first president of the United States of America on the banks of the Potomac, and a home managed and maintained by the Mount Vernon Ladies' Association. For the statement "This is George Washington's Mount Vernon" to be true, we should really be pointing at the structure. If instead I held up a

postcard from Mount Vernon and made the same statement, you might think, "Oh, he means that is a picture of Mount Vernon. I know that the actual building isn't the picture." By default, we know that a picture of Mount Vernon is not Mount Vernon. The physical place and structure is what we mean.

So, what makes Mount Vernon *Mount Vernon*? Like all physical objects, it is changing at every moment. Sunlight is interacting with the paint and discoloring it. As the seasons change and temperatures rise and fall, materials that make up the house expand and contract at different rates, creating wear and tear. This particular historical site (like many similar sites) has been restored to make it look like it did at a particular point in time. Even if we didn't make any changes, the house would slowly deteriorate. As it constantly changes, the core element that makes Mount Vernon itself is its historical contiguity. Even if all the wood, stone, and glass that make up the home were slowly replaced, it's still the house that George Washington lived in. It's an artifact and a place.

It's not just Mount Vernon's specificity of place that matters here. The site operates on the same default logic at work in our conception of the identity of a painting like the *Mona Lisa*. If I show you a picture of the painting and say, "This is the Mona Lisa," you'll likely think, "Oh, he means this is a picture of the *Mona Lisa*, the actual *Mona Lisa* is in Paris." Given this focus on unique artifacts, I refer to this conception of preservation as "artifactual." We would default to the same artifactual notion of identity for the Statue of Liberty, the Great Sphinx of Giza, or Angkor Wat. In each case, a singular artifact or constellation of artifacts constantly changes and contains an infinite amount of potential information to study or explore.

Conservation science, collections care, and historic preservation provide methods of preservation for artifacts. The widely accepted definition of *preservation* in these domains holds that it is "action taken to retard or prevent deterioration of or damage to cultural properties by control of their environment and/or treatment of their structure in order to maintain them as nearly as possible in an unchanging state."[2] This artifactual approach focuses solely on care for

an object's physical manifestation. In keeping with this focus, conservation scientists use materials science and chemistry to understand how and why an object is degrading and attempt to limit the extent of degradation. In this context, they may make specific targeted conservation treatments and repairs to stabilize an object and limit its physical change.

In the conservation of works of art and preservation of historic sites, there exists a range of specialized vocabulary under the umbrella concept of preservation. Restoration, for example, is the use of evidence to restore a site or object to what it once was. This unquestionably involves altering and changing the object, but given that the object is always changing, one can justify a particular restoration action based on the reasons the site is being preserved. Alongside restoration, historic preservation also offers the notion of "reconstruction." This might involve rebuilding a site from scratch based on its believed historic location. In this case, the site retains its historical contiguity.

The Same Spelling and the Informational Object

In the case of Mary Shelley's *Frankenstein, is* means something fundamentally different from *is* in the case of Mount Vernon. The copy of *Frankenstein* I read in high school, your mother's copy, or Carl Sagan's copy all satisfy the requirement of being *the* book. In the case of these informational objects, what matters is that the encoded information is identical. As long as your copy and my copy have the same words spelled the same way, then from our default frame of reference, we both can say we have Mary Shelley's *Frankenstein*.[3]

It is worth drawing out some of the fundamental differences between informational objects and artifactual ones. *Frankenstein* the physical medium might be paper, but I could read it on an iPad, or it could be written in the sky by a plane; whatever the case, the medium is irrelevant. As long as each of the letters shows up, its authenticity is not in question. To have read *Frankenstein* is to have seen its words in the correct order.

This logic isn't just for written texts. Each of a hundred Albrecht Dürer prints *is* the print. Each copy of a photograph from its negative *is* the photograph.[4] Each LP of The Beatles' *White Album is* the album. These examples from various media demonstrate the qualifier "informationally identical." The photo, print, album, and so on demonstrate medium-specific manifestations of the quality of "same spelling." For each medium, we carry with us feelings about what qualifies as informationally identical. For example, most of us would likely agree that a poor quality photocopy of a photograph doesn't count as being the photo. Of course the photocopy contains some of the information present in the photo, but not enough of it to count. Or for that matter, if someone poorly developed a photograph from a negative, the resulting image wouldn't count as being *the* photo. Thus a key feature of informational objectness is sameness. Any claim about something being informationally identical comes with either a tacit or explicit description of what counts as the information.

The notion of "same spelling" establishes the idea that procedural conditions are required to create an authentic instance of the object. Consider, for example, Dan Flavin's light installations from the 1960s.[5] These works involve placing a series of lights in a space. His work is actually the light, not the physical bulbs that create it. So what in this case constitutes the work? When Flavin sold his work, he didn't sell sets of bulbs. He sold certificates of authenticity that included diagrams showing how to set up the work using standard parts and the authorization to do so on his behalf. He thus established the criteria for a successful instance of the work, what counted as the "same spelling" for these installations. He did not specify the kind of bulbs he used (which are no longer produced) because, from his perspective as the creator of the work, they were not required to authentically produce it.

Librarians have developed a sophisticated conceptual model for describing different levels of sameness for books—Functional Requirements for Bibliographic Records (FRBR). It is worth taking a moment to map this model onto the way I have been describing these

differences. Components of FRBR include the tangible book (the item), all the copies of the book that are functionally identical (the manifestation), the text of the book in a specific language (the expression), and the essence of an author's creation (the work).[6] Much of FRBR is particularly tied to the production and dissemination of books, so it does not exactly map onto other domains, but it does illustrate the many nuanced ways there are to dissect sameness. Significantly, only the first two components (the item and the manifestation) are physical things; they exist as artifacts. Where the expression functions informationally, it is identified not by its physical carrier but by the information encoded on the carrier. Depending on how loosely one conceptualizes the work, it could be either informational or folkloric.

Throughout this chapter, I have been referring to these categories as default frames of reference. Having explained a bit about two of them, I can unpack this concept somewhat. These conceptions of preservation are not inherent to any given object, but we can at least approach an object as artifactual or informational. For example, the only way for an informational object to exist is for it to be encoded on a medium. All informational objects must have something like an artifactual host that they inhabit. Similarly, as I suggested earlier, every artifactual object hosts a practically infinite amount of information. A few examples can help make this concrete.

Examples from work in early modern printed English books, like the works of Shakespeare, are useful for exploring this intersection, in that they have clear informational properties establishing the "same spelling" criteria, but they have also increasingly been studied as material culture.[7] You can find black-and-white digital copies of the second quarto of *Hamlet* in an online resource like Early English Books Online. However, those copies were scanned from rather low quality microfilm made from originals. Looking at the digitized microfilm, you can see the information, that is, the letters that make up the words and their layout and composition on the page. However, the digital copy is somewhat misleading because the original item also included information encoded in lighter red text—essential

information that is not visible in the black-and-white microfilm. This largely could be resolved by just getting better scans of the book pages. Thankfully, the Folger Shakespeare Library does in fact provide higher-resolution scans. You can also imagine how someone doing textual encoding could use markup to note which text is what color. Indeed, recent work with medieval manuscripts has demonstrated ways to get at far more information stored in these works.

Intentionally encoded information is not the only data we can access and keep for the future. Surprisingly, a considerable amount of valuable information can be found in the dirt left behind in books by people who have handled them over the years. Using densitometers and very high quality digital images of copies of manuscripts, scholars have been studying the relative dirtiness of individual pages, which in turn can tell us a story about the use of objects. You can similarly imagine analyzing the chemical properties of the glue in a book's binding or examining the cellulose in the pages to figure out which tree species was used to create the paper. And, in all seriousness, there is some ongoing interest in studying the smell of different early modern books, as it could help demonstrate aspects of the circulation of these books. These smells have chemical properties that can be recorded. All this is to stress that, while it makes sense to focus preservation activities on the informational qualities of a work, this entails either implicit or explicit claims about which aspects of the underlying material and artifactual object need to be carried forward. Individual copies of Shakespeare works have informational properties, but they also exist as rare and unique artifacts in their own right.

The same duality of informational and artifactual qualities of objects is afforded by works where we default to the artifactual frame; all artifacts have information in them, and information is always entangled in the artifactual qualities of the media it's encoded on. One of the primary purposes we keep, conserve, and preserve artifacts is their potential informational value. While we default to thinking through the artifactual frame for things like paintings or

sculptures, we usually work with those objects through surrogate informational representations of them. Slide collections have been a mainstay in art history education, used by students to identify works and trends in art history. While it's fair to say that you haven't really seen the *Mona Lisa* until you've looked at it on the wall in the Louvre, when it comes to teaching people about the history of art, we don't insist that they go and see every art object. Instead, we tend to be fine with using photographs that document the key informational features of those works so that we can use them to teach. (This idea of documentation opens up a different concept in preservation that we will return to later.) Similarly, scholars publishing in an art history journal often include images of the work they are analyzing and discussing. They don't say, "Take my article and go and look at each of the works I talk about." The images make legible the informational qualities they want to work with and are thus sufficient for the needs of the essay; by reproducing these images side by side, the historian can draw attention to features of the object and invite comparison and interpretation that isn't available when you visit the works.

So it's not that different preservation activities are innately associated with particular objects. Instead, there are distinct preservation frames of reference to approach any given object, some of which tend to be the defaults for preservation in a given area with a given medium or media. So far I have described two (artifactual and informational). I've got one more to present, and then I will work through a series of contexts to apply them.

The Same Meaning in Folkloric Objects

The story of Rama and Sita, as told in the epic Sanskrit poem *Ramayana*, was described to my wife and me by a Balinese tour guide as "our Romeo and Juliet." In the story, Prince Rama, helped by an army of monkeys, journeys to rescue his wife Sita from the evil Ravana. Dated between 500 BCE to 100 BCE, the story exists in hundreds of variations and is central to the multiplicity of religious and

cultural traditions that are lumped together as Hinduism. The story exists not just in these various texts but also in more or less every cultural medium.

While some parts of the narrative are crucial for presenting the story, the variability of its expression across cultures and mediums is itself important to its nature. In some versions, Rama's human nature is central, in others, his divinity. Yet in other versions, Sita is a more central character. The main Javanese variant includes a range of other regional deities. These versions of the same story don't satisfy the same spelling rules of being informationally identical. But if you ask someone if they count as the story of Rama and Sita, there is a good chance that they would say yes. This effectively satisfies a much looser or fuzzier conception of the informational, or same-spelling, requirement. The story needs some key elements or features to count, but this requirement is far less restrictive than is the case in the informational frame. An ethnographer or a folklorist would certainly say that these variations are the story. In fact, they are likely to suggest that the variability of these narratives is one of the most important things about them. Folklorists hold that when folklore becomes fixed in a medium, it loses something of the cultural vibrancy that exists in how it mutates and varies. It is in a sense no longer living culture but something that has been pinned down dead. Understanding a bit about how folklorists conceptualize culture will be useful in seeing how this represents a third and, again, fundamentally different lineage in preservation.

Folklore is widely misunderstood as "old stories" or tales. In practice, folklore is about the logic and meaning of the everyday and informal, about how traditions and customs are passed on.[8] It's not only stories that exhibit these qualities but also the things we say (jokes, songs, myths, and legends), things we do (customs, games, rituals, rites of passage), things we make (handmade crafts, personal collections), and things we believe (superstitions, ideas about the supernatural and the vernacular aspects of religion). Folklorists go out of their way to seek out and document these varied expressions of the everyday, to trace how they emerge and change to fit the needs

of a given time. Outside these formal practices of collecting folklore, human cultures and societies act as folkloric preservation systems, preserving the folklore that is of use to their cultures. Folklorists do document and study folklore and thus create informational objects that are preserved in keeping with that frame, but societies continually refine and revise useful aspects of folk knowledge and carry that information forward through the daily life and practices of people.

The oldest form of preservation, folkloric preservation is a fundamental aspect of all human societies. It is one of the essential factors undergirding and enabling civilization from its origins and the basis of culture and language.[9] Think of everything we know that we didn't learn from reading or finding in some kind of media. When we learn language from our parents or our families, the folkloric process is at work; thus the medium of folklore is the aggregate embodied and enacted memory of a given society. As traditions and practices are enacted and repeated, they disseminate information to others. In this sense, folkloric preservation has operated as a core part of human cultures at least as far back to the beginnings of *Homo sapiens* some 200,000 years ago. There is a good chance that it could have functioned as part of Neanderthal societies or earlier archaic humans as far back as 2 million years ago. It is worth stressing this history, in part, because the folkloric frame of preservation is likely the most critical of the three, one that is essentially hard coded into our bodies. However, this mode of preservation comes up the least often of the three, or is the least likely to be part of most formal definitions of preservation and conservation. It is so fundamental to what we are that we are often too close to it to be aware of it.

In the twentieth century, folklorists increasingly turned to new media to document the variations in the performative nature of folklore. Through tape recording, photography, and film, they captured individual expressions of experience and perspectives. These new media made possible an entirely new kind of preservation while at the same time presenting significant preservation and conservation challenges.

It is not a stretch to claim that these now old media (for instance, photography, film, and tape recording) were themselves responsible for new ideas of what preservation could be. An 1877 *Scientific American* article claimed that through the creation of the phonograph, "speech has become, as it were, immortal."[10] It's difficult to imagine how powerful that must have felt, to be able to play back the actual sound of a previous event for the first time. Significantly, the impact of the phonograph (literally, "sound writing" in Greek) resulted in changing notions of memory. Sounding much like advertising for computers in the last several decades that compare our brains to hard drives, an 1880 article on memory and the phonograph defines "the brain as an infinitely perfected phonograph."[11] The development of the phonograph and various other new mediums implicates how the affordances of our bodies are part of this dialogue. We rethink our conceptions of memory in dialogue with what our media afford us. We build our media in the imaginations of our minds and, conversely, we imagine our minds through our media—as phonographs, video cameras, and hard drives.

The development of audio recording resulted in new capabilities for preserving and recording the world, and cultural heritage professionals were purposefully leveraging it early on. As early as the 1920s, wax cylinders were being used to collect and preserve folksongs.[12] The field of oral history, the purposeful collection and recording of individuals' stories, developed alongside these technologies. In the first meeting of the National Colloquium on Oral History in 1966, it was suggested that the "tape recorder [was] important enough to oral history to constitute almost a part of the definition [of oral history]."[13] New media not only reshape our personal notions of mind and memory, they also shape and reshape the development of professions, like oral history, that function as societies' organs of cultural memory. The emergence and dissemination of these recording technologies afforded new kinds of scholarship and preservation work, but it was not clear how these new practices would be impacted by the technologies. Historically, the practices of folklore had been moored in the study of written texts. The introduction of

recording technologies kicked off controversies about what the actual source or object of preservation was. For many, the transcript of the recording remained and remains the primary artifact, while others have fought to get the raw original recording recognized as the artifact. New media technologies do not in and of themselves determine the future of preservation. The affordances of those media enter into the ongoing dialogue of professional practice where their role is negotiated.

As various *old* new media developed over time (wax cylinders, records, cassette tapes, 8-millimeter film, VHS tapes), they have generally been thought of as a means of registering and carrying the signal, the recording, or image. That is, the default frame of reference for these documentary media is informational. Given that many of these audiovisual media are not particularly long lived, scholars in the field of A/V preservation have largely come to consensus that they need to digitize this content, particularly content on tape, as a means of preservation.[14] This approach is entirely consistent with understanding this content on informational terms.

It is worth briefly noting that documentation has been a primary mode of preservation in the performing arts (theater, dance, music, etc.). Performing arts documentation starts from the same kind of recognition that folklorists start from. A performance is a unique, temporal lived event; it does not persist through time. While you can make perfect copies of the information in a music score or script of a play, they are not the lived experience of attending the event. Thus, similarly to folklore and oral history, the field of performing arts preservation has adopted and adapted new media as they have emerged as a means for recording and providing access to the performances of works. The case of performing arts documentation further clarifies some of the key tensions at the heart of preservation.[15] While we can preserve things, tangible objects, we often care deeply about experiences. The only way to preserve those experiences is to somehow register aspects of them on a medium. Similarly, the documentation approach in the performing arts also defaults to an informational frame of reference. The mediums are chosen by the

documenters and thus lack much of the richer kinds of artifactual information that might be associated with objects where the original artifact was itself part of its creator's choices.

Epics, Archives, and Butterfly Gardens: Applying the Frames

I've introduced three different frames for thinking about preservation—artifactual, informational, and folkloric and suggested how many kinds of objects get sorted into conceptual default frames. In that process, I have attempted to demonstrate how the different frames connect and intersect, and how they each apply to preservation in a given context. To push this point further, I will take three additional examples of contexts—the *Iliad*, archival records in general, and different kinds of butterfly collections—to surface how these different frames of preservation come together to enable future access to objects, information, and stories. My intention is to bring to the fore issues and concepts that are useful for thinking through what we can and should mean when we eventually discuss digital preservation.

Homer's *Iliad*

The *Iliad* is a useful example for exploring interconnections between the preservation frames I've described. In particular, the fact that the work predates written language in Europe and has remained a key story and historical record throughout much of Western civilization provides a rich context for exploring how something can endure for long periods of time. These stories are a useful tool for illustrating the way that these different strands of preservation intersect. As with all my examples, this is not intended as a deep and serious history of the topic but an opportunity to mobilize some of that history to think through some of these interacting concepts. So apologies in advance to experts for any nuances I have not drawn out.

The *Iliad* was likely composed in the seventh or eighth century BCE. It tells stories of events that are suggested to have happened about four hundred years prior in the early twelfth century BCE. The earliest full manuscript of it we have access to was copied in the tenth century AD. As such, it persisted in an oral tradition and then in a manuscript tradition long into its history. Many of the key features of the text replicate those that mapped to the affordances of the medium of human memory for retelling. In particular, it makes use of repetition, which was key to enabling such epic storytelling in a preliterate society. You can think of the written versions of the works as a remediation of their original form. In the same way that early films were functionally recordings of staged performances, early written works like this carried forward elements of the affordances of previous media into the form of subsequent media. So we have this transition from folkloric oral tradition to informational replication of written texts.

Many readers, the author included, experienced the story of the *Iliad* only through translations. Those translations, though, are generally interpretations of more than a single original source text. There are more than two thousand manuscript copies of Homer's works, and an entire field of scholarship explores variations and changes in these to best understand how the tale developed and changed over time.[16] The problem is that we don't have copies of the text dating back to when it was likely originally written; what we have are a series of different copies dated to different points in time. While the manuscript tradition operates through a logic of informational identity, where each copy is authentic if it has the same spelling in it, in practice, the process of copying a text introduces variances over time. Humans just aren't perfect copiers. The deviations that crop up over time and variations in the texts look a good bit more folkloric than informational.

So how does one work with these variant copies? Importantly, it is at this point that the artifactual characteristics of each copy become critical. That is, the locale where the copy was found, the material it was made of, and its age as determined by carbon dating

all become the essential evidence used to reconstruct the history of these texts. The artifactual qualities, in particular the long-lived nature of the media that these texts were encoded on, is exactly what has enabled us to gain access to their informational content. All three frames have been critical for getting us a good copy of the work that we can use as a source for all kinds of things. Importantly, the history of each of these aspects becomes a key part of thinking through what kinds of insights the text can afford. In the case of Homer's works, historians have spilled considerable ink over the years arguing the extent to which they might provide evidence of the historicity of Troy and the Trojan War.

As a final note on the *Iliad*, it is worth stressing that the stories are far greater than the texts as they existed at any one given point in time. That is, the folkloric process whereby a narrative is reinterpreted and explored in countless new expressive forms has continued apace. These stories have been remediated as plays, ballets, children's books, comic books, major motion pictures, and so on. All of these incarnations functionally preserve parts of the story. Moreover, as the stories morph and mutate into new versions, we find what it is about them that remains vital enough to our culture that society carries them forward into these new forms. It's likely that these variations teach us as much about the stories' meanings as do the most pristine and authentic copies we might reassemble in the best critical edition of the texts.

Archival Records

I would be remiss to write about preservation's lineages and not go into some discussion of archives. The production and management of records is one of the oldest preservation traditions, and it is a good place to pick apart some of the intersections between these different preservation frames.

Many of the oldest preserved objects in human history are records. Record keeping is partly the basis of the development of writing systems. In Babylonian times, inventories of granaries were recorded

on cuneiform tablets. Records of astronomical observations have been carried forward from ancient Egypt and China and are still used by astronomers today. In just these two examples, we can see how different preservation frames have come to play a role. Cuneiform tablets turn out to be one of the most durable mediums for encoding information, having survived a substantial amount of benign neglect. In contrast, the astronomical records from around the world have persisted largely because the information was so continually useful and vital that it has been frequently copied and has migrated forward to new media.

Modern archival practice is rather pragmatic in terms of preserving records. It focuses on both improving storage conditions to prevent the decay of the material objects records are encoded on as well as supporting techniques such as preservation microfilming, which creates microform copies of documents that, in proper storage conditions, could potentially last for a thousand years. In these dual strategies we can see consideration of both the material object and the informational object. However, the considerations for the material object are less about its artifactual qualities and more about trying to inexpensively ensure the longevity of the information stored on the object.[17]

The focus on the informational object in records is also evident in the related preservation tradition for records called documentary editing. While you might think of documentary films, this field is focused on editing and publishing editions of textual records. The Association for Documentary Editing cites the Papers of Thomas Jefferson project started at Princeton in 1943, which in part sparked the United States National Archives to create the National Historical Publications Commission.[18] Documentary editing projects preserve records through publication, for example, transcribing handwritten letters into text that can then be printed and shared. This approach to publishing records is much older than modern documentary editing. For example, the efforts behind the *Thesaurus Graecae Linguae* date back to the work of French scholar and publisher Henri Estienne in the sixteenth century.[19] In many cases, extant copies of

primary sources persist only as a result of being published in these volumes.

In this context, we can see the publishing of records after the advent of movable type as being contiguous with the much more ancient manuscript traditions in which scribes meticulously copied texts, more or less since the advent of writing itself. This underscores the continual process by which the affordances of new mediums have been explored and exploited by those interested in the preservation of information. When microfilm technology developed in the 1930s, librarians, archivists, and historians were thrilled with the prospect of reproductions of sources.[20]

While the focus on the informational content of records has been and continues to be primary, there is of course a nearly limitless amount of information in any given material object that could be probed and explored to provide additional information. Recent work in multispectral imaging has been particularly relevant in this area. Through composite images of records like drafts of the Constitution or of the Archimedes Palimpsest, this technique has demonstrated viable ways to surface seemingly hidden information from inside the artifactual and material features of an archival record. In the case of the Declaration of Independence, these imaging techniques were central to demonstrating that Thomas Jefferson had crossed out the term *subjects* and replaced it with *citizens*.[21] In the case of the Archimedes Palimpsest, a series of works of Archimedes thought to be lost to time were recovered from a thirteenth-century prayer book. The works of Archimedes had been erased and the parchment reused, but through multispectral imaging, traces of the texts that aren't visible to the human eye could be surfaced and made legible.[22] These points on novel imaging techniques demonstrate the challenges of articulating the informational aspects of records. Artifactual objects contain nearly limitless information. Furthermore, these examples demonstrate that the development of new technologies will continue to result in not only new mediums but also new methods and techniques for surfacing informational aspects of artifactual objects.

Ways to Preserve Butterflies

So far, all of my examples have been human-generated objects or works. It is possible to test the efficacy of frames of preservation by exploring how well they work in relation to preservation in the natural world. In this context, contrasting different kinds of butterfly collections offers a useful way to see how these concepts play out.

The main hall of the Milwaukee Public Museum has a butterfly garden at one end, and a large set of wooden cases where pinned-down preserved butterflies are on display at the other end.[23] These two ends of the hall serve as useful points of contrast in frames of preservation. They also demonstrate how similar preservation frames function in the collecting and preserving activities of natural and biological science institutions.

In the butterfly garden, generations of butterflies unfold through cycles of birth, life, and death. The garden does not preserve any individual butterflies; it functions as a system that perpetuates species of butterflies. None of these are exact copies. These are not butterfly clones. Instead, preservation happens in this living collection as a result of the variability of the individual butterflies. This isn't just the case for butterflies; the same plays out for all kinds of living collections found in zoos, aquaria, botanical gardens, parks, wildlife preserves, and sanctuaries.

The pinned-down butterflies in the cases at the other end of the hall preserve butterflies in a fundamentally different way. The individual butterflies were killed at some point in the past and then treated and encased in such a way that their remains would deteriorate as slowly as possible. This is itself indicative of an entire strand of preservation practice for natural history museum specimen collections as well as collections of herbaria: specimens are collected and then treated to make their remains persist into the future.

The butterfly garden operates in the folkloric frame, while the pinned-down preserved butterflies function in the logic of the artifactual frame. The DNA of each butterfly in the garden can be thought of as its informational identity. Although there is functionally more

information in any given butterfly than simply its genetic code, the genetic code is very much a critical piece of encoded, replicated information. If we went about cloning butterflies, then we would be doing the informational process, but when the butterflies reproduce on their own, it is the variability of their genetic codes that is a key part of sustaining a given population. The pinned-down butterflies function according to the logic of the artifactual frame. Each butterfly is historically contiguous with the butterfly that died and was pinned down years ago. It may well be that some of these species have gone extinct, and these remains are the primary things that provide us access to information about them. In this artifactual frame, the pinned-down butterflies are part of the historical preservation and conservation science approaches to preservation.

This is not just the case for how the records of life are preserved in cultural instructions. These processes are similarly evident of how the natural world itself preserves. For example, fossils operate under the logic of artifacts. Through a variety of processes, a dead creature's remains are preserved and when later discovered can be studied to understand life from the past. The fossils are historically contiguous with the once living creatures, even though they are very different from those creatures since the time when they were alive. At the same time, evolutionary biologists make use of "living fossils" such as the platypus, which are functionally living relics that demonstrate features of animals from the past but have been preserved because a particular ecosystem did not introduce selective pressures that would weed them out. Evolutionary biologists use actual fossils and living fossils, both of which preserve information about life in the past but do so through fundamentally different mechanisms, as the basis for reconstructing the development of species over time.

Taking the Frames Forward

- -

I've suggested three different ways of framing the work of preservation. In doing so, I have used a range of examples to stress the ways

that each of these frames operates under very different logics, which while internally consistent are often at odds with each other. Each frame is distinct and in some ways incompatible. However, in practice, the frames also intersect and interact in the practical work of preserving things.

In the artifactual frame, we attempt to extend the life of physical media. It is the historical contiguity of the artifact that is the focus of preservation. In the informational frame, we work to clearly establish criteria for copying encoded information from one media forward to the next. In this case, the physical medium is simply a carrier or host for the encoded information. In the folkloric frame, variability and hybridity of information play a key role in how stories and sequences of information preserve but also change and adapt to new circumstances. In this case, approaches to documentation that illustrate that variation are part of the core preservation approach, but at the same time, cultural or biological ecosystems themselves serve as preservation systems, carrying forward the information that is most useful to their contemporary needs.

This all serves to establish a set of frameworks that we can carry into thinking about digital objects. With that noted, as demonstrated at many points, it is the formal and material affordances of the mediums of objects that have played key roles in establishing what preservation means in different contexts over time. To that end, it is critical for anyone interested in digital preservation to understand some of the key aspects of digital forms and media. But this is the subject of the next chapter.

Understanding Digital Objects

Doing digital preservation requires a foundational understanding of the structure and nature of digital information and media. This chapter provides such a background through key points that emerge from three related strands of new media studies scholarship. First, all digital information is material. Second, the database is an essential media form for understanding the logic of digital information systems. Third, digital information is best understood as existing in and through a nested set of platforms. I will start out by first giving an overview of each of these three points and then delve deeper into them.

Whenever digital information is stored it is physically encoded on media. It is critical to recognize that all raw bit streams (the sequences of ones and zeros encoded on the original medium) have a tangible and objective materiality. This provides an essential basis for digital preservation. However complex some digital system is, somewhere in there is binary information encoded on a tangible physical medium. Therefore it is possible to determine the entire sequence of bits on a given medium, or in a given file, and create a kind of digital fingerprint for it that can then be used to verify and authenticate

perfect copies. At this physical bit stream level, there is an inherent linearity to digital information. Wherever information is encoded, there is a first bit, a second one, and a last one. However, this feature is abstracted away at the level of information retrieval and management that results in something radically different from much of our other media.

The logic of computational media is, by and large, the logic of the database. Where the index or the codex is a valuable metaphor for the order and structure of a book, as new media studies scholarship suggests, the database is and should be approached as the foundational metaphor for digital media. From this perspective, there is no persistent "first row" in a database; instead the presentation and sorting of digital information is based on the query posed to the data. Given that libraries and archives have long based their conceptions of order on properties of books and paper, embracing this database logic has significant implications for making digital material available for the long term.

Digital systems are platforms layered on top of each other. While the bit streams are linear, the database logic of new media functions in a very nonlinear fashion. At the base level, those linear bit streams are animated, rendered, manipulated, altered, and made usable and interactive through nested layers of platforms. In accessing a digital object, computing devices interact with the structures of file systems, file formats, and various additional layers of software, protocols, and drivers. Working through a few examples will help clarify this concept. Experiencing an object's performance on a particular screen, like playing a video game or reading a document, can itself obfuscate many important and interesting aspects of digital objects, such as the rules of a video game or deleted text in a document that still exists but isn't rendered on the screen.

As a result of this nested platform nature, the boundaries of digital objects are often completely dependent on what layer one considers to be the most significant for a given purpose. In this context, digital form and format must be understood as existing as a kind of content. Across these platform layers, digital objects are

always a multiplicity of things. For example, an Atari video game is a tangible object you can hold, a binary sequence of information encoded on a physical medium identical to all the other copies of the game, source code authored as a creative work, a packaged commodity sold and marketed to an audience, and a signifier of any number of aspects of a particular historical moment.[1] Each of these objects can coexist in the platform layers of a tangible object, but depending on which is significant for a particular purpose, one should develop a different preservation approach.

In what follows, I will delve deeper into each of these three points: the materiality of digital objects, the logic of the database, and the platform nature of new media. I will provide examples to demonstrate the relevance of these points for understanding digital objects in a way that enables us to start thinking about preserving them. I will then work through a few examples that tie these concepts together with a few other key conceptual points for understanding digital media.

The Digital Is Always Material

Much of the language we use to talk about digital media obfuscates the materiality of digital information. My Google Docs files are out there somewhere in the metaphysical-sounding "cloud." Make no mistake: the cloud is made of other people's computers. This is itself a core challenge in working with digital objects and media. The hard drive in your computer is sometimes literally a black box. Inside that box is a complex mechanism that encodes information at such a small scale that you can't see it.[2]

On some level, most people understand that digital information is made up of "bits," which often conjure an image in my mind of 1s and 0s flowing off a screen like in the movie *The Matrix*. If you search for the term *bits* on Google image search, you will find images showing 1s and 0s on a screen, many of which appear at an angle to suggest motion and movement. What you won't find is any images like

Recording of single magnetizations of bits on a 200MB hard disk platter (recording visualized using CMOS-MagView). Uploaded from Matesy GmbH to Wikimedia Commons

the one above. Those 1s and 0s are the fundamental lowest unit of digital information. However, the vision of them flowing off a screen fails to capture the very material and physical nature of digital information.

Here you can see the magnetizations of individual bits encoded in bands on a hard disk platter. At this level—the level of microns— each inscribed unit of information is visibly tangible and physical. Each bit has dimensions. Ultimately, reading and writing to any underlying media substrate involves a digital-to-analog translation and then back again. That is, some bit of information is encoded onto the medium and then read back from it.

This point isn't just true for hard drives. You can actually see the individual bits on a punch card or a role of punch tape. The presence

or absence of a punch is read as a 1 or a 0, and it's easy to see that each punch has a length and a width. Some might be slightly wider or longer than others, or slightly offset, but as long as they conform enough to be read and interpreted, they function to store the encoded information. A rewritable CD uses a laser to encode bits in dye. On most commercial CDs and DVDs information is encoded in tiny indentations called pits, which are read by a laser in the drive. In the case of flash media, the memory in USB drives and in mobile devices like iPhones, electrons are stored in parts of the media. Those electrons exist at the limits of what we might even call material. But rest assured, electrons are very much part of our material universe and do not exist on some sort of metaphysical plane.

These examples underscore a key point: all digital information is material. This has a critical implication for the work of digital preservation. No matter how complex or challenging a digital object or work, it is encoded on a physical object as a linear sequence of markings. The sequence of bits can be read from the medium, checked for accuracy, and copied to another medium. This process of "bit preservation" is relatively straightforward and quite easy to verify. Yet these bits are really only useful to us when we can render and interact with them, which is made possible through another key aspect of digital media, the database.

Anything Can Be First in a Database

Right click. Sort by. These are two of the most basic operations that computer users around the world use. In any number of applications you might sort files, songs, or emails by their name, date created, date last opened, author, file type, or file size. In most operating systems you can similarly change what you might view about each of these files. You can see them in a list view, with large icons or small ones, or with all their details in columns with headers that act as prompts to sort the display of information. The grammar of these interfaces, filtering and sorting, replays itself at nearly every level of abstraction

in computing. To this point, media scholar Lev Manovich explains, "As a cultural form, database represents the world as a list of items and it refuses to order this list."[3] Our relationship with digital information is anchored in the interface to a database. In that relationship, the underlying order and sequence of the bit stream is interacted with through a multiplicity of orders. It is replaced with a wide range of possibilities of sequence. This is fundamentally different from the way we interact with analog media.[4]

It's true. Even at that base level of the hard drive we just explored, those drives are themselves broken into sectors. The sectors of the drive are managed through tables (in database terms, lists of values stored in rows). So while the information on the drive, the bit stream, is laid out in a linear fashion, the drive abstracts those sectors into a coherent volume of space made available to the computer for you to use as file storage.

This database logic is best understood through contrasting it with some of the linear and referential logics that have been a key part of various other media. For example, the codex, a bound manuscript, allows me to refer to page 39 of this book and for you to quickly turn to page 39 and see what I'm referencing. Similarly, you can flip to the index at the back of this book and see an index different from the linear one that comes from turning each page. For example, if you were interested in where I talk about databases, you could look up the entry for databases in the index and identify each of the pages (including this one) where I discuss the concept.

The index in this book has a bit of the database logic to it. It's somewhat like picking different ways to sort the book, similar to how you might sort information on your computer. There are other, albeit more time-consuming, ways of sorting information in a book. For example, a concordance would list the key words in a given book along with their context. So if this book had a concordance, it would include each sentence that the word appeared in. This would let you read the contexts in one place instead of having to turn to each page to read them.

So the logic of the database has long been with us. It's not something brand new that came with digital media. However, it wasn't the default; it took a lot of work to get analog media to act like a database. The default with a book is to turn from one page to the next. In contrast, many of you reading this book on a computer or mobile device may well have first hit Ctrl-F and searched for whatever term you were most interested in and used that as your point of entry to the text.

The search function is one of the core aspects of the database logic. We don't read databases. We query them. One of the key myths (not to say that it's false but just that it's reached the level of retelling to function as a legend) of the World Wide Web is that Yahoo!, originally started as *Jerry and David's Guide to the World Wide Web*, worked from a logic of "organizing content" by hand crafting indexes of sites on topics. In contrast, the upstarts at Google developed Page-Rank, an algorithm that computationally indexed the web and weighted the results based on links between web pages. The story is useful for librarians and archivists to consider. Are we trying to be like Yahoo! and approach digital content as if creating the index of a book, where we spend considerable time trying to organize and describe it, or will we act like Google and spend our time finding a way to surface relationships out of the underlying data?

Another key aspect is that, while order and sequence has been a core part of library management of collections, database logic lets order and sequence fall away. Or more specifically, computational media enable a multiplicity of orders and sequences. A vertical file system or books shelved according to the Library of Congress classification system are organized based on the very real limits of physical space. Each thing can be in one and only one place. So, at many universities you can walk the library stacks and find this book on the shelf, likely among the Zs with the other library science books. You can't, however, right click on the shelves and see all the books alphabetized by author, or by some subject heading. You can do this with records in the online catalog, but in computing it is the things themselves that are being shifted and reordered. This kind of order-

ing has been a core part of the work of libraries and archives, which makes sense, as ordering is key to finding and accessing objects placed in physical locations. Importantly, the card catalog is a key example of how libraries have long been making use of this kind of database logic to enable a multiplicity of orders.[5] It's a point for later in the book, but it is worth underscoring that database logic has long been in play for library and information science, and it has always been a massive undertaking, working against a kind of resistance in the form of books, paper, and files. In contrast, for digital media database logic is the default. It is something the field still has a long way to go to fully embrace.

It's critical to remember that (1) there is always some sequence of 1s and 0s encoded on an underlying tangible medium and that (2) across all the levels of abstraction we are about to discuss, this information is accessed and manipulated through database logic. The remainder of this chapter builds on these two points and starts from the medium to explore the relationships between different kinds of platforms in digital objects. In this context, I then unpack a series of key features of digital media that result from this platform nature.

It's Platforms All the Way Down and All the Way Across

All our interactions with digital information are mediated through layers of platforms. In keeping with the field of platform studies, I am using a rather broad definition of *platform*: that is, whatever the programmer takes for granted when developing, and whatever, from the other side, the user is required to have working to use a particular software, is the platform. Under the heading of "platform studies," an entire body of research and scholarship has emerged to explore the ways that computing platforms "enable, constrain, shape, and support the creative work that is done on them."[6] This includes, but is not limited to, operating systems, programing languages, file formats, software applications for creating or rendering content, encoding schemes, compression algorithms, and exchange protocols.

The best way to explain platform logic is to talk through an example. We can start with a bygone set of files from my own personal history: a copy of a website for the band I started in high school. Sadly, these files are lost to history, but the relative lack of sophistication makes them a good case study to work from.

Imagine I hand you an external hard drive, and on it is a copy of my band's website. You plug the drive into your computer, open it up, and explore what is on it. In the root directory you see a file called "index.html" and some other folders. You click on the index .html file and your web browser launches it. Right there you can see the webpage render. On the homepage you can see pictures of the band; they just show up right there on the page in your browser. You can click over to read bios of everyone in the band on a different HTML page. You can even click on a page where you can access one of the band's songs as an MP3. You click on a song and it plays in your browser. You are enjoying, or at least experiencing, the music of Marzapan circa 2001.

This is just one way to experience these files. Your web browser is a platform for viewing websites, and it allows you to interact with this site as the creator had intended. If you close your browser and start opening up those other folders on that directory, you can poke around through each of the individual files that make up the site.

Just as you can with any paper file folder, you can sort electronic files by type, name, date, and so on. As you explore the directories, you learn some new things about the band website. You see things you couldn't have seen on the screen in your web browser. From this view, you can see that some of the files were created in 2001 and others in 2003. You can click on the index.html file and open it in a different application, like a text editor, and there you can see the HTML markup that was interpreted by your browser to create the page. There may even be comments in the HTML that provide additional information about why it is laid out the way it is.

If you right click on one of the MP3 files, it should launch whatever application your computer uses as a default for playing audio

files. You could also right click on the file and select to view the file's properties. In this case you see metadata that is embedded in the file. From there you can see that the file's author is called "Marzapan" and that it is apparently from an album called "Beauty of a Bad Situation." All this information is actually text embedded inside the file in its ID3 tags.

If you want to see how this works, change the file extension from .mp3 to .txt. Ignore the computer's somewhat passive-aggressive message asking you if you are "sure you want to do that." Clicking on it will open up whatever program you use to open text files. There you will see a lot of nonsense characters, but you will also see the text that showed up in the file properties, the album name and the author. This embedded metadata is encoded as text within the file so you can read it with any tool that can read that kind of encoded text, in this case Unicode. There is a good chance that you may see additional text in here too, as all the information you saw in the file properties through the file system was only the information that the file system's creators thought was particularly relevant.

You keep clicking around, and you may discover that, while you could see only one of the MP3 files when you looked at it through the web browser, in fact, the entire five-song EP is there. This kind of pattern basically repeats across all the layers of platforms. You can find things that weren't visible at the higher level of abstraction as you explore farther down, from how it was rendered, to the structure in the file system, to information embedded in the files. At this point, you've seen the website as it renders, you've seen the individual files and directories, and you've seen some of the information embedded in some of those individual files. You could go ahead and make a logical copy of all that data onto your desktop if you want. And there might still be more information on that drive that isn't showing up yet.

At another level, you could go ahead and open up any of the files you found here in a Hex editor, an application that allows you to see

the underlying binary data of a file. For any files you put through this process, you would learn a good deal about the actual sequence and structure of the information in the file.

You could also get a forensic copy of all the information on the drive. When the younger me deleted things off the drive, I thought I was erasing the information on it. But I wasn't. As is common with many digital storage media, when deleting something we are generally just telling the system to forget that there is information there and mark that space as open to be overwritten. So, if you created a forensic copy of the sequence of bits as it is actually laid out on the disk, and then used the Hex editor to look through what is actually stored in each area of the disk, it is entirely possible you might find that much of the allegedly empty space on the disk still has files on it that you could recover.

Depending on exactly how this was erased, I might need to send this out to a special forensic recovery group that could disregard what the disk says is the case about the information on it and force read the presumably blank parts. While you can't access the information that was overwritten, you could well find out that before I put my band's website on this disk, it had all the papers I had written in high school on it as .doc files, and you could open any of them.

That was a quick tour of the many layers of platforms that are stacked up on each other in the case of my disk drive. The table opposite lists this as a series of layers.[7]

As you work your way up from the bottom to the top of the table, you isolate individual layers with distinct affordances and properties. Importantly, the base layer, the bit stream on a physical medium, is the only layer that is really material. Returning to the concepts from the last chapter, at this level we are interacting with a potentially artifactual object. Everything above the bottom layer is informational. That is, when you move from the first layer to the second, you move from information encoded in a medium to the digital binary signals.

Think of the layers in the stack as the objects you are preserving. Each layer represents a different conception of an object that

TABLE 1. *Levels in a Digital Object Explained*

Level	Explanation	Example
Compound or complex object	An object made up of multiple files but experienced as one thing	The website as rendered in the web browser
Rendered file	A file rendered through a software application	The MP3 files or JPEG files from the disk as viewed through players or viewers
File in the file system	Information about individual files visible through a file system	Looking at the directories of files on the disk, seeing the individual properties
File as bit stream	The linear sequence of binary values in the file	Opening a file in the Hex editor
Subfile information	Extractable and viewable information from inside the file	The text in the ID3 tags embedded inside the MP3 viewable in the text version
Bit stream through I/O	Series of 1s and 0s as presented to the computer	The contents of the drive that can be copied over
Bit stream on a physical medium	Physical encoding of information on the underlying medium that is interpreted	The physical characteristics of the drive, in this case the magnetizations on the disk that may still contain additional information

your current or future users might be interested in studying. That is, for someone studying published websites, it's going to be critical to focus on the top-most layer. In contrast, for those interested in a drive like mine that might be part of a manuscript collection, how the information was organized on the disk and even the deleted files might be of interest. In short, identifying which layers of the platform are significant to an organization's preservation intent becomes a critical part of doing digital preservation.

The platform nature of new media presents an opportunity to delve into key concepts, which I explain using the example of the Marzapan website: screen essentialism, format theory, compression, exchange protocols, encoding schemes, and source code and source

files. These concepts provide a means to understand a given set of digital content for preservation and access purposes.

Avoiding Screen Essentialism

At the start of the above example we looked at the content of the website through a web browser. If you ask someone what a website is, there is a good chance they would point to the screen and say "it's that." It's what is being rendered on the screen. On one level they are right. The website is what it looks like. However, as we discovered while digging further into the files, there is actually a lot more potentially interesting information that shows up at different layers in these platforms. There is a tendency in working with digital information to take for granted that what something looks like on the screen is what is significant about it. As the example above shows, this can be a very misleading idea. New media scholars have derisively dubbed it "screen essentialism."[8] That is, a screen essentialist is someone who isn't paying attention to the significant aspects of digital objects that just don't show up on the screen.

As the example above illustrates, at almost every nested layer in the stack of platforms there is potentially significant information that does not appear in the common experience of interacting with a file in its default applications. Within the sectors in the media, the files shown in the file system, and the embedded metadata in the files themselves, there are nooks and crannies where potentially interesting information might be waiting to be interpreted. The way we get around this problem is to step back and make sure that we have a solid understanding of all the layers of platforms that are in play in a given context and that we have thought through which of them are particularly relevant for what we want to preserve about an object.

Comprehending Format Theory

As we explored the hard drive, we repeatedly ran into file formats. At the file level, those file extensions (.mp3, .jpg, .doc, and so on)

become key players in our story. The file format and the rendering application enable us to interact with the digital object. At this point we can think about moving horizontally out from the table above. That is, the vertical stack of digital layers detailed above accurately describes the information in the disk, but it does not describe how at each of those layers other platforms need to be invoked to interact with content. File formats are a good example of this kind of horizontal connection.

File formats enable most modern computing. A file format is a convention that establishes the rules for how information is structured and stored in a file. File extensions (.mp3, .jpg, .doc), in part, define the file and enable it to be interpreted. They also tell the computer's operating system which application it should use to render it. You can also identify files based on information in the file's header or signature. Every file format has its own history. To some extent it conceptualizes the world that it functions in. For example, the success and widespread use of PDFs is tied to how well they replicate aspects of print documents. PDFs "partake of the form and fixity of print that other digital text formats frequently do not."[9] In that vein, PDFs are best understood as part of a history of document sharing and reproduction that traces back to technologies like xerography and microfilm. It's important to realize that the format of a file is more than a container of information; it is information in its own right.

MP3 files offer another example. Like many file formats, the MP3 uses compression. A compressed file will generally be smaller in file size than one that sequentially encodes all the information in a file. As a point of contrast, a WAV file generally contains uncompressed PCM (pulse-code modulation) audio data. PCM data includes, in linear order, information for each sequential state of sound. So toward the beginning of the file you will find parts related to the beginning of the recording and toward the end bits that are part of the sound. Exploring compression will help establish what might be significant about a file in a given context.

Understanding Compression

A compressed file is generally smaller than an uncompressed file. It sounds like someone might have just put it in a vise, but in computing compression is accomplished by systematically removing some of the information in the file. In the case of lossless compression, the file will simply remove information that is redundant and identical. For example, an image file, instead of storing values for "red pixel, red pixel, red pixel," could encode that sequence as "3 red pixels." There is also lossy compression, where a decision is made about what information isn't particularly relevant, and then that information is systematically removed. Lossy compression can dramatically reduce a file's size.

In the case of an MP3 file, there are different levels of compression that can be used to create increasingly smaller files. A file that is slightly compressed likely won't sound any different to you. This is because the algorithms used to compress audio files are based on nearly a century of signal processing research. Telephone companies spent considerable resources working up methods to identify which parts of audio information human hearing is attuned to. These experiments identified people deemed to have a "golden ear" and trained tools and systems based on their tastes and sensibilities. In this regard, each MP3 "carries within it practical and philosophical understandings of what it means to communicate, what it means to listen or speak, how the mind's ear works, and what it means to make music."[10] The MP3 also carries a history grounded in the law and the marketplace. As a proprietary format, the MP3 generates money every time an application runs it.

Finding MP3 files on a piece of digital media is relevant to the history and story of the format. It also communicates something about the audio file's history and production. If instead we had found WAV files with uncompressed audio data in them, it might have signified that the creator of the files cared more about audio quality. At the same time, it would likely be perplexing, as the smaller size of an MP3 file is part of what made it so useful as a format for

distributing over the web. That is, if there were WAV files on the website, it could well prompt questions about why that format was used. Similarly, if the files were OGG files, a free format unrestricted by software patents, it could communicate that the creator of the file was more committed to the open source software movement than to making sure that most users who visited the site could easily play it in their browser. In each case, the format of the file, and information about how the file is set up within the parameters of its specifications, convey considerable information that, in many cases, is essential to what is significant about it.

Exchange Protocols

File formats are related to other kinds of ancillary platforms. As just noted, the constraints of bandwidth for transferring files over the Internet have determined which file formats have succeeded and failed. Bandwidth itself is tied up with both the material infrastructure of the Internet (fiber optic cable, Internet service providers, cell towers, and so on) and the infrastructure that exists in protocols, like HTTP, TCP/IP, and the Domain Name System, which govern how the World Wide Web functions and how information is transferred. Just as the black box of a hard drive obfuscates the materiality of digital information, so too does much of the rhetoric and design of these systems, protocols, and platforms.

Media studies has continually demonstrated that understanding how any of these platforms works involves unpacking who they work for. That is, even something as seemingly banal as a protocol's technical specifications "matter, ontologically and politically."[11] While protocols aren't actually written onto the Marzapan hard drive in the example above, they are implicated in it. The content was designed to be accessed over the web and as such, HTTP, TCP/IP, and the Domain Name System, among many other protocols, as well as the physical infrastructure of the web, play a key role in how and why content is structured as it is.

Information Encoding

Information is often encoded within files via standards that are specified and exist outside the files themselves. This is how it was possible to read the text inside the audio file in a text editor. The text inside any given file is likely encoded based on standards that, just like the format, convey information and provide context about the object's history.

Text can be encoded in any number of ways. For example, ASCII text comes with a set of affordances for producing a particular set of characters, while versions of Unicode include different affordances for encoding more kinds of characters. In approaching these elements as platforms, it is critical to maintain information about the encoding scheme used so that future users can correctly interpret objects in their platform context. For instance, if an encoding scheme didn't have a way of representing diacritical marks in text, you don't want someone to assume that an author who failed to use the necessary diacritical marks was simply careless. This surfaces a broader point. Any and all changes to a file—whether to normalize it, migrate it to newer versions of a format, or update it with improved encodings— can impact the user's ability to accurately contextualize it in the range of platforms it is implicated in from a particular moment in time.

Object Rendering

Our experiences with digital information are generally mediated through a range of graphical interfaces that render the information and in many cases enable our interactions with it. This is part of the reason it's so easy to be a screen essentialist. The experience of using computers is that of interacting with content through interfaces on a screen. On one level, even your operating system is rendering digital information. It is the graphical user interface you use to navigate and manipulate files. Importantly, different versions of a software application, or different implementations for reading files, may result in those files rendering in very different ways.

As an example, many early works of Net Art, artworks created to be displayed on the World Wide Web, depended on quirks and features that were available only in early web browsers. So in some cases, to capture what a work was intended to look like, it becomes necessary to actually record what it looked like on a screen using the original intended rendering software and hardware.[12]

Source Code and Source Files

Another genre of information—source files—makes possible much of our experiences of files and how they are rendered. In the case of music files, audio tracks for each recorded instrument would have been mixed and managed in software like Pro Tools, Acid Pro, or Apple's Garageband. For an image file this could be Photoshop or Illustrator, which come with their own file formats, .psd and.ai files, respectively.

Source files are generally much more persnickety than the resulting files they produce for distribution. That is, a Photoshop file can be opened only by Photoshop, but a JPG exported from Photoshop is standardized to the point that many applications can be used to render it. Along with that, every new version of Photoshop comes with new features, so the format needs to change. The source file is nearly infinitely changeable and as a result far more complex than the JPG it might export for dissemination. For a Photoshop file, you could futz around with all kinds of layers and tweak different aspects of the process of manipulating an image. In the case of an audio source file, you can always turn up the reverb on the kick drum, change how the guitar pans from the left to the right channel, or go back and record another set of vocals.

This relationship between easily renderable files we view or listen to and the source files that generate them is also true of software. Most of our experience of using software involves running an application that has been compiled. That is, the application was written in a computer programing language, like C or BASIC. In its source code form, it was written using commands in text. That

source code was then compiled. A computer program was used to turn the source code into machine code which is, generally, no longer legible to be read as text by a person. It is instead optimized to run quickly and efficiently on a computer. In the case of Photoshop, there is the software that you install on your computer and use to edit files, but there is also the original source code that was compiled to create the software.

Both of these are objects that could be studied. When someone uses Photoshop to edit images, the interface and its history privilege and suggest particular ways of working with images. As a record, the source code for Photoshop can be used to understand and explain how and why Photoshop suggests particular ways of working with images. To this end, how Photoshop does this has been a subject of research in software studies.[13] Similarly, the source code for the first release of Photoshop has been acquired, preserved, and released by the Computer History Museum.

The Messiness of the Digital

- -

Through this chapter I have attempted to provide an overview of key aspects of digital media and theory that enable us to think through and understand digital media. In the next chapter I will connect these aspects of new media to the lineages in preservation we explored in chapter 1. In pulling these together my intention is to clearly articulate and unpack some of the often unspoken assumptions that animate work in digital preservation. In theorizing digital media in this chapter, I want to return to one of the key implications that come from the study of digital media: digital media are messy.

Apple computer commercials present a visual rhetoric of computing as a sterile white world where things "just work." This is the veneer of computing. The reality is much more like the gritty world filled with wires and cables depicted in *The Matrix*.[14] This visual rhetoric is indicative of the way that the surfaces—the screens of computers—are used to intentionally obfuscate complexities of the

platform nature of information hidden underneath. The digital world appears to be a cool rule-bound universe of logic and order. In practice it is a world of partially completed and conflicting specifications, files that were never valid but seem to work fine in the application most people use them in, and, deep down, information that is made up of physical markings on tangible media.

Those underlying media wear out. They get brittle. They can warp and degrade when it's too hot. They can get covered in lint as the fan on your computer tries to cool them down. The messiness of the digital is even written into the source code. As Matthew Kirschenbaum writes, "Programmers even have a name for the way in which software tends to accrete as layers of sedimentary history, fossils and relics of past versions and developmental dead-ends: cruft, a word every bit as textured as crust or dust and others which refer to physical rinds and remainders."[15] At every level, the platforms that enable, constrain, and construct our interactions with digital information are handmade by individuals, companies, and international committees. Just about every aspect of this information can tell us things about the people who saved the files, the folks who created the software, and the communities and societies they are a part of. The digital world is messy. It's important that in our efforts to collect, preserve, and provide access to it we don't tidy it up in ways that remove its significance.

- - - - - - - - - - -

Challenges and Opportunities of Digital Preservation

With an understanding of digital media and some context on various lineages of preservation, it is now possible to break down the inherent challenges, opportunities, and assumptions of the practices of digital preservation. One of the big takeaways from the lineages of preservation is that preservation is always about a dialogue between the material affordances of our media and our visions for cultural expressions that endure. Our cultural forms are remediated and reconfigured in dialogue with the affordances of media and formats. So when it comes to digital preservation, where do we place it in the lineages of preservation?

As is often the case, the answer is, it's complicated. The artifactual conservation approach of computing machines is outside the mainstream of digital preservation practice. Computers are amazing at making informational copies. However, they are so amazing at making copies, that aspects of the artifactual end up recurring in platform layers of the informational objects. I will quickly attempt to describe what I mean and at the same time forecast how this chapter works to ultimately explain this.

For a series of reasons explained below, the artifactual historical contiguity approach has been effectively abandoned in the mainstream of digital preservation work. The challenges of trying to keep digital objects functioning on their original mediums are just too massive. As a result, the mainstream of digital preservation practice is about informational objects, not the underlying material that they are encoded on. This will be the focus of the first part of this chapter.

Thankfully, digital media affords a massive opportunity. Computing has developed with a core focus on making and authenticating copies. As a result, there has never been another medium that is so primed for the informational approach to preservation. So, I will spend some time in this chapter explaining more on this aspect of digital information.

With that noted, because of the nested platform nature of digital information described in the last chapter, there are all kinds of features of digital objects that end up having artifactual qualities to them. There is a palimpsestic quality to those layers of information. While "information" seems to sound like a straightforward and sterile concept, when we drill down through all those layers of platforms, we repeatedly find seemingly hidden information. As a result, much of the preservation thinking necessary for working with artifacts using the historical contiguity approach ends up being very useful in approaching the preservation of the informational content in bit streams. The physical and material affordances of different digital mediums will continue to shape and structure digital content long after it has been transferred and migrated to new mediums. I realize that this is confusing. It will become much clearer through a series of real-world examples.

The result of these two points—(1) that there are considerable artifactual qualities of informational objects and (2) that digital preservation has effectively given up on the conservation of underlying physical media—is that digital preservation is in a significantly different relationship to supporting preservation sciences. A conservator

working with a painting wants to understand the chemistry of it all. For the conservator the basis of the work is in the sciences of the natural and physical world (chemistry, material science, physics, and biology). In contrast, the underlying sciences for digital preservation are the sciences of the artificial: computer science and computer engineering, machine learning, and artificial intelligence. We are only just starting to understand the implications of this, but it means that our relationships to underlying sciences need to pivot as we increasingly move to work with digital preservation.

Conservation of Digital Media: A Nonstarter

Much ink has been spilled about why digital preservation is so hard. Much of the impulse behind that work is grounded in a yearning for the affordances of older new media. Because of their long-lived media and good conditions around those media, we have direct access to forty-thousand-year-old cave paintings and two-thousand-year-old scrolls, sculptures, and buildings. Even in more recent history, one of the triumphs of preservation, microfilming, was the idea that in good conditions copying records onto microfilm could get them to last nearly a thousand years.

Estimates on the average life spans of different kinds of digital media vary dramatically. But one thing is clear: they are nothing like what we have with our analog media. Magnetic tape, floppy disks, hard drives, flash storage, CDs, and DVDs each vary to an extent, but the key point is that the media is generally good for a decade or two before it requires some rather extreme techniques to get data off it. To be sure, there have been many attempts to create more long-lived media; for example, the M-Disc is a stone CD that will purportedly be good for a thousand years, and there is an effort to create an aluminum-based tape storage that would keep data safe even when exposed to fire. However, these technologies have yet to really take off in the marketplace. Experts are highly skeptical that they could take off because the refresh cycle on technologies is so rapid

that most digital media never get anywhere close to their end of life before they are discarded.

The interfaces, both the hardware connections (think of what it would take to find a reader for an eight-inch floppy or a Zip disk) and the software and drivers that can open and read data, often come and go well before media has reached the end of its life. This isn't an innate characteristic of computing. It is less about the nature of digital media than it is about planned obsolescence and a massive computing industry that pours considerable resources into keeping pace with the expectations for better, faster computing devices with more and more storage in smaller form. While we have seen explosive growth in storage space over the last half century, there is no inherent reason for it to continue at the same rate. Each successive advance in digital storage technology has involved new techniques for increasing the density of storage mediums and still keeping the read times for them relatively fast, but there are very real physical limits that for some mediums are rapidly being approached. In any event, the results for conserving digital media remain the same. Even if you have old media, it takes a lot of work to access the information on it. This work becomes more difficult as the years pass and as the underlying media continues to degrade.

Historically, conservators have developed and created techniques to repair, treat, or otherwise make media serviceable for use. So if you have a work that isn't on acid-free paper, you can de-acidify the paper to extend its life. Similarly, in architectural restoration a conservator might restore part of a structure based on an in-depth understanding of how it was constructed. This is unimaginable in the case of digital media. A hard drive, for instance, is an incredibly complex device made of parts that would be nearly impossible to source, and the specifications for such devices will likely be just as difficult to source. There is little hope for a future when a hard drive conservator would fix or treat a fifty-year-old hard drive to make it ready for a patron to access.

Traditional notions of conservation science are, outside of some niche cases, useless for the long-term preservation of digital objects.

However, it is easy to overstate this point. Most ideas about the longevity of digital media are theoretical, based on stress testing media to simulate their use, and not on working with the old media. Archivists have increasingly been able to use forensic techniques to extract data from old media, including media that are three or four decades old. Similarly, tools and techniques are being developed to read and work with damaged or degraded media.

While maintaining aging computing hardware is largely out of scope of digital preservation practice, a vibrant (and invaluable) area of scholarship has emerged in working with exactly these devices. New media and digital humanities labs like Trope Tank at the Massachusetts Institute of Technology, the Media Archeology Lab at University of Colorado Boulder, the Media Archaeological Fundus at Humboldt University, and the Maryland Institute for Technology in the Humanities at the University of Maryland have established collections of historical computing technology, which are enabling extensive exploration and analysis of these technologies.[1] It is unlikely that these machines will work a hundred years from now, but there is still a significant temporal window for scholars to work with them and help us better understand them. The work occurring in these labs is producing an understanding of these technologies that will be critical for working with these machines. The research will be instrumental in our ability to make sense of content that is carried forward into newer systems, and it also is contributing to knowledge of how to move content forward. This work is relevant and significant, but it represents a distinct area of work and practice. It is now generally accepted that if you are able to recover data from such media, the first step in preservation is to copy that information off the media and move it into a contemporary digital storage system. The future of digital preservation does not lie in the maintenance of old computing systems and hardware. The practices of digital preservation are primarily focused on making copies and moving those copies forward to new systems. The good news is that if there is one thing that computing technologies are built to do, it's copying.

Computing Is Copying

The preservation of informational objects (those objects that subscribe to the "same spelling" approach to identity) has always required some faith in the longevity of underlying media. The words are written on the scroll. Those words inhabit their media. The words wait to be copied and transferred forward at a future date. Copying has always been a bit fraught too. How sure are you that this copy is identical to the last in all the ways that are significant? Indeed, much study of manuscripts focuses on how copies diverge over time. There has always been an amount of human error that creeps into this process. Computing media is fundamentally different in this respect.

Rendering a file generally involves copying it. That is, the file exists on your storage media but is read and transferred back to you to view. What you're viewing is not the copy on your hard drive but the one transferred into another part of your computer. This is similarly true of anything you view over the web. For anything to show up on your screen it needs to be copied from its source to your computer. Creating, transferring, and verifying copies are thus a core part of the nature of computing.

Computers are largely designed to treat their storage media less like a medium they are writing a story on (where they come back to where they last left off to start again) and more like a closet (where they arrange and store things as efficiently as possible). If you've ever defragmented your hard drive, this is very much like reorganizing a closet. As your computer has tucked files here and there across sectors in a hard disk, it now goes back and tries to tidy up, optimizing where each file is stored. Yes, at the most basic level the computer is writing, overwriting, and rewriting on the medium, but the system is treating that medium less like a medium and more like a container. To approach a hard drive like a container is to approach it the way a computer does.

As information moves back and forth, as it is transferred between computers or parts inside a computer, its integrity is being more or less constantly checked and rechecked. Most digital networks and storage devices compute CRCs (cyclical redundancy checks) to verify that information is correctly transferred and copied. These checks compute numbers that act as a kind of digital fingerprint for the file so that the number can be recomputed once it is transferred to identify if the file wasn't copied exactly.

In this area, computer engineers have developed a whole range of approaches and techniques to make data more durable in the face of both their distrust of the longevity of physical media and the need for constantly copying and transferring information. The RAID, originally standing for Redundant Arrays of Inexpensive Disks, was designed in 1987. Building on approaches that were in place more than a decade earlier, RAID offers a way to virtualize a storage system to keep multiple copies on the underlying media so that if one drive fails the content of the drive would persist across the other drives in the array. Similarly, forward error correction, a technique of encoding redundant information—multiple copies of the information in the object itself—goes back as far as the 1940s. In forward error correction, redundant information is encoded with the transferred object so that any information lost or degraded in transit can be reconstructed to be identical to what was intended to be sent. As yet another example, the ZFS file system (which originally stood for Zetabyte File System) and others like it compute checks at the block level of the storage device and, without the user even knowing it, will check and repair data. These techniques exemplify how computer systems approach their storage.

In digital preservation, this kind of checking is called fixity checking. By comparing an object's digital fingerprint to a file in the future, we can offer clear evidence that what we have is exactly the same as what we had before. There are many ways to generate fixity information: making sure the file has the same file size, computing CRCs, or using more sophisticated cryptographic hash functions to ensure the authenticity of digital information in cases where someone

might be trying to tamper with it. All of these methods offer evidence that the informational content of a digital file (the entire sequence of os and 1s in it) is identical to what it was before. Those of us working in digital preservation get all of this technology and capability for free.

Caring for and preserving informational objects has gone on for millennia. Cultures have long copied poems, stories, and other works. However, copying has always been somewhat at odds with our media. This is no longer the case. Computer science and engineering has designed and implemented techniques embedded in the core of computing technology that are fundamentally focused on the question of how to make and verify perfect copies. The result is that we can embrace the informational lineage of preservation and assert with confidence that there has never been a medium so well aligned with the informational preservation imperative to make lots of copies and check to make sure those copies are accurate.

At this point it might seem that we can just turn our back on the conservation/artifactual preservation lineage. However, it's a good bit more complicated than that. While digital preservationists have basically given up on the underlying media, interestingly, many of the affordances and kinds of questions that we were able to engage with as a result of the materiality of objects have made their way up the layers in these platforms. It turns out that there is a range of strangely artifactual qualities tucked away in the nooks and crannies of our platform-based informational objects.

The Artifactual Qualities of Informational Objects

When we were dealing with the book *Frankenstein*, what counted as the informational object became relatively transparent. You can see every letter, word, and punctuation mark. When you copy all of that over to something else, you've got the information of the text. In contrast, the platform nature of digital information results in all of these different spots where there is encoded information that could

be relevant but isn't necessarily visible. Here again we get to the idea of screen essentialism. Returning to one of the examples discussed earlier, the Archimedes palimpsest ends up representing a pattern that repeats again and again in the completely informational world of digital objects.

As a reminder, the Archimedes Palimpsest is a tenth-century Byzantine Greek copy of unknown works of Archimedes, which was overwritten with a religious text in the thirteenth century. Through the use of multispectral imaging and computational tools, it was possible to read the text that had been overwritten. The material object retained traces of the Archimedes text that were not visible to the human eye but were in fact still there waiting to be discovered with imaging technology. This pattern now plays out repeatedly, but through entirely informational objects. This is the central source of the screen essentialism described in the last chapter.

In what follows I will briefly describe a series of contexts: a playwright's word files, the history of copies of two individual copies of Apple II video games, and aspects of a more recent video game. Each of these contextual histories demonstrates different ways that informational digital objects carry artifactual and, in some cases, folkloric qualities. Each case also returns to key aspects of the platform nature of digital objects, as these potentially significant qualities may be obscured through interactions between the various layers of software, formats, and protocols required to render and interact with these objects.

Larson's Word Files

Composer and playwright Jonathan Larson, most famous for his musical *Rent*, tragically died shortly before the show's opening in 1996. His papers, along with around 180 floppy disks, were gifted to the Library of Congress Music Division. Curator Doug Reside's work with his files has become one of the most significant examples of the kind of digital scholarship that becomes possible as more and

more manuscript collections provide access to this kind of born-digital information.[2]

Larson wrote *Rent* with Microsoft Word 5.1 on a Mac. If you boot up an old copy of Word on a Mac, or on an emulated version of a Mac, and read the final draft, you can see the text. However, if you open up the same files using a different text editor, you see something completely different. Many of the words are completely different. On the Mac you see the text as he would have seen it, the completed draft. But in another text editor you see something similar but distinctly different. Various lyrics to songs in the musical are different from how they appear in Word. The Word version matches the final score. How can it be that different word processors present different text?

Word 5.1 did something it called a "fast save." When a user saved a document, instead of overwriting the whole file it would append all the overwritten text to the end of the file. Because the text is encoded using common text encoding specifications, you can very well open and read it in another text editor, but what you see isn't what Larson would have seen as he was editing the text. You see the text of an earlier draft, and then down at the bottom of the file you can see the text that is included to overwrite those particular spots in the text that it replaces. The logic for making sense of those fast-save appended chunks of text in the file and working them back into the text isn't there in the other text editor. So when opened in another text editor, the file reveals something of the history of the creation of the file. Tucked away in the file, invisible to the way it was used, is the history of edits and changes in the text. If understanding the history of drafts of this work is important to you, then you have lucked out. A wealth of information on the history of the text is right there for you to see.

Based on the way this particular version of the Word software worked, documents created with it come with these historical traces. When using the right software, or interestingly in this case the wrong software, those traces come to light and show the process through which the document was created.

The Mystery in the Mystery_House.dsk

Mystery House, a 1980 game for the Apple II, allows a player to explore an abandoned Victorian mansion. The game presents players with graphics showing different rooms and places in the house and text describing what happens as you move through it. The details of the game aren't particularly important for this example.

After downloading a copy of a disk image of the game, a bit-for-bit copy of an original 5¼ floppy disk on which this game had been saved, it is possible to boot the game up in an Apple II emulator and explore it. You can also take a copy like this one and explore it through a Hex editor. A Hex editor is a computer program that lets you read the actual binary data that is laid out on a disk. At this point the disk is really a virtual thing. The disk image file is a bit-for-bit copy of how information was laid out on an actual floppy disk, but we have no idea where that original physical disk is or if it even exists anymore.[3]

When Matthew Kirschenbaum did exactly this—downloaded a copy of a disk image of the game from the web—and started looking around in it with a Hex editor, he found something unexpected. As a reminder, text encoded inside a file is itself interpretable and renderable outside the file. So when exploring sectors of a disk with a Hex editor, the editor can render text as it is actually laid out on the disk. What Kirschenbaum found was text from two completely different games, *Dung Beatles* from 1982 and *Blitzkrieg* from 1979. As is the case with many digital storage media, the information on a disk is not erased when deleted. Instead, the space is simply marked as empty. As a result, when you poke around in the actual sectors of the disk, or the bit-for-bit copy of those sectors in a disk image, you can find traces of files that were overwritten. The end result is that some decades later, by exploring sectors of this copy of the disk, it is possible to learn what had been on this disk before the Mystery House game was saved on it.

The disk image of the game is entirely informational; it is a sequence of bits that has been copied and shared with many different

users. However, in the process of copying this disk, more than the informational content of the intended game was copied. By exploring the contents of seemingly overwritten space on the disk, it becomes possible to learn about previous uses of the physical object on which the game had been encoded. Aspects of that artifactual physical object have been carried forth into the informational world of replication.

"Here Lies Peperony and Cheese"

An example from another video game reaffirms the way that personal and individual aspects of use and experiences with digital media can get encoded into them and transmitted forward, in some cases taking on their own cultural lives. *The Oregon Trail*, an educational video game released in a variety of incarnations and versions dating back to 1971, is a bit of an iconic and nostalgic touchstone for people who grew up in the United States in the 1980s and 1990s.

Most of the tropes associated with the nostalgia of the game are the result of its designers' intentions. For example, the programmers wrote into the game the oft-used phrase "You have died of dysentery." However, at least one of the tropes and memes associated with the game was user generated, and its persistence testifies to the widespread history of bootlegged copies of the game.

Those who grew up with the game *Oregon Trail* will remember how, over time, the landscape of the game became littered with the tombstone memorials of the various players who went before. These tombstones are popular enough that there is a free web-based *Oregon Trail* tombstone generator where you can create and share tombstones with friends. What made the tombstones fascinating was their persistence across individual plays of the game. What you wrote out for your characters on their tombstones persisted into the games of future players of your particular copy of the game. It's like a grim kind of scoreboard that created a layer of interaction outside individual plays. Along with that, it made the game function as an ongoing

world. These graves enacted the passage of time in the game. Each play apparently happened after the previous one as the deaths, and often-absurd messages, piled up along the trail.

Piracy resulted in one of these tombstones taking on a cultural life of its own. Each tombstone message was saved to part of the disk the game was running on. Instead of purchasing clean original copies of the game, many players played on pirated copies. When players booted up one of those pirated copies, they would find a tombstone in it that said, "Here lies andy; peperony and cheese." For context on the joke, Tombstone pizza ran a commercial in the 1990s where a sheriff who was about to be executed was asked what he wanted on his tombstone, that is, his gravestone, but responded with the toppings he would like on his Tombstone brand pizza, in this case, pepperoni and cheese.

So some player, presumably named Andy, put a misspelled joke about this commercial in his copy of the game and then let others copy his copy of the game. That copy of the game then became the basis for many pirated copies of it, and as a result the monument that player wrote into their local copy of the game has become a commemoration that took on a life of its own as a meme outside the game world.[4] The saved game information on that particular copy of the game has become part of the game's cultural meaning.

This example illustrates the ways that folkloric objects, which have largely been missing from this discussion, are very much still a part of our digital preservation ecosystem. In this case, a joke from one of the users enters the canonical story around the game. An individual variation on the game emerged and replicated, in much the same way that variations replicated in oral traditions and manuscript traditions.

Representing Indigenous Peoples in Colonization

The 2008 release of *Sid Meier's Civilization IV: Colonization* came with considerable controversy. In the game, players enact the role of a colonial power colonizing, pillaging, and conquering the Americas.

While the surface of the game—how it presents, represents, and models the colonial encounter—is available for analysis and critique, the way the game itself was constructed also opens up another vector to approach it: source code.

Civilization IV was built to be modified. Much of the game is written in Python scripts that are readable and editable by its players. While there is a core part of the game that runs compiled code that cannot be read as text, much of the rules and logic of the game are written in a way for players to be able to edit and change them. *Colonization*, a commercially released game, is functionally a large mod of the game. It uses the core engine of the game and simply includes a lot of additional files that rewrite some of the game's rules to change it into the game it is.

Researcher Rebecca Mir and I were able to explore the game files to unpack how it establishes the differences between the indigenous peoples of the Americas and the Europeans.[5] From the perspective of the game's source code there are "normal" peoples (colonial units controlled by the player), Native peoples (controlled by the computer), and Europeans (also controlled by the computer). Normal peoples come with a range of abilities and characteristics. The game's code takes many of those "normal" peoples' abilities away from peoples who are flagged as "isNative." So in the source code you can trace exactly which abilities of the European powers are removed from the native peoples. The result is that, beyond understanding the experience of the game, because of how it was designed and set up, it is possible to see exactly how the game enacts its colonialist vision. In fact, a new area of humanities scholarship, critical code studies, is doing exactly this kind of close reading of source code to explore its extra-functional significance.

What is relevant here is that because of the way the game was designed, every copy of the game came with parts of its underlying source code open to anyone to explore and read. Even if you weren't able to play the game, you could learn a lot about how it worked from reading the Python scripts and the XML files in it. In this respect, the game object contains both the ability to experience and run

the game and, when explored through your file system, the ability to deconstruct some of how it works.

Copying Bit Streams as a Preservation Action

Taken together, these four examples illustrate how the interactions between any and all of these layers in the platform nature of digital objects create places where potentially significant information might be tucked away and present to be further explored and interrogated. Where it was relatively straightforward to define the informational qualities of a book (just make sure all the words are spelled the same), there is a nearly endless amount of potentially significant information tied up in the artifactual qualities of digital objects. Many working in digital preservation consider making a bit-for-bit copy of all the information on physical media to be not an act of copying but one of preservation—stabilization, treatment, or conservation of a physical object. From this perspective, we move increasingly into different relationships to the supporting sciences for preservation.

The XKCD comic *Old Files* offers a ready example of how this is part of the lived experience of carrying forward our digital past. It shows the protagonist, a representation of the author, down at the bottom of the stratigraphy of his personal digital files. As we move down the layers, from his current "documents" files back to his "Old Desktop" to his "High School Zip Disk," we find bubbles representing various files, including prom photos and a love note. At the bottom he opens a text file and rediscovers that as a youth he had written poetry.

The comic visualizes the way that file names created for quick use, like "Old Desktop," end up becoming permanent parts of the organization of information and the way that, in practice, copying forward old files feels much like scraping off layers of sediment, and reading back into our past. The artifactual is encoded up and throughout the layers and carried forward through time as data makes its way from one medium to the next.

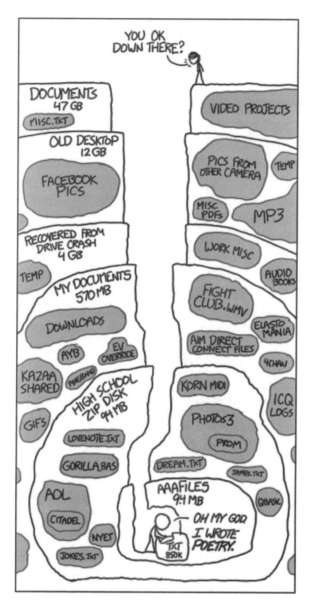

Old Files by Randall Munroe. From *XKCD: A Webcomic of Romance, Sarcasm, Math, and Language*, 2014. Creative Commons, Non-Commercial 2.5 License

Renderability, File Format Sustainability, and Porous Object Boundaries

In each of the cases described here—the various kinds of textual documents and video games—one of the central issues is how you go about opening, viewing, and interacting with a file. One word processor shows some information, while another does not. This draws attention to a critical aspect of the platform nature of digital media that is unique and challenging for preservation purposes. A print book, a painting, a statue: these are objects that you experience via your senses. Yes, you might need to know how to read text in the book to make sense of it, but you don't need to know what encoding scheme it used; nor do you need to have the right fonts installed or open it in the right version of WordPerfect.

The authentic rendering of digital content, and not confusing rendering in one situation with all possible renderings, becomes a central consideration of digital preservation. As the examples in this chapter and the last demonstrate, specifying the boundaries of the digital objects is itself a challenging intellectual exercise in a way that just wasn't the case for discrete and largely independent physical objects. It is generally not enough for us to have sequences of bits; we need to understand issues related to the likelihood that we will be able to render works in a given format in the future and have an understanding of what kinds of use we might be able to offer for objects for which we may lose the ability to render. These are points that I will return to multiple times later in the book.

Computer Science as the Digital Material Science

If we take the bit stream as the base layer, the object that is to be preserved and then studied and interrogated by users, then we have entered into a very different relationship with supporting sciences. When the Royal Museum in Berlin opened a lab to conserve collections in

1888, they hired a chemist to run it. Conservation science has involved a deep engagement with the natural and biological sciences.

Conserving physical objects can always be improved through a deeper understanding of the nature of those objects. But the second we leave the world of physical objects, the world of the medium, and move up to the layer of the bit stream, we have left the natural world and entered the world where artificial intelligence, computer science, engineering, and an ever-growing range of fields and disciplines are developing entirely based on the premise of working with and manipulating digital information.

The field of digital preservation needs to further develop and explore potential relationships with approaches and ideas in the computing sciences. For example, virtualization and emulation technologies, approaches to virtually replicating both hardware and software, continue to advance and show considerable promise for work in digital preservation. Advances in computer vision techniques and natural language processing techniques present considerable potential for organizing and describing digital objects.

Returning to a theme discussed at the end of the previous chapter, digital information is far messier than it seems like it should be. It's all 1s and 0s, right? Not to mention that we have set up a whole range of tools to make it easier to correctly copy those 1s and 0s. The challenge is that on top of the base layer of the bit stream the nested layers of platforms—all the file formats, encoding standards, operating systems, rendering applications, and so forth—need to interlock to enable various ways to interact with and make sense of that information. So we need to be proactive in making judgment calls about what matters about some material, what risks we are willing to take with it, and how we can make it available today with an eye toward the future. Digital preservation has no hope of being an exacting science. Instead it must be a craft grounded in our working theories of preservation and digital information. In the remainder of this book, I offer a pragmatic and iterative guide to how to approach this craft.

- - - - - - - - - -

The Craft of Digital Preservation

Digital preservation is a craft, not a science. At least that's the central contention behind this book. The previous chapters establish a basis for why this is the case. Digital preservation should not be understood as a rupture with an imagined analog past. Instead, digital preservation is best understood as part of an ongoing professional dialogue on related but competing notions of preservation that go back to the very beginnings of our civilizations. Aside from this, the history of computing is best primarily understood as a social and cultural phenomenon instead of a technical one. Rhetorically, computing is sold to us as clean, efficient, and nearly perfect logical mechanisms. However, experience teaches us that computers are very much a part of the messiness we know so well from our analog world. Drives fail. Bits flip. Files corrupt. Software brims with cruft. Digital preservation must be a craft and not a science because its praxis is (1) grounded in an ongoing and unresolved dialogue with the preservation professions, and (2) it must be responsive to the inherent messiness and historically contingent nature of the logics of computing.

In defining digital preservation as a craft I assert the following. Digital preservation is not about universal solutions. Instead, it is about crafting the right approach for a given preservation context. Digital preservation is not primarily technical in nature. Long-term access to digital information requires flexible approaches to planning that consistently engage with conceptual issues. Machines alone cannot accomplish digital preservation. Digital preservation requires the work of craftspeople who reflexively approach digital preservation problems in situ and develop approaches that match the resource, material, and conceptual constraints of a given setting.

What follows is my attempt to establish a frame of reference for the craft of digital preservation. The intention here is not to lay out sequential steps in a process. Instead, throughout the following chapters I offer points of entry into issues that need to be considered to ensure long-term access to digital information. Different approaches are required for different content, uses, and audiences. Those differences are fundamentally constrained by an institution's resources. Ultimately, the craft of digital preservation is an ongoing dialogue between the affordances of media, the intentions of creators and curators, and the institutional commitments and resources that enable preservation.

Expansive, Iterative, and Interactive Approach

Preservation is access in the future. Everything that is necessary to enable access in the future is necessarily a part of digital preservation. This requires us to take an expansive view of the subject. Digital preservation requires adequate planning, description, and modes of access. There is a logical order to working through these issues, and that order provides the organizational structure for the rest of this book. The following four chapters touch on a broad range of issues related to ensuring access in the future. Each chapter focuses on an area of craft: (1) preservation intent and collection development,

(2) managing copies and formats, (3) arranging and describing content, and (4) multimodal access.

As a note on language, throughout these chapters I often defer to using archival terminology (*appraisal, arrangement, description,* and so forth) over bibliographic or curatorial terms. Several aspects of archival practice resonate with aspects common to many forms of digital content. Archivists have been dealing with complex hierarchical relationships, aggregations of records, and massive scales for a long time. The archival frame of mind from the cultural heritage professions (libraries, archives, museums, conservation, folklore, history, archeology, literature, records management, anthropology, among others) is often the best fit for digital preservation.[1]

While I draw on this language from archives, it is important to remember that the collection practices of libraries, archives, and museums are not static. It may seem we need only to import well-established analog preservation practices into the digital environment. In general, this is a great place to start. The values and wisdom embedded in these practices shouldn't be tossed out just because something seemingly new has come along. However, the dynamic and evolving processes of working with analog collections can easily be oversimplified and ossified into a static foil to be compared and contrasted to. The practices of preservation and access of analog material are anything but static.

The preservation and access of analog materials is not a solved problem. Various shifts have occurred in preservation lineages, and several shifts are occurring right now. It is critical that we make sure digital preservation is in dialogue with the state of the art in all areas of our fields and not drawing on outmoded ideas about collections. For example, while the More Product, Less Process (MPLP) approach to processing archives is more than a decade old, it has not fully made its way into archival practice.[2] Similarly, the development and growth of community archives for understanding archival practice is receiving growing attention.[3] If you are unfamiliar with these shifts, don't worry at this point. I will discuss MPLP and community archives where it makes sense to integrate them in the following

chapters. The key issue to note is that practices of working with collections are constantly evolving, and, more broadly, preservation will not and cannot become a solved problem. It's tied up in a range of ideologies and values and has and will continue to evolve as any professional craft does. Things are not preserved; they are *being* preserved. That is, preservation is an active process. We solve individual preservation problems in individual contexts and ensure hand-offs to the next generation of preservation craftspeople.

In separating the areas of craft and putting them in order in the following four chapters, I realize that this may look like a straightforward sequential process. There is a logic to this sequence. It generally makes organizational sense to begin with intention and end with access. However, I want to stress that, in practice, digital preservation remains a rather nonlinear, iterative, and interactive process. In any given situation, issues and affordances of objects and media in one area of craft will have significant effects on the others. As you start working in one of these areas of craft and work through the others, you will often need to pivot your approach because of a new development in another area of craft. The framework in the diagram below and in the next four chapters is not a checklist. Think of it more as a guide to the questions to think through in the process of making and enacting your digital preservation strategy.

The diagram below models how I see these four areas of craft interacting. In this model, preservation intent and collection development function as the foundation of your digital preservation work. All of the work one does to enable long-term access to digital information should be grounded in a stated purpose and intention that directly informs what is selected and what is retained.

Next are the core areas of digital preservation work: managing copies and formats. The central issue in this case is how to establish systems and processes to ensure bit preservation and plan for the future renderability and usability of digital content. After that comes arranging and describing. Content is accessible only when it is arranged in a way that is legible to current and future users and when it is described in such a way that it can be discovered by those users.

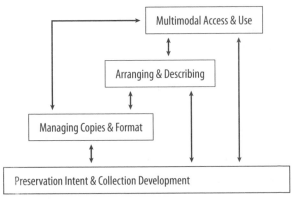

Areas of digital preservation craft and their relationships. Diagram by author

Lastly, I have included multimodal use and access. One of the key affordances of digital media is that access is possible in a much wider range of modes than is the case with analog materials. Access no longer needs to (or should) default to looking at one page, of one thing, in one place, at one time. These new modes of access bring with them their own set of rights, permissions, and ethics issues that must be considered as well.

All these areas of work function as part of a logical sequence. However, I've included bidirectional arrows between each of these areas of activity to underscore that issues raised in any particular area may have significant ramifications for rethinking processes in another. For example, if the content an institution is preserving has no rights restrictions or privacy concerns in terms of access, then an organization could design its core preservation infrastructure to be far more open and widely accessible. Similarly, if an institution decided that all that is necessary for access to a collection of a million images is the ability to bulk download it as it was received, then this would entail far fewer resources than if a collection required item-level descriptions for each of those million images. In that case, for the purposes of preservation it might be treated as a single item with a single set of

fixity values instead of as a million individual items. Throughout the coming chapters, I will highlight points where these different areas interact or connect with each other to underscore this issue.

In the same vein, it's important to think through each of these areas at least at some basic level at each stage in developing a preservation strategy or plan. At the start of any collecting initiative, think about who will use the material and how you are going to get it to them, but don't feel that you need to have everything completely planned ahead. Realize that you need to be open to a range of possibilities that may emerge later as the technologies we work with continue to develop and evolve. Good digital preservation work is done by working a given preservation problem in all of these areas at once. You want to surface issues that might arise in each area as soon as possible, and thinking through them together helps do that. All of these areas of activity are set inside a broader frame. Each area of craft is enabled and enacted through the policy and practices of the institutions that ensure preservation happens.

Policy, Practice, and Institutions

--

Policy is what you say you are going to do. Practice is what you are actually doing. Whether you're at a national library with a staff of thousands, at a house museum with a staff of one, or just an individual working to keep your digital information in order, it's important to have both policy and practice.

A considerable amount of time and energy has been invested in establishing digital preservation policies at institutions and reviewing and studying those policies.[4] This is critical work. It is essential for an organization to clarify what it intends to do. Internally, this helps an organization. Policy development and review clarifies roles and responsibilities and their distribution throughout the organization. Externally, formalizing policy helps set expectations for what assurances the institution offers its stakeholders. Still, policy often seems a bit fancier than it really is. Functionally, policy is simply

high-level statements about expectations and practices. As such, policy statements need to reflect the realities of practice.

Preservation is possible only through the alignment of the work that people do—their tools, their work flows, and the resources they are given to support those activities. As such, policy makes all of those inputs align and become legible to everyone involved. I have not included a chapter that focuses on policy or practice, as all that follows in the next four chapters serves as input that can be used to continually refine and define organizational policies and practices. With that in mind, every organization serious about digital preservation should establish a regular, at least annual, process whereby explicit statements about digital preservation policy are reviewed and revised based on continued developments in each of these areas of craft.

In discussing policy, I have shifted to talking about institutions and organizations. When I say "we" I'm generally referring to you, the reader, an individual interested enough in practicing digital preservation to read this book. However, digital preservation is not something that we can do alone. I realize that some readers may be working completely on their own, outside any organization or institution. Take heart, there will still be valuable information ahead for you. For at least a while, we can each act as our own institution, or establish our own institutions in our communities. Institutions are broadly construed here to include families, civic groups, collectives, and any other number of more informal groups. The issues described ahead will be relevant to an organization that is a single individual and one that employs a cast of thousands. Ultimately, however, only those institutions that outlive any individual can enable long-term access.

Preservation happens because of institutions. Even if you are just organizing and managing your family's photos and documents, if they are going to persist beyond your lifetime, it will require something bigger than yourself. They could persist through family institutions, handed off and made legible to the next generation, or they could be handed off to a local historical society. In any case, individuals alone can't do digital preservation. In the grand scheme of things, our lifetimes are fleeting. Given the nature of digital media, it is unlikely

that, without actions and interventions, our digital records will last long into the future and be intelligible and accessible without the support of an institution. To that end, even for an individual working alone, the chapters ahead are useful for thinking through and making plans for the handoffs to institutions that will be necessary to ensure access to content in the future.

Relationship to Other Models and Frameworks

There are several models and frameworks for digital preservation practice and planning. It is not my intention to add to this list. Most notably, the Open Archival Information System Reference Model (OAIS), Trustworthy Repositories Audit & Certification (TRAC), and the more recent National Digital Stewardship Alliance Levels of Digital Preservation (LoDP) offer frameworks for doing digital preservation.[5] Although these three are the most popular and widely used at this point, there are many others.[6] Rather than offer a competing or additional framework, I aim to provide a complementary context for reflexively practicing digital preservation as a craft. The issues in the following chapters need to be considered and explored when working in any of the given models. Part of the idea of digital preservation as craft is that there isn't a single system for doing digital preservation. It is a field that requires continued refinement of craft. The chapters ahead are intended to support individuals in refining their craft and applying that craft in support of the missions of cultural heritage institutions.

My approach is most closely aligned with LoDP, which makes sense, as I was one of the people who helped develop it. The central assumption behind LoDP is that digital preservation is about making the best use of limited resources to mitigate the most pressing risks of loss of digital information over the long term. It is worth noting that LoDP covers most of the issues that would be raised in a TRAC audit. So the good news is that there is considerable alignment between these models and frameworks.[7] My approach is also

a good bit broader than the focus of LoDP, which is solely the technical aspects/requirements for digital preservation. The chapters ahead deal with the broader issues required for thinking through policy and practice. These policy and practice issues are much more present in things like TRAC. I won't spend much time discussing or working through these frameworks, but the points I raise throughout the rest of the book are useful in working inside any of them.

The idea of digital preservation as craft is partly a reaction to what I see as the "over-diagram-ification" of digital preservation. All models are wrong, but some are more useful than others. As such, my suggestion is to not get overly attached to any of the diagrams or models but instead to focus on the core issues at play in the work. In my experience, this comes up in cases where the OAIS model is used as the only lens through which some in digital preservation can think through or conceive of the work. For some, the boxes in the OAIS model seem to override the realities on the ground that the model is supposed to help them navigate. This is particularly important, as the OAIS establishes a series of problematic power relationships between content creators, users, and institutions.[8] The frameworks are useful as maps, but it's critical to remember that a map is not a territory. As maps, these frameworks are useful as tools only to the extent they help do the work. So don't take any of them as commandments we are required to live by, and don't get too locked into how any of them conceptualize and frame digital preservation problems.

The next four chapters are intended to provide guidance in mapping that terrain. After reading them you will be well positioned to think about what it is that matters about the things you want to preserve. Then you can make sure your approach to digital preservation actually respects what matters about that content. From there you can be sure that you have organized and described it in such a way that it would be discoverable and intelligible to your users now and in the future. Providing users with multimodal access enables them to provide feedback, in turn allowing you to think through how someone would best be able access it and make use of it. When you're doing those various activities, you're doing digital preservation.

- - - - - - - - - - -

Preservation Intent and
Collection Development

For more than a decade, millions of people around the world have been logging on to play the massively multiplayer online game World of Warcraft. When players load up a copy of the game on their computer, it connects to one of many servers where they interact with thousands of other players. Together they can go on quests, fight various monsters, and duel each other.

If you wanted to preserve World of Warcraft, what would you save? The individual copies of the game can be played only when connected to the server environment. Even if you have a server set up, if you logged into the game in some future time, it would be an empty and vacant place devoid of its players. Much of the experience of this game is tied up in the culture and experience that emerges among players. So even if a bunch of people logged into the game world a hundred years from now to play together, none of that cultural and social context would be there.

So what is World of Warcraft? The answer is that there isn't *one* answer. There are many Worlds of Warcraft. It is a packaged piece of software sold in stores. There is the game world that emerges from the combination of the packaged software and the server environment.

There is its player culture and community, which is documented in user-generated videos, and through ancillary guild websites. It exists as a design object, documented in the born-digital records of Blizzard Entertainment, the company that created and runs the software. If you were interested in that corporation's history, you might best document it through an oral history project. Which of these Worlds of Warcraft most warrant preservation? The answer to this question depends on the mandate and mission of the institution interested in preserving it. Before deciding which of them you want to preserve, it's essential to clarify your preservation intention and align that with your plans for collection development.

This establishes the two key questions of preservation intent. First, what aspects of the thing you want to preserve are significant? Second, what do you need to do to make sure what matters to you about this thing persists into the future? It may surprise you that these questions often go unasked. In many cases, institutions move forward with preservation projects with tacit and/or unarticulated answers to them. If you haven't taken the time to puzzle through these questions, there is little reason to believe that whatever you acquire, manage, describe, and provide access to will best meet your unstated goals. The messy nested platform nature of digital information makes this challenging. Further, users care mostly about the meaning that can be made from collections of objects, not the objects themselves. So, it is critical to be deliberate about how we answer these questions in any given context. This is why digital preservation must be continually grounded in the articulation of preservation intent.

A statement of preservation intent lays out exactly why content was collected and what features of that content need to be attended to so that the content can be used for the purpose it was collected for. Establishing preservation intent starts by answering the question "Why are we doing this?" Articulating preservation intent is an ongoing dialogue between the significance of the things you want to preserve, your digital preservation policies, and your ongoing approach

to collection development. In many organizations, these strands of work are taken to be fundamentally different areas of activity. However, if you haven't clearly articulated your intentions for preserving a particular set of content, then you have no basis to be sure that your policies can support that intent. Similarly, if digital collection development planning happens outside discussions of preservation intent, then an organization may not have the resources to follow through on its plans and desires. You want to be purposeful and strategic, and this requires explicitly articulating preservation intentions. This is particularly critical, given that deciding what matters most about the material can lead to radically different approaches to collecting, preserving, arranging, describing, and providing access to it.

In this chapter I work through several examples of digital collections and objects that cultural heritage institutions have been collecting and preserving. I start by focusing on the challenges of pinpointing significance; because of the context of their creation and differences in what is deemed valuable about them, similar objects can result in different preservation approaches. I then explore the extent to which significance often exists outside what might seem like the default boundaries of a given object. This opens to a brief, broader discussion of how the novel possibilities of digital collecting enabled by affordances of digital media can inform strategies for digital collection development. As in any craft, principles and approaches emerge through the praxis of doing the work. Together the examples underscore how well-articulated preservation intent makes the resulting collections easier to evaluate and more transparent for future users.

Throughout the chapter I will use these examples to highlight how, based on the curatorial mission of an institution, you might make different decisions about significance for a given object. Each case highlights key issues to consider as you articulate preservation intent. Ideally, organizations should set up processes to create preservation intent statements. These could take a variety of forms but can simply be short write-ups about the content's significance that

are mutually understood and agreed upon by various stakeholders. As several examples demonstrate, these intentions are revisited and revised through the practices of acquiring, organizing, describing, and providing access to content. If you find yourself with a lot of digital content in your repository for which no one has articulated preservation intent, then by all means go back and do so.

Pinpointing Significance in Context

To articulate preservation intentions, you need to pinpoint what it is about the content that matters to your organization's mission. At one point, many in the digital preservation field tried to identify context-agnostic notions of the significant properties of various kinds of digital files and formats. While there is some merit to this approach, it has been largely abandoned in the face of the realization that significance is largely a matter of context.[1] That is, significance isn't an inherent property of forms of content; it's an emergent feature of the context in which the content was created and the purpose it serves in an institution's collection. Even basic claims about which records or objects are identical, or that one thing is an original and another a copy, come with a set of assumed conventions about the criteria for what matters about the nature of the record or object.[2] This realization is a key part of why organizations have started to shift to a preservation intent approach.[3]

Discussing a few examples of different kinds of digital content will help illustrate how tricky identifying and articulating significance can be. We will briefly consider the significance of content on Salman Rushdie's laptop, Carl Sagan's floppy disks, and CDs and DVDs submitted to the Veterans History Project. All three of these carry a multitude of potentially significant information. Understanding the context in which they were each created and the purpose for which they have been collected can surface themes for establishing preservation intent.

The Rushdie Laptop

Salman Rushdie's papers were acquired by Emory University's Rose Manuscript, Archives, and Rare Book Library. This collection came with three laptops. The laptops contain email correspondence, drafts of writings, and other notes—exactly the kind of material that archivists seek for a collection of personal papers of a literary figure. It's a great collection.

It is relatively simple to copy the files off the computer. However, the team working with the laptops realized that, given that this was the personal digital working environment of a significant literary figure, much of the other information that exists in the computer itself (its interfaces and applications) was of potential interest to researchers.[4] As an example, Rushdie made extensive use of the "sticky notes" function of the Mac operating system, which allowed him to keep color-coded notes that look like Post-it notes.

Given the context of the laptops and their significance relative to the library's intention to preserve Rushdie's personal papers, it made sense to keep a copy of the laptop's contents (after removing files from the computer that were outside the collection's scope and weren't retained) and emulate the digital writing environment so researchers could explore how it appeared to Rushdie. Currently, one of these laptops is accessible in such an emulated environment. I will discuss emulation and virtualization in the next chapter and again in the chapter on access, but in short, these techniques enable one to provide access to digital content through a replica or a virtualized manifestation of its original software and operating system.

For these laptops, it made sense to set the bar high for preservation intent, and indeed, the archivists have targeted a rather high level of authentic rendering. Given that these computers were used by a significant literary figure, it was prudent to invest time and resources to get as rich and authentic as possible an experience of the digital information and files. The artifactual qualities of information in these machines have the potential to be valuable to the core reason a collection like this was acquired. However, different contexts

of use for digital media can suggest different approaches, as the following example shows.

The Sagan Floppy Disks

Carl Sagan's papers were acquired by the Library of Congress Manuscript division. The massive personal papers collection came with a significant amount of born-digital content. The collection includes 379 floppy disks containing more than 18,000 files, mostly WordPerfect documents. From this description, one might think that this content is a great candidate for making forensic (bit-for-bit) copies of each disk. At first glance, it seems like this case would be very similar to the Rushdie laptop. That is, given that this is a personal papers collection, it would seem to make sense to try and get the most high fidelity copies of each disk so that one might be able to recover deleted files or find otherwise hidden information tucked away in the layers of information present in them. However, an understanding of the context behind these disks suggests a different approach.

Carl Sagan was not much of a computer user. This might seem strange, since his collection included hundreds of floppy disks. Sagan's writing process involved a constellation of technologies and people. When working on books in the 1980s and 1990s he would dictate sections into a tape recorder.[5] The recordings were then sent out to be transcribed. The transcripts of those recordings are what fill nearly all of the floppy disks. From there, Sagan would mark up printouts of the transcripts and edit, revise, and assemble them into drafts. So the Sagan archive is, in large part, full of printouts of the files from these disks. The printouts are interesting in that they show all the hand edits and rewrites. So, what is it that matters about the files and the disks?

Given this context, it makes sense to take a different preservation intent approach to these disks than to the Rushdie laptops. While someone might be interested in the peculiarities of the disks or their files, they aren't really going to tell you much about him and his writing practices. As another point of comparison, unlike playwright

Jonathan Larson's floppy disks (from chapter 2), which included information hidden away in the files from the quick-save process on the computer he used, Sagan's disks weren't even directly used by him. Here again, we find a key distinction for establishing preservation intent. It's not that floppy disks in general have significant properties or, for that matter, that the kinds of files on those disks have significant properties. What matters is the context in which the disks and the files were used and the connection between that context and the purpose for which a collection was acquired. In the case of the Larson floppy disks, it makes sense to set the bar higher than for the Sagan floppies. However, because of the limited role computing played in Sagan's writing process and because these disks largely reproduce content that is available throughout the rest of the collection, it's appropriate to take a much less fussy and high-touch approach to capturing information from these disks. Simply getting and retaining a copy of all the files is likely sufficient. One could even argue that, since this material is largely reproduced in printed form, it might be reasonable to not bother with or retain the disks at all.

However, the information in the disks comes with several important affordances. First, the files illustrate and explain part of Sagan's writing process. So although they contain largely redundant information, they provide additional contextual information for studying his writing process. Second, the WordPerfect files making up the bulk of the content consist of searchable text and time stamps, enabling scholars to more easily access and study the collection. This gets at a point that will come up later about access: increasingly, one set of objects can serve as metadata for another set. There is no need to digitize and run optical character recognition on much of this collection to search it. It is possible to use the text of the files and the dates to do full-text searches through much of the content of the archive.[6] This surfaces a significant affordance of the WordPerfect files over the paper records and the audio tapes in the archive. While the content may be redundant, the indexability of the digital files means they have considerable potential in terms of access.

The key point is that the context for the use and creation of digital media can suggest different approaches to determining what is significant about a given set of objects. The files on Rushdie's laptop are the result of his personal computing usage, while the computer files in the Sagan archive are far less personal. These contexts of use suggest that the Rushdie files have a preciousness that invites one to consider giving them more attention and care than the Sagan files. The significance of particular content can be surfaced and assessed only in the context of its original use and the preservation intent of an organization.

Veterans History Project CDs and DVDs

The Veterans History Project (VHP), part of the American Folklife Archive at the Library of Congress, collects and preserves firsthand experiences of US veterans. It collects a wide range of personal materials, including photographs, letters, diaries, and maps, but the bulk of the collection comprises oral histories. Many of these histories are now transferred to the archive on CDs and DVDs. While in some contexts, a CD or a DVD might be thought of as an object, a record, or an artifact, in this case, these media are thought of as carriers.[7] They are a means to transfer the oral histories, not artifacts in their own right.

The distinction between these media as carriers versus artifacts may seem pedantic, but these different perspectives and intentions about media result in key differences in how one approaches collecting and preserving content. From this perspective, it makes sense to focus on the audio-visual content carried on the medium and much less on the format itself or the idiosyncrasies of the way the information is stored or presented on the medium.

While one could create disk images of each piece of media, in this case, it would also be completely justifiable to simply extract the audio and video files and then consistently normalize them into a coherent set of content that will be easier to ensure long-term access to. This approach would result in a loss of information; we can imagine

a future user wanting to know what information other than the A/V files was stored on these disks or how it was ordered and placed on the disk. For example, some of them include DVD menus for navigating the content. However, since the intention of this project is to maintain records of individual veterans and to collect and preserve recordings of them, it is completely acceptable to focus on the content of the recordings and not on the elements of their carriers. This is how you establish preservation intent: clarify the purpose of a collecting initiative and map that purpose across the features and affordances of your content.

Focusing solely on the content of the audio and video files makes it possible to establish a work flow whereby each recording is normalized. The resulting collection will be far more standardized and easy to work with. One can imagine that a project like this could be even better positioned to generate this level of consistency by developing a mobile app that allowed individuals to create these recordings, describe and tag them, and directly upload them. Taking even more direct control of this part of the process would result in more uniform content.

This case illustrates how a particular preservation intent can establish a different frame with which to consider digital media. That is, given the intention of this project, it makes complete sense to focus less on artifactual qualities of digital media and treat it instead as a carrier of audio-visual information. When a project tightly establishes its intention like this, it becomes possible to produce normalized content that will be far easier to access in the future. This is most often the case in situations where an organization is running a documentation project or a digitization effort. In the examples of personal papers collections from Sagan, Rushdie, and Larson, a collecting organization is left with whatever files and formats the individual used. Keeping these original formats opens up some potential challenges for future renderability of content. When one can instead default to normalization, as in the case of the Veterans History Project DVDs and CDs, the result will be resources that are more consistent and easier to work with in the future. That is, controlling the

contexts and formats, or making normalization part of the acquisition process, will inevitably make preservation and management of collections easier in the future. This illustrates how the arrows in the diagram in the last chapter flow out from preservation intent to work on management of formats, arrangement and description, and access. Decisions about preservation intent have clear and direct ramifications for what you do in each of those other areas.

Significance Is Sometimes outside the Object

When you get serious about preservation intent, you will often find that what is most significant about an object in a given context isn't best captured and preserved in the object itself. It's important to remember that, for the most part, people now and in the future are less interested in things themselves than in what things signify. Meaning is tied up in the contextual issues surrounding the social, cultural, and economic roles that objects play in our lives. Thus the documentation about the object, or recordings showing the object in use in its original context, may be better at capturing its significance. This is one of the key reasons being intentional about preservation early and returning to those intentions often are so essential. While you could just keep "the stuff," it's possible that what matters about "the stuff" isn't inside it but something that would best be recorded or documented through other means. As noted in the Veterans History Project DVD/CD case, this kind of documentation generally gives you control over the formats, making it easier to sustain access to the content.

This point is true of preservation in general. You can preserve the heavy machinery equipment from a factory, but that won't tell you much about the lived experience of working there. If you want to know about that, doing an oral history project with the factory workers would likely give you better material to preserve. You can preserve letters and artifacts left at the Vietnam War Memorial. However, photos and videos of people interacting with the memorial

and the personal stories they share enable different kinds of understanding of how the monument functions. You can preserve the score of a symphony, but a recording of it captures what it was like to be in the audience. So on one level, there is a continuity between preservation of digital and analog objects. However, the platform nature of digital objects introduces several additional reasons and possibilities for documentation as a preservation approach. In all of these contexts, we begin to move a little bit out of the confines of preservation intent and into broader questions of collection development. Rather than pinpointing the significance of an object as in previous examples, in these contexts we set aside the object and ask questions about which objects should be selected for preservation.

Several examples will help illustrate these points. In what follows I briefly describe approaches to collecting a work of Net Art, a medical database application, a massively multiplayer online game, and an iPad app. Each case demonstrates how, depending on the context in which an object operates, collecting and preserving content that documents aspects of its use and function might be preferable to preserving the object itself.

Form Art: Is It the Object or What It Looks Like?

Alexei Shulgin's *Form Art* is an interactive website made of basic form elements in html—things like checkboxes, radio buttons, dialogue boxes, and so forth. Created in 1997, the work would have originally been rendered and viewed in a browser like Netscape 3. Even then, what the work looked like on your screen depended on the browser you used; that is, the artist had already lost significant control of its appearance. Rhizome, a digital library anchored in the New Museum in New York City, is preserving the work as part of its ArtBase.[8]

These kinds of form elements are styled to take on a different look in various browsers. Below you can see one example of how the work's appearance changes over time as one views it in a contemporary browser.

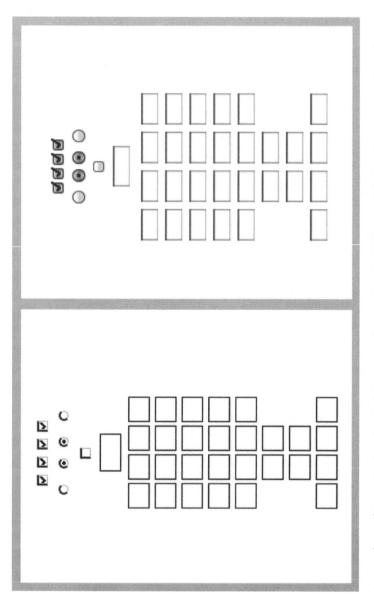

Screen shots of *Form Art* by Alexei Shulgin (1997) as rendered in Netscape 3 (*left*) and a recent version of Google Chrome (*right*). Courtesy Ben Fino-Radin. http://rhizome.org/art/artbase/artwork/form-art/

The image illustrates how in a new browser and a new operating system the underlying work can appear significantly different. It is still recognizable, but the gradients and added color in the Mac instance of the Chrome browser result in a very different visual representation of the same underlying HTML.[9]

At this point the question becomes, what matters? The work's appearance, the underlying HTML, or both? Given that this is a work of art and how something looks is a key part of understanding its aesthetics, it seems clear that what it looks like on the screen likely matters. At the same time, maintaining the HTML is likely equally important to someone who wants to be able to pick apart exactly how it was constructed and designed.

As is evident in the images above, it is still possible to record and render exactly what this work looked like on the screen by taking a screen shot. The screen shot is a pixel-perfect copy of what appeared on the screen in a standard image format that will be simple to render now and in the future. At the same time, maintaining old systems and hardware to render a work like this in an old browser on an old operating system is also a viable way to achieve this kind of authentic rendering. Yet virtualizing or emulating old systems on new hardware will inevitably be a complex process, and having even a reference image of what it looked like at a particular moment in time would likely be valuable as a way to evaluate the extent to which it is being authentically rendered. Here a general principle emerges. Documentation (like the screen shot) can be useful as a means to both preserve significance and create reference material to triangulate an object's or work's significance. Given cases like this, where the resulting documentation is trivial in size, it makes a lot of sense to liberally incorporate documentation strategies.

It is worth noting that how something renders isn't simply a question of software. Different speed processors will render both the play and representation of an object differently. Different sound cards will play sounds back in distinct and varied ways. Many of these subtle differences are readily apparent to users.[10] Further, works look different when rendered on an old CRT monitor than

they do on an LCD screen. Importantly, these differences would not be captured in a screen shot, as they lie in the properties of the screens themselves and not in the images rendered on those screens. Still, there are ways to achieve the appearance of CRT monitors. To some stakeholders, those aesthetics are significant enough to warrant the development of filters to make an LCD screen look like a CRT monitor.[11] In sum, even capturing what a computer is displaying on the screen through screen shots or screen recording can potentially miss aspects of a work that could be determined to be significant. To that end, some working with born-digital works have used video recording and photography equipment to document how these works look and sound.[12] The takeaway here is that when a work's rendering is particularly significant, you have the option of recording the work, through either the computing environment itself or externally with a camera or an audio and video recording device. You will end up with something that does not capture the interactivity of the work, but you will have a stable and easy-to-render documentation of exactly what it was in a particular historical context.

Grateful Med: What Are Its Boundaries?

Grateful Med is a software program developed by the National Library of Medicine (NLM) to provide access to medical databases. Developed in 1986, it was in use and continued to evolve until 2001. Recognizing the significance of the software, in 2016 the National Library of Medicine brought on Nicole Contaxis as a digital stewardship resident to plan for its preservation.[13]

It's easy to refer to Grateful Med as if it's a single coherent thing, but on closer inspection, it becomes nearly impossible to parse its boundaries. As will be the case with any piece of software that was in use for more than a decade and a half, it has myriad versions. If this were the only issue, then one could set about identifying the versions and then getting copies of them. However, if you boot up any one of the applications, you would quickly realize that they are really just an interface to NLM databases. So when we think about Grateful

Med, we aren't just thinking about the interface. We are also thinking about what that interface interfaced with. If you wanted to get that, you would need to preserve the client applications along with the back-end server instances that they connected with. Given the span of time the software ran, those back-end systems would involve various constellations of software and hardware technologies and their dependencies. If that wasn't enough, the actual content, the data accessed through that interface and server, was itself changing and evolving. So if you wanted to capture what it would have been like to use the software in 1989, you would also want to have a copy of what was in the databases in 1989. In short, like many digital systems we care about, Grateful Med is a sprawling, interconnected set of applications, systems, and data sets. The more questions you ask of it, the larger, more complex, and more daunting it seems to become. What hope is there of preserving it?

This is exactly why it is critical to step back and ask "why are we doing this?" and "what can we do with the resources at hand?" Much of Grateful Med's history is documented through the National Library of Medicine's archives. So that documentation, both born digital and analog, can provide access to much of the backstory on the software. Along with that, separate work in the library focuses on maintaining and keeping the databases. So, while it might be interesting to provide access to the historical databases, it's not clear that, given the work it would require, there is enough reason to do so.

Throughout Contaxis's research, a related piece of software turned up that became a much easier target for preservation but still spoke to the broader ambitions of preserving Grateful Med. This application, called HowTo Grateful Med, is a much simpler standalone piece of software that was created as a tutorial for using Grateful Med. The how-to application includes sample searches in Grateful Med, so in this respect it is a self-contained bit of that sprawling infrastructure. Even better, it was created to explain and show how the software worked, information that wouldn't be present in the software itself. For the purposes of preserving a discrete application that can be played in an emulated or virtualized environment

and show someone what the software was and how it worked, the how-to application provided an ideal target for preservation. It turned out that the best way to preserve specific aspects of Grateful Med was to not attempt to preserve it at all but preserve something that was created to show people how to use it. By taking time to consider preservation intent, looking at what other kinds of information and documentation already exist in support of that intent, and then exploring various potential targets of preservation, Contaxis was able to focus on something far easier to work with.

World of Warcraft: Is It a Thing or an Experience?

As I mentioned at the beginning of the chapter, World of Warcraft[14] involves multiple software components. It's actually a lot like Grateful Med. Anyone playing the game needs a copy of the game to run on their computer, but those copies are being updated and patched all the time. Thus what the game is remains a moving target. Since its launch, there have been myriad additional releases of more quests, places, weapons, armor, and other game components. The game's aspects change, sometimes on a weekly basis. And the game you install on your computer isn't enough to really play the game. You have to connect over the web to a remote server that runs additional software on it that creates the virtual world you then inhabit with other players. The server-side environment is also undergoing constant tweaking and change. So if you wanted to capture the entire software ecosystem that constitutes the game, it would be challenging to parse the significance of the software. That would, however, not really get you close to most of what the game's players or future scholars interested in the game likely think is significant about it.

If you were able to keep versions of the software and run your own instance of the server when you logged in, it would be hard to call the game you ended up in World of Warcraft. You would log into a giant, lonely, empty world. As a massively multiplayer game, the entire experience of World of Warcraft is dependent on interacting with thousands of other players who are playing at the same time.

To clarify, that giant, lonely, empty world would be *a* game, but in the sense that World of Warcraft is meant to be experienced as a place in which individuals interact with each other, the empty world would not be the game as it had been experienced. On one level, this sort of digital object is more like the stage on which a play is performed than a painting that hangs on the wall. As such, documenting a live performance would work better. It can also be argued that many of the most interesting aspects of such a game are the kinds of culture and crafts that are produced in and outside it, in which case it would be more appropriate to approach it the same way as a folklorist or ethnographer documenting a culture.

This is exactly the approach taken by several organizations interested in preserving World of Warcraft. Stanford University Library's special collections department has created collections of user-generated videos shared on YouTube as a way to capture aspects of the game world and part of the cultural exchange and discourse that has been created around the game.[15] In this case, the artifact (the game itself) may really be the backdrop to what a player or a scholar studying the game might see as the most significant aspects of it. Therefore, documentation created by users and members of a gaming community may be both technically far easier to render and maintain into the future and also far richer as material for understanding the cultural aspects of a game.

Furthermore, all aspects of this game could be viable targets for preservation by any number of institutions with distinct missions. The game includes a significant amount of artwork, so an organization could acquire it as an aesthetic object, in which case they might make decisions about which aspects of its visual and audio art are most important. The game made several significant advances in game design, so an institution acquiring it as part of a design collection would find its source code to be of particular interest. The game is a hugely successful global business product, so its born-digital corporate records could be valuable for an institution that preserves records of the history of business, technology, and enterprise. The game's in-game chat system has transmitted billions of informal communications

between players, which could be studied by linguists, sociologists, and folklorists interested in the language habits of its global population of players. World of Warcraft can be collected and preserved for multiple purposes. Only by fully articulating your intentions and connecting those to your plans for collection development can you ensure access to collections in the future.

Planetary: Acquiring the Process behind the Object

Planetary is an application for iPhones and iPads that visualizes a user's music collection as celestial bodies and acts as an interface for playing music. The songs are represented by moons, the albums by planets, and the artists by suns. The application is an interesting enough example of graphic design and interaction design that a team at the Cooper Hewitt Design Museum contacted the creators of the app and developed a plan to acquire it.[16]

The challenges in acquiring an iOS app are manifold. Even during discussions with the app's creator, a new version of the iOS operating system was delivered to most iOS users. This meant that the application was already obsolete and functionally unrunable before it was acquired. If the objective was to keep a copy of the app running on an iPad, it was going to be challenging. One could maintain an iPad with the old operating system, but the dependencies in place in this situation (the hardware, operating system, and application) would degrade over time. The prospect of emulating the operating system is itself daunting, in that iOS apps are designed to make use of many of the unique affordances of the hardware. In any event, returning to the objective of the Cooper Hewitt's focus on creating a useful and useable collection of materials to inform design, their team decided to take a fundamentally different approach.

The underlying source code of the app had been developed over time through Git, a distributed version control system. This meant that the entire design history of the source code existed in the developer's version control system. Since the Cooper Hewitt Design Museum's focus on collecting is to document design and preserve access to it,

they decided to focus on "Planetary the software system" instead of "Planetary the iPad application." This made it easy to acquire and enable access to the complete copy of the source code, including its revision history, bug reports, and code comments. After acquiring this content, the team released the source code on GitHub under an open-source software license for anyone to download, explore, and build from. Planetary's source code documents and provides access to information that would not have been available if they had instead focused on preserving a final version of the app. The source code extensively documents the creation of Planetary. The source code, like most source code, also consists of easily rendered and read textual characters and graphics files in standard formats. As a result, the code and files will be far easier to maintain into the future.

Collection Development: Are We Focused on the Right Things?

In this chapter I started by picking apart aspects of particular digital information stored on individual objects (floppy disks and laptops) and then stepped back to second-guess the extent to which documentation of objects might be better at capturing significance that exists elsewhere (audio and video recordings, source code). It is worth stepping back once more to ask more broadly, how do institutions decide what is significant? Particularly relevant to the project of this book, what affordances can digital media provide to change some of the ways we engage with communities in the process of doing selection and collection development?

As noted earlier, objects, works, and records are largely of interest not in their own right but in the ways that they enable us to tell stories about people. Libraries, archives, and museums are created and sustained as part of the power structures of society. As such, if and when they aspire to be neutral, they passively legitimize the priorities and ways of seeing that are part of the status quo.[17] No archivist or librarian is neutral; it is simply a question of whether they

consciously attempt to identify and respond to the biases of the status quo and ensure that their collections represent multiple voices, or if by not asking the question they are simply replicating the status quo. I will delve into an example to explore how new approaches to born-digital collecting are reframing the process of collection development and even pushing back against the idea that collection development is itself the ends of such work.

Documenting the Now

--

Documenting the Now is an effort to explore the ethics of collecting and preserving social media content and to develop tools and approaches to collecting and preserving that content so that content creators have a voice in how their information is collected, preserved, and used. Social media content, like Twitter and Facebook, represent a novel cultural form through which people worldwide are interacting with each other and their cultures. This has led to the collection and preservation of histories and interactions that weren't perceivable before. As these platforms become even more significant in daily life, it becomes increasingly important for cultural heritage organizations to collect and preserve their content.

After the killing of the unarmed teenager Michael Brown in Ferguson, Missouri, in 2014, a significant part of the response of activists played out on and was coordinated through the use of Twitter. A small team of archivists began to collect tweets mentioning Ferguson, quickly amassing more than 13 million of them.[18] The tweets are governed by legal restrictions put in place by Twitter, but given the ways tweets can be used for surveillance and to target protesters, how this content is collected, preserved, and accessed presents ethical issues that are bigger than those governing the terms and conditions that come with working with Twitter data. Following these explorations, the archivists created Documenting the Now, a collaboration between archivists and activists that develops tools, work flows, and

approaches to collecting, preserving, and accessing social media content and engages with content creators and gives them a voice.

While it is indeed possible to hoover up all kinds of digital content, it is critical for organizations to reflect on the extent to which doing so replicates long-standing paternalistic processes whereby institutions collect data and information about various peoples instead of either collecting it with them or supporting those peoples to collect their own information. Social media is opening up new genres of objects that demand the attention of cultural heritage institutions and also prompt significant new ethical issues around preservation and access work. When we look to develop strategies for collection and preservation intent, it is important that we not only focus on content that has been collected in the past but also consider new and emerging forms of digital content that can offer additional vantages for documenting the present.

From Intent to Action and Back Again

The examples shared in this chapter illustrate how the approach taken for preserving any given set of digital content is going to vary dramatically, depending on what it is, its significance to you or your institution, and how you want people to access it in the future. At first glance, it often seems that preservation of some object or set of objects is straightforward. However, when you start to ask questions about why you are preserving something, it often becomes much more complex and strange. When you start pulling on the thread of preservation intent, it's clear that it connects to basically every aspect of an institution's collection development and strategic planning.

The discussion of preservation intent in these examples has already touched on issues that surface in the later chapters. The decisions one makes about intent have cascading effects into the other areas and affordances of digital information and media, and ethical considerations in each of the subsequent chapters have the power to

push back and get you to redefine your intentions. Returning to the Grateful Med example, it is possible to preserve the sprawling massive entity that is all the different software and systems it interacts with, but doing so would require far more resources than one could justify to engage in the activity. This is the crux of the process for all of us interested in digital preservation. We must anchor our work in clear intentions so that as we inevitably make decisions about what is practical—given the nature of our objects, our ethical obligations, and the resources at hand—and if we need to make compromises to those intentions, we are doing so deliberately.

- - - - - - - - - - -

Managing Copies and Formats

A small rural public library staffed by an individual librarian has a collection of digital photos. A college library with fifteen staff has an assortment of digital collections including, among other things, born-digital manuscript material, copies of the student newspaper's website, and PDFs of undergraduate theses. A large university library with one hundred staff has sizable heterogeneous digital collections too numerous to account for in this sentence.

The significant variation between each of these contexts in terms of resources, staff time, and organizational structure should result in substantially different approaches to the core work of digital preservation: developing a process for managing copies and dealing with issues related to long-term renderability of digital formats. This chapter explores these issues and the realities of planning for digital preservation in different contexts.

Managing Copies and Formats as Digital Collections Care

It's useful to contextualize the practices presented in this chapter within long-standing practices for caring for analog collections. Libraries, archives, and museums have developed related but distinct notions of "analog" preservation work. This work falls into a variety of categories: conservation, restoration, rehousing, and preservation reformatting. Broadly speaking, collections management and care has become the central approach to base-level preservation work across many kinds of cultural heritage institutions.[1]

In a collections care framework, the objective is to first and foremost establish sound general conditions for storing and managing collection materials that will best serve all the various objects one is preserving or may preserve. For physical objects, this focuses largely on environmental conditions that slow deterioration of materials: making sure collections are stored in a dry space, at the right temperature, and with the right air-handling system; in a location where they aren't likely to be damaged if there was a flood, with a properly designed fire suppression system, and so on. This chapter is concerned with translating the overarching idea of collections care into the context of digital preservation, or two primary areas of activity: (1) establishing systems and practices for managing multiple copies of digital objects in the storage environment you establish, and (2) developing overarching plans for mitigation of potential problems related to digital formats.

In keeping with the wisdom of the cultural heritage professions, it is critical to establish overall systems and practices that make sure the basic storage conditions and environments are sound for preservation. For digital preservation this means establishing systems, work flows, and practices to first and foremost manage replication of digital information. The base-level work of digital preservation is making, managing, and checking copies. Beyond that work, it makes sense to consider many of the other aspects of digital preservation

for a wide range of objects and files. We can't predict the future. But we need to think strategically about potential risks for access to digital formats.

This chapter is primarily focused on establishing the requirements for your digital storage system. Chapters 7 and 8 focus on issues that should be considered around the acquisitions of individual collections. In contrast, the core processes for managing copies and policies around formats described in this chapter should be general-purpose infrastructure. Your core digital preservation approaches to copies and formats should fit the overall contours of your institution's collecting mission and resources. This is about the digital infrastructure you establish to enable the more tailored work that is done around individual collections.

The first half of this chapter focuses on explaining the core concepts and needs for managing copies. Managing copies is what mitigates the risks of data loss; this is often referred to as "bit preservation." To make this more concrete I illustrate how these bit preservation practices play out differently in cultural heritage institutions of various sizes and when working with different kinds of content. This is not a one-size-fits-all approach to storage systems. It is key that an organization make the right system design decisions based on its resources, objectives, and the nature of the content they are working with. After that, I consider issues around formats and authentic rendering. I will also discuss some aspects of authentic rendering later in the chapter on multimodal access. In this chapter, I focus on approaches and strategies that cultural heritage institutions are using to manage risks to future accessibility of content in the design and development of storage and repository systems.

Bit Preservation

--

Bit preservation, ensuring authentic bit-for-bit copies of digital information into the future, is accomplished by establishing a storage system and managing multiple copies. Three core processes are required

for bit preservation: (1) a process for managing multiple copies of your data, (2) the management and use of fixity information to ensure that you can account for all your digital information, and (3) practices and processes to ensure that your data is secure and that it can't be inadvertently or maliciously corrupted, damaged, or deleted. Having more resources allows for better ways to systematize and automate these processes, but with relatively small collections it is still possible to implement these processes with minimal resources and time and be confident you have authentic copies, as long as someone continues to mind and tend the content.

Maintaining Multiple Copies

In digital preservation we place our trust in having multiple copies. We cannot trust the durability of digital media, so we need to make multiple copies. Thankfully, as discussed earlier, it is relatively trivial to create multiple copies. However, it is one thing to make copies and another thing entirely to systematically manage replication of digital content.

Here is a key difference between managing copies for digital preservation and simply backing up your data. In backup, all you need is a complete copy of whatever system you are using so that you can recover it if the current system is damaged. But when you set up your system and process for managing copies, you need to do more. You need to establish practices for defining exactly what content you are going to preserve and make sure that the way you organize that content will be intelligible to users in the future. We will return to this issue later in the chapter on arranging and describing content. At this point, it is enough to underscore the importance of establishing boundaries between working files that are being regularly changed and rearranged and digital content that has transitioned into being static content you are preserving. This is fundamentally an intellectual distinction. The various storage systems you establish don't care if files are working files or those being "archived." However, it is important for you to be clear on this, as it connects directly

with the next two points. You will need to manage information on the fixity of your content and its security, and both of those are dependent on the rules you establish for managing copies.

So, how many copies should you keep, and where should you keep them? On one level, the more copies the better. The NDSA levels of digital preservation recommend at least three, and three has become the de facto standard for many cultural heritage organizations. Other approaches and systems involve keeping as many as six or more copies. Instead of prescribing some magic number, I think it's best to understand exactly what kinds of threats to loss of information you are protecting yourself against. For starters, having at least two copies is going to help ensure that you don't have a single point of failure. A second copy is essential. If you don't have a second copy of content you care about ensuring access to, stop reading the book now and go and make one. Seriously. After that, an important consideration involves making sure that you are not co-locating those copies. If you have four copies on different hard drives in your office, but a fire burns down the building, then you've lost all four. So once you have at least two copies, you need to make sure that you establish practices that mitigate different disaster threats. That could be as simple as keeping a second copy at home, or trading copies with another organization across the country, or using a cloud storage provider like Amazon or Dropbox to store one of your copies.

Another important consideration is that ideally you aren't keeping all of these copies on the same kind of hardware. For example, hard drives have distinct lifetimes, so if you buy a bunch of hard drives today to store multiple copies, it becomes increasingly possible that they could fail at about the same time. Along the same lines, some working in digital preservation recommend keeping copies on different kinds of media. So you might have copies on spinning disk hard drives (magnetic media) and some on CDs (optical media). This could protect you from something like an electromagnetic pulse (EMP) event that could damage magnetic media but leave the optical media unaffected. However, more and more organizations are

moving away from the different forms of media in part because (1) it's not clear how significant the threat is, and (2) it's increasingly difficult to make use of other kinds of media at scale.

Having a lot of copies is great, but it's ultimately useless if you don't have a fully articulated process for *managing* those copies. Open-source platforms like LOCKSS (Lots of Copies Keep Stuff Safe) are built to do exactly this kind of management.[2] These systems often also come with capabilities to check and manage fixity and deal with information security, two points I will discuss next.

Maintaining Fixity

In discussing the nature of digital media I briefly mentioned the concept of fixity. This is a slightly confusing concept, but if there is one piece of digital preservation jargon that you need to know, it is *fixity*. It's best to understand fixity as part of how we are able to answer the question, "How do I know that this digital object has not changed or degraded?" The way we answer this question is by establishing the fixity or the stability of a set of digital objects.[3] What is slightly confusing about this is that we are not saying the content is fixed into a particular medium. Instead, in keeping with the informational object focus of digital preservation, we are trying to confirm if the object's informational content is identical to what it was the last time we checked. Given that we're talking not about artifacts but about information, it is really a question of whether you still have the exact sequence of information you had before. In this sense, fixity is synonymous with the slightly more descriptive term *bit-level integrity*.

So, beyond maintaining multiple copies of your digital objects, you need to ensure that you are maintaining the fixity of those objects. As you make those copies, as you transfer them forward from one storage medium to another, it is possible for some of those copy processes to fail and for information to be lost. It is also possible, although far less likely, that you can lose information from data at rest. This is often referred to as "bit rot," and it is (in general) far

less of a threat to long-term access to information than data loss that can occur during transfer. Digital information is always encoded on physical media, and over time as that media degrades the binary information encoded into it can become less legible. This can result in individual bits being either dropped or misread. In any event, the way that you manage these risks is by collecting fixity information, checking against that fixity information on some kind of schedule, and, when errors emerge, engaging in repair actions to make sure that all the copies you are maintaining are pristine.

There are a few different kinds of fixity information you can collect and work with. At the most basic level, you can look at things like the expected file size or file count. If the digital content you are preserving is one hundred megabytes and made up of fifty files, then seeing that you have the same size and number of files gives you some level of confidence that you have the same materials. These kinds of methods (file size and file count) are somewhat useful; however, it is relatively simple to generate and maintain far more powerful forms of fixity information through the creation of MD5 or SHA cryptographic hash functions.

A cryptographic hash function is an algorithm that takes a given set of data (like a file) and computes a sequence of characters that then serves as a fingerprint for that data. Even changing a single bit in a file will result in a totally different sequence of characters. For example, I computed an MD5 hash for an image file and returned the value "4937A316849E472473608D4347EBE9EF." Now if I compute the hash for another copy of that file and get the same result, I'll have rather high confidence that those two copies are exactly the same. Similarly, if I have a stored value from the last time I computed a hash for that file, when I recompute the hash in the future and get that value again, I have a high degree of confidence that the file has not been changed or altered. For a sense of just how high that confidence can be, it is worth noting that the MD5 hash offers more confidence as a characterizer of individualization than a DNA test does for uniquely identifying a person.[4] Now, people are going to tell you that MD5 is broken and you should use something else, say,

SHA-1 or SHA-256. MD5 is broken in terms of most of its use for cryptography, but this is not particularly relevant to using it for identification in the way that we are. With that said, the SHA functions come with some additional level of assurance in that they are (at least for now) cryptographically sound. I won't get into exactly what that means, for it is outside the scope of this book, but if you are interested, there is a wealth of in-depth information on the topic on Wikipedia.

To manage the fixity of your content, you will need to collect this fixity information, check it, and then use that information to repair data. This opens the question of how often should you check the fixity of your content. Again, it's important to start with an understanding of where the biggest threats to loss are likely to occur. You are far more likely to lose information when transferring data. So you should check fixity information before and after materials are transferred so that you can compare them. There are a few great pieces of open-source software such as Fixity and Exactly that can do this if someone wants to transfer data to you. Similarly, there is a tool called Bagger that puts data into the Bag-It specification. So-called "bagged" files simply include hash values for files in a manifest text document alongside the information that is being transferred or preserved. This enables a simple means to verify that information transferred to you is exactly what was intended to be transferred. In the same vein, you will want to make sure that you check the fixity of your content when you migrate it to new storage media. So if you move everything from one hard drive to another, or from one magnetic tape archive system to another, it is important to make sure everything is transferred correctly.

Beyond that, if your system can handle it, it is a good idea to check fixity of all your content at some regular interval, for example, monthly, quarterly, or annually. Many organizations, particularly those that are using storage systems that are made up entirely of spinning magnetic disks (hard drives), do this kind of regularly scheduled checking. In contrast, organizations that are using storage systems based on magnetic tape generally are not doing this. Magnetic tape

degrades a little every time you read it, so it's generally better to trust the storage medium at some level instead of rapidly wearing it out. Also note that some file systems (like ZFS mentioned previously) and some tape drive systems have built-in processes for fixity checking and repair. In these cases, regularly scheduled fixity checking is being done in your system but below your level of awareness. Similarly, most cloud vendors are running ongoing processes for monitoring and repairing data. However, in both cases, what is and isn't being done to your data isn't transparent to you as the repository manager. Conducting regular fixity checks of content and maintaining records of those checks will allow you to make assertions based on evidence about the exact state of your content. In any event, the most critical thing is that you (1) establish a practice for maintaining fixity information and (2) make sure you are checking it, at the very least, when you need to move data around.

Information Security

You can manage multiple copies and have a great system for managing and checking fixity and using that fixity information to repair digital objects if necessary. And yet you could lose everything. All you need is the ability for any one person to go in and delete all your copies. This could be malicious (someone who gets fired logs in and deletes the data), but far more often, this kind of loss comes from someone accidently executing the wrong command and deleting more than they intended to. To manage these risks it is important to think through who can do what in terms of deleting data or gaining physical access to the devices where data is stored.

On the most basic level, you could address this by doing something as simple as keeping a copy of your data on an external drive in a locked drawer or safe. If all your content is accessible through an online system, then it likely requires you to ensure, at the very least, that it isn't easy for someone to run commands that can affect all your copies. Information security concerns are not just for those working with sensitive information. I know of a major library that

found that some of its digital master files for a project had been re-sized for a PowerPoint presentation in its permanent storage location. Permissive write permissions to files are an invitation for data loss. You want to limit the ability for anyone to edit copies in the place where you are storing them.

Worked Examples

In the pragmatic and practical spirit of this book, I want to work through a few examples of how organizations of varying sizes and managing different scales of content might address these core digital preservation system design issues to manage bit preservation. I start by talking about what a single individual working at a small institution might do. I then discuss how someone at a mid-sized organization could focus some sustained time and energy on these problems. From there, I get into the complexities that emerge in large organizations with substantial and likely heterogeneous content. Together these examples illustrate how the right approach for a given organization will emerge as a result of matching its resources, needs, and goals. Importantly, this can result in very different approaches across different kinds of organizations.

The Lone Arranger in a Small Institution

Most libraries, archives, and museums have a very small staff and very limited resources. For example, the average rural library in the United States has 1.5 staff.[5] Many of these institutions have modest but truly invaluable digital collections. From my conversations with staff from these institutions, this often involves born-digital audio and video recordings of things like oral histories and events, digitized materials like historical photographs or documents, and, increasingly, born-digital institutional records (board meeting minutes, audit records, financial materials). In exploring the state of these digital materials in small institutions, my students and I have discovered

that most of this content is facing significant and pressing near-term bit preservation risks. Thankfully, the scale of these materials often means that it is very simple to quickly make rapid progress.

First off, it's necessary to do an inventory of the organization's digital content and establish a regular process and policy by which that inventory is updated. This could be something as simple as producing a monthly or quarterly update to what materials you have. You want a full running inventory of what you've got, at least the number of files in each directory and their file sizes. That way you can do a quick check to confirm later when you check in on them that they are still all there. Once you have the inventory, you are in a position to get copies of everything you need to manage organized in one place so that you can get fixity information for everything and then start maintaining multiple copies.

It's entirely possible for a small organization like this to have so little content that it could be saved on a single external USB hard drive. So keep a copy on one of those, then unplug it and put it somewhere safe that doesn't have too much temperature variance. Then you could get an account for something like Amazon Glacier, or even just the simpler Dropbox. These services will do regular checks of your uploaded content, which will also likely be stored in a place with a different disaster threat than where you are. For any of the content that you can share broadly, you could also upload copies of it to Wikimedia Commons or the Internet Archive, both of which offer free hosting and have some rather robust infrastructures for preserving digital content. These nonprofit institutions offer long-term access to your content and a means for that content to be used and discovered.

If a small organization takes these few small steps, it will dramatically reduce the risks of losing digital content. I've talked to several people who have amazing unique oral history collections that exist on one person's desktop computer's hard drive. Those collections are just one spilled cup of coffee away from being totally lost to history. Making copies and checking them regularly will ensure that this content is far more likely to persist into the future.

A Medium-Sized Organization with a Modest Collection

The larger your organization is, (likely) the more resources you have to tackle the challenge of digital preservation. In this area you might find college libraries, medium-sized public libraries and public library systems, and different kinds of museums. There is a good chance that organizations of these sizes are producing and collecting content at a level for which it would be far too complex and time consuming to do the kind of manual copying of content and checking for numbers of files described for the small institution. Along with that, the more files you have, the more likely errors in copying information will occur. So it's a good idea to establish a system that is a bit more automated and sophisticated.

This presents a few primary vectors to consider, based on your resources and how you want to build out your organization into the future. At this point the primary options are to buy into a hosted solution or hire staff to establish and maintain your own storage infrastructure. In many cases it makes sense to do a combination of both. Your decision should be informed by the way your organization is set up and the trajectory you see for the growth of your collections. I will briefly offer my take on each of these, but I would stress that even at a relatively small organization, digital preservation needs to be written into someone's job description as an area of activity they are focused on. Preservation is a core function of a cultural heritage institution, and it's essential that it is resourced and staffed as such. Even if you have three to five staff, someone in that team should spend at least 10 to 20 percent of their time on ensuring long-term access to your content. Further, some of that time should be spent exploring different options and thinking through various planning scenarios. At the heart of digital preservation as craft is the notion that it needs to be practiced by a professional.

The first option is to buy a hosted solution. I know of several medium-sized institutions that pay for products like Preservica, Rosetta, DSpaceDirect, or ArchivesDirect.[6] This is not an exhaustive list, nor am I endorsing any of these tools; the list is simply

illustrative. These tools, and several other related ones, are useful in that they offer user interfaces to automate a lot of the work required for checking and maintaining copies of your content. It's still a good idea to get into the habit of regularly exporting your data and also keeping a local copy of it somewhere. That way, you will be protected if something goes wrong with the vendor you are working with. Many hosted solutions fees are directly tied to how much content you are working with, so the sweet spot for many of these products tends to be for cases in which you are storing relatively modest amounts of data. However, these companies and nonprofits are often interested in obtaining larger clients' business as well. If your organization is set up to make it easier to contract out for services like these than to hire or establish permanent staff to build, maintain, and manage systems, these products become particularly attractive. One of the biggest concerns with these one-stop digital preservation solutions is the potential for vendor lock-in. Since you are buying a system to enable long-term management of your content, this is particularly critical. If you do adopt one of these systems, you need to establish your exit strategy. And you will still need to devote staff time to using these systems. The value proposition of these offerings is that they provide automation, maintenance, and management of your systems, so you don't need to staff those particular functions. However, you do need to adequately staff roles to make use of these systems. Remember, tools don't do digital preservation. People use resources in an institutional context to do digital preservation.

Instead of buying a digital preservation system, many organizations are investing in staff who purchase hardware and configure and run open-source software to do their digital preservation work. Given that preservation and care for collections is a core function of a library, museum, or archive, it makes sense to establish expertise in-house to do this kind of work. It is hard to imagine many libraries, archives, or museums contracting out management of the physical space where their collections are stored and the work of managing and delivering those collections. However, this is effectively something

that happens for many organizations' digital content. At the time of this writing, there exist several open-source software tools that can do much of the core work of digital preservation.[7] So a lot of this work is about configuring those tools and writing scripts to connect those pieces. These open-source tools are free, but they are free as in "free puppies," not "free beer." Adopting open-source solutions, like adopting a puppy, involves time spent on care and feeding. You'll need to give them a fair amount of love and attention. Further, the ultimate sustainability of open-source tools and services is anchored in their resources and staffing. So if your organization is adopting open-source software to manage significant portions of your work, it's important to understand how that software is funded and sustained. In many cases, it is a good idea to get involved in the open-source community surrounding the project or in the governance of a project to help ensure that it continues to thrive and that the future directions it takes in development support your organization's goals and needs. In addition, there are decisions about what kinds of hardware (for example, servers and storage media) you are going to want to use and then planning for monitoring and managing those systems and replacing elements in them over time. In a relatively small organization, a librarian or archivist with an interest in the issues, a modest budget for equipment and training, and some basic command line scripting abilities can really get a program like this off the ground. Depending on the context, this approach may cost more than some of the hosted solutions. However, if capacity for doing this kind of work can be built within the organization, it will bring additional flexibility and control to managing digital content. If you are managing a significant amount of content, it will likely also be the case that establishing your own systems and processes will ultimately be less expensive as your collections continue to grow. It's likely that you'll be doing more and more of this work, so building in-house capacity is generally a good idea.

Beyond these two options, I will briefly mention a third, joining a distributed preservation cooperative. Several emerging organizations, like MetaArchive, provide some level of services to member

organizations but are still based on the assumption that institutions will develop their own core competencies and infrastructure for much of their digital preservation work.[8] These efforts support outsourcing some of the work for digital preservation systems through pooling resources of member organizations to support tools and services that they would otherwise not have the resources to maintain.

A Large Institution with Substantial Digital Collections

The larger the institution, the more increasingly complex digital preservation challenges become. The same three options from the medium-sized organizations are still viable for larger institutions. As the scale and complexity of an organization's structure and collections grow, however, new digital preservation challenges emerge. The result is that large institutions use various approaches for different kinds of content, or for different subparts of their organization. There are two distinct scaling challenges. The first is about organizational policy, and the second is that you increasingly face challenges around the technical limits of tools and services. I will briefly describe each set of issues.

The larger an organization, the more time and energy you are going to need to devote to policy and planning. In a large institution you will have a lot more types of users to support, and it will become important to understand their distinct needs. At the same time, you likely exist in a space where there are a lot of other stakeholders in play. There are decision makers, such as deans and boards, whom you need to convince that there is a need for this work. There are also often related organizational units in the bureaucracy: the IT department, a communications office, or other units that collect and manage content or play a role in decision making around IT system policies. The more complex these relationships become, the more time and energy required to work across these groups and establish a coherent strategy. Different groups will likely have different requirements, and a good deal of time will likely be spent making sure that stakeholders are not talking past each other. For example, the

word *archive* means something totally different to someone working in IT than to a professional archivist.[9] In many cases, the complexity is so great that the objective of coherence becomes overly ambitious. At the very least, you need to sort this all out enough for the organization to function as well as it can and to align resources to establish systems that work. This is all to say that as organizations become larger it becomes critical to have full-time staff who are given the authority and resources to run digital preservation programs.

As collections grow, so do many of the technical challenges related to managing them. When you are working at the scale of consumer computing, this is all relatively straightforward. If you want to store and work with data in terms of gigabytes or a few terabytes (which is often the case for institutions primarily storing textual or image-based data), then the costs are low enough that you don't really need to know a lot about the internal trade-offs that exist around different system design choices. However, if you deal with tens or hundreds of terabytes or petabytes, you'll need to rethink some of the assumptions that are in play for working with computing systems. It is not unusual for organizations collecting digital audiovisual content to quickly reach these larger storage volumes.

To manage content at these larger sizes, it is often useful to maintain hierarchical storage systems. Magnetic tape systems are significantly slower to use than what we are generally used to with spinning disk and flash memory, but they remain substantially less expensive. As a result, magnetic tape is still a valuable technology for data preservation at scale. As mentioned before, it doesn't make sense to check fixity on a regular basis, as this can stress and quickly wear out the magnetic tape media. Aside from the scale issues related to storage volume, there are access and use challenges that emerge with larger quantities of content. That is, it becomes increasingly challenging to index content or to run checks against data because of the speed at which a process runs. The more your needs move you outside the realm of consumer computing, the more you will need to understand the various nested black boxes that make up the comput-

ing platforms you use to do digital preservation. There is much more to say on this subject, but enterprise storage systems and architectures—itself an entire area of expertise—is outside the scope of this book. An organization that is at the point where it needs this kind of work should also invest in full-time staff members who manage and maintain, or are well versed in managing contracts related to, these kinds of systems.

Authentic Rendering of Digital Content

So far, this chapter has focused entirely on bit preservation, the work necessary to make sure you have authentic copies of content available in the future. The work of managing copies for bit preservation is a solved problem. The broader work required for digital preservation is a more open-ended set of challenges. Thankfully, the broader challenges of digital preservation are far less pressing than bit preservation. If you don't get bit preservation right today, you won't even have the more long-term challenges of digital preservation to worry about in the future.

The central challenge of the broader area of digital preservation is that software *runs*. The active and performative nature of that *running* is possible only through a regression of dependencies on different pieces of software that are often tightly coupled with specific pieces of hardware. Along with this, it is important to determine whether there is enough context, so that someone in the future can make sense of the digital objects (a topic we will delve into in the next two chapters). Two primary strategies exist for approaching format issues: emulation and format normalization/migration. I will briefly discuss both and explain why many organizations are increasingly hedging their bets and normalizing but also keeping their original formatted material.

This work is directly related to things I will cover later in terms of access to content. However, it shows up here because some approaches

to ensuring long-term access play a role in how you design and manage a digital preservation storage system. So again, in keeping with the interactive nature of digital preservation planning, the rest of this chapter and the access chapter should be read against each other.

Do Formats Go Obsolete?

One of the central concerns behind digital preservation theory and practice is that today's digital formats could very well become obsolete and unintelligible in the future. Even something seemingly simple like a PDF requires a considerable range of dependencies in software to accurately render. The preservation threats that file formats present are challenging in that they are about trying to predict the future. Unlike the bit preservation, the future usability of file formats is tied up in the future trajectories of computing in society.

Formats are specifications. They are not essential truths about files. Think of formats as something akin to what a priest reads from a text in a religious ceremony: formats are canon. In contrast, files vary, just as people live their beliefs in their everyday life once they leave a place of worship. The extent to which any particular file does or does not conform to the specifications is always an issue. Many everyday software applications create files that we use in other software applications that are to varying degrees invalid according to the specifications for files. Many files are authentically invalid, and their invalidity may itself be significant. All conversations about formats need to start from the understanding that they are conventions for how files are supposed to be structured, not essential truths about how files are structured.

A series of factors have been identified to evaluate the sustainability of a given digital format.

- Disclosure: if the specifications for the format are widely available, then it's possible to validate files and to develop new modes for rendering them.

- Adoption: the more widely a format is used, the more likely there will be a range of implementations for it and the more likely there will be continued market demand for making it possible to access the content.

- Transparency: the more transparent the structure of information inside a file, the easier it will be to make sense of the file if the ability to render it was lost.

- Self-documenting: if a format embeds metadata in its files, then it's more likely that someone could make sense of the file even if the ability to render the content had been lost.

- External dependencies: the more a format depends on a particular piece of hardware, operating system, or software to render, the more susceptible it is to being unrenderable, if one of those dependencies fails.

- Patents: many file formats are proprietary, which can limit the number of their uses and make their lifetimes reliant on the company owning the patents.

- Technical protection mechanisms: things like encryption or digital rights management software make it harder to access content, and as such become additional external dependencies to getting access to the content.[10]

All of these factors are worth considering when engaging in digital preservation planning. However, it increasingly appears that adoption is the core driver for continued accessibility. Simply put, assuming we make it through anthropogenic climate change, and that we continue to have thriving computing technology industries (I concede, large assumptions), we are very likely going to be able to render just about any widely used format. So if you have PDFs, MP3s, JPEGs, or GIFs, you've got every reason to believe that people will be able to open those files. If those formats become risky, their wide use makes it likely that tools and services will be created to help migrate them.

With that noted, it is worth unpacking the practices and techniques that are available for more obscure formats and to those

who want to further mitigate potential risks of loss of accurate renderability of digital content. Cultural heritage organizations have developed a variety of techniques for managing the potential threat of format obsolescence. One can transform an object (normalize or migrate it) to another format, document it through a method of recording, limit the kinds of formats you accept, offer varying levels of assurance based on different kinds of formats, or emulate or virtualize the systems required to provide access. In many cases it's preferable to hedge your bets and draw from several of these options.

Normalization and Migration

The most straightforward way to get around problems with a format is to migrate or normalize your content to reduce the number of digital formats you have to manage. You just don't have to deal with a particular format anymore. Normalization involves changing formats as part of ingesting digital files you acquire, so that you transform files from a wide range of formats and specifications into a specified set of formats that you are more confident of for the long haul. Migration is the same basic idea but undertaken en masse at some point in the future when you would transfer everything in one format to another, more sustainable format that has emerged.

For example, an organization might decide that if it receives files as compressed JPEGs, it would normalize them into uncompressed TIFFs that are not dependent on the JPEG compression technology. Similarly, an organization might decide to do the same action but for all of their JPEGs at some future point. This move could be justified for the sake of sustainability, but it is likely completely unnecessary. JPEGs are so widely used that it is hard to imagine we wouldn't be able to render them. Remember, digital preservation is about risk management and threat mitigation. So just because a format might theoretically be more ideal in terms of sustainability, all that is relevant is the likelihood that the risks will be a problem worth responding to. There are enough pressing actual problems for all of us that we don't need to spend time responding to highly unlikely

imaginary problems. With that said, if at some future point it looked like it was going to be difficult to open JPEGs, then it could make sense to migrate them en masse to some future format. I'm just not particularly concerned because image formats have matured over the last few decades, and the requirements for rendering images in a wide range of web browsers have largely moderated some of the issues that were particularly worrying before the web.

The biggest challenge for an organization that wants to normalize or migrate content to a new format is quality assurance. How can you be sure that what mattered about the original file is in the new file you create? The only way to get that assurance is to put a lot of time and energy into establishing practices and methods for doing quality assurance. Any quality assurance method is also going to require having a solid operationalization about exactly what matters about the material you are working with. Given that there are so many potential aspects of a digital object that could be significant, in most situations, this is challenging. As a result, organizations that do normalization or migration increasingly tend to either keep the originals or put considerable effort and care into establishing processes for quality assurance. If instead of normalizing files you use the same process to rapidly create derivatives in other formats, you can justify putting much less time and care into quality assurance while still getting the benefits of hedging your bets against format obsolescence.

Documentation

As discussed earlier in the chapter on preservation intent, there are cases where nuances in how information is rendered are so critical that one wants to record exactly what something looked like on a screen or sounded like through a particular hardware setup. The examples of Form Art and World of Warcraft from the last chapter illustrate the value of documentation such as taking screen shots or using tools to create audio or video recordings of what is rendered. At that point, you are functionally creating new content, so you have

a lot more choice in deciding which formats you use for the audio, video, or images.

For something particularly dynamic or complex, or for which pixel-perfect rendering is crucial to its significance, it is highly likely that audio, video, and image formats will be far more stable and reliable than other formats. Of course, this documentation won't be the original interactive object or work. So there would be considerable loss of much of its actual qualities and features if this was the only thing that was acquired. As was the case with generating derivatives but maintaining originals, this can be a great way to hedge your bets. That is, you can document an object or series of objects, and future users can compare the resulting images and recordings to a rendering of the actual object in another system to check the quality and authenticity of its rendering.

Limiting Accepted Formats or Offering Levels of Assurance for Formats

One of the best ways to deal with potential format issues is to anticipate them up front. This is possible only in situations where those involved in preserving content can intervene upstream in the production of that content. For example, if you run an institutional repository, you can require that papers be submitted in PDF format instead of taking any number of various word-processing formats. Or similarly, if you run an archive in a media production organization (like a TV or radio station, newspaper, or digital publication) and can make submitting and validating files through the archive system part of the ongoing production work flow, you can bake format management and quality assurance into the daily grind of the operations of your organization. You can also enforce validation of files when they are uploaded and, if the file fails, require the user to fix and reload it.

To be a bit less restrictive, some institutions offer different levels of assurance for different types of digital files. For example, the University of Michigan offers high, medium, and low levels of assur-

ance for files in different categories of formats.[11] The value in this approach is that it suggests and recommends formats that are likely to be easier to work with for preservation purposes but doesn't turn away anyone's content if they can't meet that bar.

Emulation and Virtualization

The last approach to dealing with issues around file formats and their dependencies is to do very little now and instead focus on technologies that can either virtualize previous systems or re-create them through emulation and thus render content that wouldn't be renderable on more common operating systems. Considerable progress is being made in this area, and several organizations have begun experimenting with emulation- and virtualization-based approaches. In practice, this is a method of access for rendering content.[12] However, it is also a key consideration in access planning, which puts it here in the chapter on core digital preservation concerns for formats.

Emulation and virtualization are compelling in that they let us leave the bits alone. All transformation of digital objects involving migration, normalization, and documentation is actually a process of making new digital objects. So the ability to leave them as they are and just work on building systems that can render them is appealing. Importantly, emulation and virtualization open up the possibility of future migration via the same processes. That is, virtualizing an old system to render content and then using rendering in that system to forward migrate it to a new format.

Like much of the focus in this book, the answers to many digital preservation questions begins with "it depends." In most cases it makes sense to hedge our bets and consider multiple approaches. The costs of keeping content in multiple formats are usually low enough to justify the expense of keeping both original files and normalized or derivative files. So it's good to default to keeping multiple formats of content and consider not doing so only when it becomes cost prohibitive. If you do this though, it is important to establish

procedures and processes for articulating the relationships between these various derivative forms of data.

Do No Harm, Protect the Bits, Monitor at Scale

--

Leaving this chapter, I suggest that all of us involved in digital preservation take a kind of digital preservation Hippocratic oath on the issue of file formats and generally agree to *first do no harm*. Once you've received the content you want to preserve, do a minimal review of what you have and then move it into your preservation storage system and do the work required to ensure that you have multiple copies of it and that you are checking them regularly. This will allow you to create derivative files whenever you want or need them in batch. If you feel you have good reason to do a lot of initial work on the materials and need to transform or normalize them up front for some reason, feel free to do so, but just be sure you have good justification for doing that.

That large-scale digital loss has occurred and is occurring is not related to the formats of files: it's about bit preservation. If you lose the bits, that is, if you (or someone else) write over them, someone drops a hard drive, or a disaster happens and all the copies in one location are destroyed, then you lose everything. So my primary advice for someone starting out in the field is to make sure you've fully covered the bases on bit preservation before you even start worrying about issues around digital formats.

If you walked into an archive where all the boxes were on the floor in a flood zone, it would be archival malpractice to fret about staples and paper clips on documents damaged by them. Prioritize. Start by getting the boxes off the floor. In digital preservation, we need to consistently make sure we aren't fretting about the digital equivalents to staples and paper clips while the digital boxes are metaphorically on the floor. Once you have a basic system in place for maintaining copies of content, then it will become easier to look at everything you have and make decisions about systematic actions

you might want to take. That is, you could well decide to generate derivative text files or HTML files from all of the various word-processing documents that exist in your collections. That way you could more easily provide full-text search of the text you have, and even render those documents directly in any user's web browser.[13] You could do this in one fell swoop, and then set up an automated process that occurs every time you ingest new content. These kinds of derivatives are valuable, as they serve both as additional hedges for long-term access to aspects of your content and as useful ways to make your content more accessible for various uses right now. If you do make these kinds of derivatives, please, in general, do not get rid of the original files. The amount of space needed to keep the originals is usually relatively trivial, and it's going to be hard to know if you've lost anything by creating the derivative file.

Arranging and Describing Digital Objects

Know Your Meme is an online community that documents Internet memes (jokes, images, and catchphrases that spread online). The site contains encyclopedia entries on individual memes and a video series about memes, and all the individual resources have user comments associated with them. All of this is powered by a back-end database that connects and associates these individual resources. Given all of this, if you wanted to preserve Know Your Meme, what should you do in terms of describing and organizing it? As previously discussed, it's critical to establish your or your institution's intentions for why you would collect it, which will inform what aspect of it to collect. However, this still leaves open significant questions about how to go about describing and organizing it. Should it be treated as an individual website with a single record? Should you make records for each and every encyclopedia entry? Should you pull out the video series and treat it as a serial publication? This chapter is about unpacking the issues necessary to answer exactly these kinds of questions.

One of the key enhancements cultural institutions make to collections in their care is arrangement and description. Archivists use

the term *arrange*, which might seem a bit strange to library and museum professionals who haven't generally needed to get too involved with the internal structures of their materials. Still, all cultural heritage organizations need to be able to organize what they have and develop methods to describe it so that it can be accessed and used. Arrangement and description is the process by which collections are made discoverable, intelligible, and legible to their future users.

I'm using the archival terms here for three reasons. First, archivists have developed methods to work with material on a large scale. Second, archivists work with material that comes with a logic and structure based on how it was created or produced. Third, archival collections are often highly heterogeneous and include a wide range of documents, objects, and media formats. As a result, contemporary archival practice works from a direct relationship between how content is organized and how descriptions should match those organizational structures. These points are all relevant issues for most contexts in which libraries, archives, and museums are working with digital content. Archival practice is grounded in an appreciation of "original order," which respects the sequence and structure of records as they were used in their original context. This enables two things. First, it maintains contextual relationships between materials in a collection that may be useful for understanding the materials. Second, it leverages that inherent structure and order as a means for providing access. That is, it saves time and effort spent in reorganizing or arranging material by letting the content's original order persist.[1] Throughout the chapter I will move back and forth between arrangement and description as interrelated activities. Ultimately, all of this is in support of providing access and use, which I will delve into in the next chapter.

With that context, here is a road map for the chapter. I start with an attempt to put readers at ease. For starters, it's best to fold the work of arranging and describing digital material into existing methods and practices. I then explain a bit about the More Product, Less Process (MPLP) approach to processing, arranging, and

describing archival collections. I have briefly mentioned this approach in chapter 4, but given its significance and relevance to working with digital content, I'm going to focus more on it here. From there, using an example of a born-digital acquisition from Stanford University Libraries, I dig into an example of how the MPLP framework can enable us to make strategic minimal interventions in arranging content and very high level approaches to describing digital content.

I then work through a series of additional examples to clarify how key features of digital information discussed earlier result in challenges and opportunities for arrangement and description. Using the example of the website Know Your Meme, I focus on how difficult it is to pin down the boundaries of digital objects. Here, the database nature of digital objects should inform approaches to arrangement and descriptions. Working through examples of two #Ferguson tweets, I demonstrate the extent to which digital objects do and don't describe themselves. From these contexts, I argue that we need an approach that respects a multiplicity of orders, variants, and copies. I explore how this is working through discussion of research on how everyday people manage and organize their digital photographs and an exhibition of animated GIFs from the Museum of the Moving Image. As further examples, I discuss approaches from oral history collecting apps and institutional repositories that hand off the work of description to contributors and users.

I close the chapter with some discussion of major changes I see shaping the future of arrangement and description of digital materials. We will increasingly operate in a world of networked and linked collections and descriptions. With more and more content made available online, a click away from the holdings of any number of institutions, individual institutional collections have become part of a linked global collection. In this context, more and more digital materials will be described and will also describe each other. This suggests a need to pivot from some of the traditional notions of cataloging functions to a world in which librarians, archivists, and curators function as wranglers of interconnected data.

So if this summary of where this chapter is headed already feels a bit complicated, don't be discouraged. As complex as things are, we are prepared to jump in and start simple.

Start from an Assumption of Continuity

Start off by not forgetting what we already do. If you have a digital photo, describe it the same way you would an analog photo. The catalog record for an ebook should reside alongside the record for a book on the shelf. An archival finding aid can (and should) directly integrate information on born-digital components of a personal papers collection. In many areas of practice, the introduction of digital media should not disrupt our practices for managing information.

Those digital photos, ebooks, or born-digital archival material may be stored in another system. You may have different requirements for providing access to those materials. However, there are significant advantages to weaving together your arrangement and description practices. It is worth reiterating that "the digital" isn't a whole other universe of objects and experience. Digital objects participate in the continuity of collecting traditions and of media forms and formats, so for starters try not to artificially separate things just because they are digital.

Given that much of the work of arrangement and description should fold into existing practices, I'm not going to focus much in this chapter on schemas and standards for description like Dublin Core, MARC, BIBframe, RDA, Encoded Archival Description, and DACS. I'm also not talking much about the specific tools you use to manage and organize descriptive metadata. If you have standards and tools you are already using, then it makes sense to start by defaulting into continuity with those practices. In that context, the key issue becomes including digital materials into the existing work flows and processes for those tools and standards. What follows is primarily focused on thinking through how to conceptually chunk digital objects into

meaningful units and what level of description to engage in in whatever schema and system you are using. For those who aren't using any tools for managing descriptive metadata I would suggest exploring them, but even without that context, the following will be useful for delving into the intellectual issues that you will need to think through outside of any tool or schema.

With all of this noted about maintaining continuity, it is worth underscoring that practices for arranging and describing collections are still, in a very real way, catching up with the present. In particular, in archival practice, a decade-long shift to a new model of approaching these tasks is particularly relevant.

More Product, Less Process: The Unfinished Revolution

- -

More than a decade ago, Mark Greene and Dennis Meissner called on archivists to move to a More Product, Less Process (MPLP) model for integrating arrangement, preservation, and description of archival collections.[2] The questions they ask of archival practice are highly relevant to working with digital content across a wide range of cultural heritage institutions. In archival practice, there is widespread consensus around the need to move in the MPLP direction. However, the move toward it is still rather slow. This reframing of archival work is still working its way into practice. As a result, it also isn't particularly well integrated into work on preservation, arrangement, and description of digital objects. I will explain MPLP to provide context to readers who may be unfamiliar with it. Given that this work was focused primarily on analog archival collections, I will also attempt to translate its implications for working with digital materials. The central problem that MPLP is intended to address is that archives have been taking too long to process collections and that this has resulted in large backlogs of unprocessed collections that are, in general, not available to users.

Archivists have long held that their work should not involve item-level description. Instead, they focus on descriptions at higher

levels of aggregation: collection-level or series-level descriptions of content. Given the scale of material archivists work with, item-level description is inefficient. At the same time, many long-standing directives for arrangement and preservation of archival collections have required an archivist to do a lot of item-level work. The core argument of MPLP is that preservation, arrangement, and description activities should occur in harmony at a common level of detail. To this end, Greene and Meissner suggest that "good processing is done with a shovel not a tweezer." The result of these suggestions is that for work in preservation, arrangement, and description the objective is "the golden minimum"—that is, the best level of arrangement and description performing the least amount of work to get records into a format that makes them usable. In practice, this should result in doing a minimal level of description at the collection level for everything an institution holds and acquires before going any further. Along with that, Greene and Meissner suggest that organizations should generally avoid putting preservation concerns in front of access concerns. For any collection, an institution should get a collection-level description together, produce a container list, and get it out to users. They also suggest that "unprocessed collections should be presumed open to researchers. Period." Their model functions as a kind of progressive enhancement approach to collections work. The work one does to arrange and describe a collection should be minimally invasive, and it should also not hold up letting users start to work with the content. In MPLP, institutions need to become comfortable making calls about sensitive information at the batch level, that is, making decisions about haystacks and not individual pieces of straw. This means those working in archives and other institutions applying MPLP should focus on approaches that let us look for sensitive information without looking at every individual item.

If we take this approach seriously for working with digital content, we would have approaches to working with born-digital materials that are very different from what most cultural heritage organizations are currently employing. You would acquire content,

create a short collection-level description, produce a container list (as digital files and folders provide the instantaneous ability to provide a list, this is rather trivial), and then make the collection as broadly accessible as possible. In many cases, you could simply upload the files to a directory on the web. The point in this approach is that this golden minimum should be the default, and that everything beyond this level of effort is something that you should need to justify.

From my observations over the years, my sense is that almost no one is doing this for digital materials. While I cannot be certain, I think that the reason for this is consistent with Greene and Meissner's diagnosis of why so many archivists continue to focus time and energy in doing far more work at the item level than they should. In their words, "Much of what passes for arrangement in processing work is really just overzealous housekeeping, writ large. Our professional fastidiousness, our reluctance to be perceived as sloppy or uncaring by users and others has encouraged a widespread fixation on tasks that do not need to be performed."[3]

However sophisticated some collection of digital material is, at the most basic level, it's possible to create a record for it and make that record available. If you stick to "the golden minimum," you will likely expend far less effort and start moving content out to users much more quickly. To illustrate this, I will provide an example of a born-digital archive that was approached in this manner.

The 4Chan Archive at Stanford University

4chan is an image board, an online community website where most users anonymously post messages and images. It has played an important role in the development of various Internet cultures and memes and is also connected with groups such as Anonymous and various alt-right movements. A key feature of the site is that it regularly erases its content. Some of the site's participants, however, want to preserve that content.

Although 4chan continues to erase itself, a copy of a significant portion of it is now available from Stanford University Library's

digital repository. This collection of about four gigabytes of data is available for anyone to download and contains more than twenty-five thousand discussion threads. The abstract notes that the collection includes a message from the collector of these documents in which he explains a bit about the scope of the collection and how and why it was collected. From the page in Stanford's repository you can see descriptive metadata about its format (Manuscript/Archive), its temporal extent (2007-13), and the contributor (identified as Okeh, Ndubuisi [Collector]).

The collector was looking for a home for this collection, and given Stanford's existing digital repository platform, and some level of comfort at Stanford with making the entire collection available, it was acquired and given this single collection-level record. Stanford acts as the repository and makes the data available for others to download, explore, manipulate, and do with as they wish. It did not take much in terms of resources to acquire, and it will likely not require that much in resources to maintain it at a basic level into the future.

This is a very straightforward way to go about arranging and describing something. First off, you can start by not arranging it. Just accept what is received as the original order. The original order of the 4chan collection is provided, and as it is largely made of digital text, it is searchable. Second, create a collection-level record and provide whatever level of access you can legally and ethically offer. If at some point in the future there is a desire to go back and break this up into a lower-level structure for some use, you could do that. However, this approach offers a very minimal golden minimum that still allows you to provide access to content. This can serve as an example of the minimum to start from.

Bounding Digital Objects: Is a Website an Item?

The 4chan archive example is useful in illustrating just how little an intervention is possible. Get what you receive. Mess with it as little

as possible. Create an aggregate record for it. Then move on. But someone could rightly question if this model offers enough to reach that minimum. How can you treat something called an archive as an item? In particular, archivists have built numerous practices around the differences between levels of description associated with the collection level, varying intermediary levels, and the item level. As discussed in chapter 2, "Understanding Digital Objects," making decisions about the boundaries of digital objects is surprisingly complicated. To illustrate this point, I will talk through an object collected in the American Folklife Center's Digital Culture Web Archive.

In 2014, the American Folklife Center at the Library of Congress began an initiative to collect and preserve records of Internet cultures. I was lucky enough to be able to help define and develop the scope for this collection.[4] As in many web archiving initiatives, the Library of Congress works with the Internet Archive to crawl websites and then describe their online collections based on the concept of a website as an item in a collection. In this case, when the Digital Culture Web Archive is made publicly available, it will be as an online collection made up of individual websites that have been archived repeatedly over time. Conceptually, each website is presented as an item. This is seemingly straightforward, but in discussing Know Your Meme, one of the sites in this collection, it will become clear how compound and multifaceted any given website can be as an object.

Know Your Meme

We now have some of the context and conceptual tools to return to the example of Know Your Meme discussed in the introduction to this chapter. While it is indeed a website and can be collected, preserved, and presented as such, it is also made up of a variety of objects that could be arranged and described according to different traditions and approaches.

As a wiki it functions as a user-generated encyclopedia. Each page has a series of authors and includes links and citations. Each entry on the wiki has a title, authors, and metadata about an individual meme.

That it's an encyclopedia supports the notion of it as an individual object that could be cataloged like one might have cataloged a set of bound *Encyclopedia Britannica*. But that's not all that there is to Know Your Meme. In addition, the videos on the site are organized into episodes and seasons. This suggests the possibility of arranging and describing each episode as part of a serial publication. All the elements of the site—the entries, each episode of the video series, each image—can have user comments associated with them, and each of those comments has its own date of publication and author. Functionally, all of these assets exist as micro-publications in the underlying database that powers the site. One could imagine treating every single element here—the episodes, comments, entries, images, and so forth—as individual items that act as part of the interrelated collection of things that is Know Your Meme. Further, in the same way that we unpacked all the parts of the Marzapan band website on the CD in chapter 2, one could unpack any of the entries on the site, which contain individual files, each of which has its own file-level metadata.

As I mentioned, in the Digital Cultures Web Archive, Know Your Meme is treated as a singular item. However, this still leaves out another dimension to the site. Using web archiving technology, that item is crawled on a regular schedule. As a result, the Library of Congress has copies of the site as it appeared to the crawler at specific dates and times. This is significant in that the homepage for the site features memes that are trending at a particular point in time. Which gets at a different, and again potentially significant, aspect of the site: individual pages on the site change and develop over time, and web archiving ensures that those changes are (to some extent) documented and captured. So not only can each element of the site be thought of as an item, but those individual elements are being documented over time as they potentially change. All of this complexity is largely obscured through the practices and methods of web archiving. This is expedient in that most of the relationships between pages and media in the site are contained or made visible in the metadata in the archived files and in the URL structure of the

site as preserved (each meme entry is in /meme and each video in /videos). So it would be possible to extract these subobjects at some future date if someone wanted to present or study them that way. That is, you or some future user could later extract from the archived website the sequence of videos and the dates they were published and could then present those as a serial collection of videos. With that noted, the technology for crawling websites involves starting from a seed URL, and then hopping from that out to links that are found on that seed page and subsequent pages. So the resulting archived websites are not a full copy of everything that is inside the Know Your Meme database and web server at any given point in time. One could have approached acquiring the site not as a site but as a database if one wanted that kind of digital object.

So, is Know Your Meme an item? Yes. It's also a collection, a multimedia serial publication, a database, and a set of files. In any event, treating it as a singular item is an efficient way to acquire and organize it and suggests a relatively minimal way of describing it as a singular thing. Using the Way Back Machine (the software used to render archived websites), users may browse the site as it appeared to the web crawler on a given day and time. In keeping with web archiving technology, the actual files that make up the website are arranged in a somewhat haphazard way into WARC (Web Archive) files. These are directories that contain all the individual files captured while crawling a site in the order they were downloaded. There are cases where it might be preferable to spend the time and energy individually collecting, organizing, and describing each individual season of the video series. However, web archiving offers a rather quick and straightforward way to capture the multifaceted nature of the site and make it preservable and accessible. Further, many of those subsets of items inside the site could be extracted and made available as derivative collections at some future date, a point we will return to in the next chapter on access.

The situation with Know Your Meme is very similar to numerous other situations. Rushdie's laptop, Larson's and Sagan's floppy disks: each object is simultaneously an item and a collection of

items. On one level, these compound objects are ideal for MPLP. It's possible to make and replicate perfect copies of these at the aggregate level and then let the lower-level item description emerge from the order and structure of the subobjects/items. If in the future it would be useful to have a set of subcomponents extracted and further described for a particular user community, you could do that. This is because, in part, digital objects have a semi-self-describing nature. Working through examples from Twitter will help to further illustrate this self-describing nature and additional nuances of establishing the boundaries of digital objects.

Semi-Self-Describing Digital Objects

The story, as reported to me by a colleague, is that shortly after the Library of Congress signed an agreement with Twitter to begin archiving the tweets, a cataloger asked, "But who will catalog *all* those tweets?" Take the story for what it's worth, both as the kind of folklore that one receives in a large institution and as documentation of the various slights faced by catalogers the world over. True or false, it still expresses a useful point of entry to a change in perspective the cultural heritage institutions need to be working through. Large institutions have millions or hundreds of millions of physical items. That's a lot of things. However, that context makes the idea of working with tens of billions of objects (like Twitter) rightfully daunting.

Like most digital objects, tweets come with a massive amount of transactional metadata: time stamps, user names, unique identifiers, and URL links. Like most digital objects, with some overall scope and context notes about a given collection of tweets, the tweets can largely describe themselves. For illustrative purposes, let's unpack an example of this principle as it relates to other digital objects. For our purposes, I'm going to do a bit of a close reading of two tweets; their unique IDs are 499768093921800200 and 499432557906104300.[5] Every tweet is uniquely identified by a string of numbers, and these two strings of numbers correspond to two tweets from August of

2014. Many digital materials, like tweets, may on their face seem frivolous. Indeed, many of the meme websites I've focused on in this book might seem insignificant on the surface. I would disagree, but I understand where that impulse comes from. However, a lot of content in platforms and systems comes with a much more immediate, visceral weight and gravity to it. Instead of choosing a banal example of one of my own tweets, I have picked two tweets that became part of the story of the Ferguson protests. These tweets, and their embedded metadata, are documentation of a significant moment in American history. These (along with others in the corpus of tweets shared with the #Ferguson tag) are valuable primary sources for understanding both the impact of this particularly senseless but tragically routine loss of black life and the emergence of the #BlackLives Matter movement.

Understanding the technical aspects of a tweet, like any digital object, is essential to deciding how to work with it as a cultural heritage object. The 115 characters that make up the text of the first tweet are a small portion of what it actually *is*. In this respect, these tweet examples nicely illustrate the issues around screen essentialism mentioned in chapter 2. To clarify, tweets are digital objects written to an explicit set of specifications. The full data of a tweet is accessible through Twitter's API (application programing interface), from which you can request a tweet in JSON (JavaScript Object Notation).

In the case of tweet 499768093921800200, the full response in JSON was 3,309 characters long and spanned 113 lines. The characters that make up the message of the tweet itself are 3 percent of all of the textual data that comes in the response. This tweet, like all tweets, is about 97 percent metadata. Just imagine for a second if the text of a book was 3 percent of it and the other 97 percent of it was machine-readable metadata. In that, you start to see some of the profoundly different ways the nature of digital objects should impact our approaches to them. For the purpose of demonstrating the type of information in a tweet, I have included selected portions of these

tweet objects. I will unpack the information contained in them. I realize that the brackets and other characters are visually off-putting, but please do read through them yourself. It will mostly make sense if you just push through and read them out loud.

"created_at": "Thu Aug 14 04:02:53 +0000 2014",

"id": 499768093921800200,

"text": "Don't Keep much distance from the Police, if you're close to them they can't tear Gas. To #Ferguson from #Palestine",

"source": "Twitter Web Client",

"time_zone": "Jerusalem",

"retweet_count": 534,

"favorite_count": 268,

"user": { "id": 250580585, "name": "Rajai Abukhalil", "screen_name": "Rajaiabukhalil", "location": "Jerusalem, Falasteen - Berlin ", "description": "إحمل بلادك اينما ذهبت، وكن نرجسياً اذا لزِم الأمر" Palestinian Doctor & Activist. Co-founder of Physicians for Palestine\r\nRa ... il@gmail.com", "display_url": "rajaia bukhalil.wordpress.com", "followers_count": 3623, "friends_count": 268, "listed_count": 173, "created_at": "Fri Feb 11 11:24:43 +0000 2011",},[6]

From the created data field at the top of the tweet, we know it was posted at 4:02 am on August 14, 2014. This time is reported in Coordinated Universal Time, equivalent to Greenwich Mean Time. This was five days after Officer Darren Wilson shot and killed Michael Brown in the street in Ferguson, Missouri. The time zone is set to Jerusalem, where it would have been 6:02 am. The text of the message is found in the "text" field: "Don't Keep much distance from the Police, if you're close to them they can't tear Gas. To #Ferguson from #Palestine." In this tweet, and other tweets from this user and others, activists in Palestine offered advice to protesters and activists in Ferguson. This tweet, and others like it, became a story reported

by major press outlets. As the *Telegraph* reported on August 15, with this tweet embedded in their article, "Palestinians have been tweeting advice on how to deal with tear gas to protesters in the riot-hit city of Ferguson."[7] These exchanges reframed the Ferguson police into an occupying force through an association with oppressed people from the other side of the planet.

Additional data in the tweet provides a wide range of contextual information. We know the author of the tweet. Beyond this, each tweet comes with substantial data about its author. In this case, we know he is Rajai Abukhalil. In his bio, which comes embedded inside the tweet object, he describes himself as a Palestinian doctor and activist. We also have a link to his website. I've redacted his email address, which is also present. We even know when he originally created his account (February 11, 2011) and how many followers he had on the day I requested the tweet (3,623). Beyond this authorship information, we also know that the tweet was sent from Twitter's web client, not from one of the many Twitter apps. The tweet also contains a good bit of information documenting its reception. This tweet was retweeted 534 times and favorited 268 times. Significantly, this reception metadata about usage is itself tied to when I requested the tweet. It's entirely possible that others would favorite or retweet this tweet, in which case this number may be different if you go and look up the tweet now.

In summary, the tweet contains, in a machine-readable form, information about its author, the date it was created, the actual text of the tweet, the method it was created by, a short bio of its author, and unique identifiers for the individual tweet and the tweet's author. This is just the tip of the iceberg, as I have not delved into the many other data fields in each tweet, but it is more than enough to illustrate the extent to which digital objects like tweets largely describe themselves. Most of a tweet is metadata describing the tweet.

At the same time, understanding this tweet and interpreting it requires us to be able to jump off to the other points of contact that aren't contained inside the tweet object. To make sense of it one wants to visit Rajai's website, read the entire stream of tweets

he posted, and see what other tweets were being shared with these hashtags at the moment this was tweeted out. When you see his tweet embedded in an article or on his Twitter time line, you see his avatar picture, but as a textual object, the tweet in JSON contains only a URL where that picture can be accessed. One wants to see which news stories embedded and linked to this tweet. All of these things exist outside the boundaries of this tweet object. As far as Twitter's API is concerned, and Twitter as a system is architected through its API, a tweet is the structured set of data that you receive like this.

Another example, a tweet from the day before, offers further context to explore information included and not included in a tweet. Again, please read it like a block quote, and I will help unpack it below.

"created_at": "Wed Aug 13 05:49:35 +0000 2014",
"id": 499432557906104300,
"text": "Wow . . . A man picks up burning tear gas can and throws it back at police. #ferguson pic by @kodacohen @stltoday http://t.co/SASXU1yF3E",
"user_mentions": [
{ "screen_name": "kodacohen", "name": "Robert Cohen", "id": 17073225,
{ "screen_name": "stltoday", "name": "STLtoday", "id": 6039302,],
"media_url": "http://pbs.twimg.com/media/Bu5XQ6KCIAEPh81 .jpg",
"type": "photo",
"user": {"id": 16661744, "name": "Lynden Steele", "screen_ name": "manofsteele", "location": "St. Louis", "description": "Assistant Managing Editor for Photography at St. Louis Post-Dispatch, Pulitzer Prize winner, insert something funny here", "created_at": "Thu Oct 09 03:53:26 +0000 2008",},
"retweet_count": 7658,
"favorite_count": 4697,}

In this tweet, Lynden Steele, the assistant managing editor for photography at the *St. Louis Post-Dispatch*, tweeted out a picture of a man wearing a T-shirt with an American flag on it picking up and throwing a can of tear gas. I haven't displayed the picture because it isn't in the tweet. Tweets exist only as textual objects. You can see in the "media_url" field where there is a link to the photo, but if you were to collect this tweet and didn't collect that image, you would have only the text about the image and not the image itself. In the body of the tweet, Lynden cited the creator of the photograph; note that Twitter itself unpacks the screen name of that user and provides his display name, in this case "Robert Cohen," a photographer for the *St. Louis Post-Dispatch*. The *Post-Dispatch* would go on to win a Pulitzer for breaking news photography for this work.[8]

Edward Crawford, the individual who was later identified as the subject of the photograph, maintained that, in contrast to the message of the tweet and the news article, he was not throwing the gas canister back at the police but was trying to throw it out of the way of children. That image became an iconic representation of the struggle in Ferguson. It was printed on T-shirts and posters.[9] Its documentary qualities also served as evidence when Crawford was charged with assault and interfering with a police officer a year later.[10] This tweet had been retweeted 7,658 times at the time I downloaded a copy of it from Twitter's API. The tweet was also embedded in a wide range of media. It documents this moment in time, and its content circulated and worked to disseminate and construct the narrative of the events as they transpired on the ground in Ferguson. The tweet helped make one white man's career and functioned as evidence against a black man; the latter died of a self-inflicted gunshot wound while awaiting trial. In this respect, it offers a chance for consideration of, more broadly, the roles that documentation and records serve as part of institutional structures of oppression and, specifically, the very real effects that records can have on the bodies and lives of those targeted by those oppressive systems.

The examples of these two tweets present a significant challenge to conventional wisdom about how to go about arranging and

describing objects. For someone who wants to document and preserve information around an event, the extent to which these objects include massive amounts of metadata is a significant boon. Each tweet contains a massive amount of metadata that can help make its content discoverable. At the same time, we see how quickly the boundaries between the content of a message and its descriptions break down. The tweet object is bigger on the inside than we might have expected. Each tweet is full of all types of information about itself. At the same time, the tweet that shows up on your screen as text and a picture doesn't actually contain the picture. Each tweet also fails to contain much of what it seems like it should contain, like embedded images, audio, or video.

We can think of the text of the tweet as its data and everything else as its metadata. However, it is just as fair to see the text of the tweet as one element in a serial publication that is the Twitter user's full stream of tweets. More broadly, these tweets are each part of the sequence of tweets that appeared to users around the world on the Ferguson hashtag. One could even think of the text of these tweets as annotations of the moment of time in which they appeared. All those tweets are pointers; they point at other things on the web and back out at very real confrontations and clashes in the streets and more ethereal networks and flows of civic, social, and economic power. Herein we see a key point about digital objects: they describe not only themselves in machine-readable ways but also each other. Further, every bit of metadata points in every direction. All the metadata in a tweet provides context to the text of the tweet, but it contextualizes and describes the linked picture, and reaches even further as metadata to incidents, moments, and flows of power.

This brings us back to the central challenge of the boundaries of digital objects. On the surface, it seems like a tweet is a useful and meaningful object to collect. But when we realize that the tweet object as defined by Twitter does not contain any images, it seems to violate our sense of objectness. Of course we often want to collect the images that seem to appear inside tweets, even when those images are functionally shoehorned or hot-linked into those tweets on

the fly when they are rendered in your browser. Similarly, one could think of each tweet as a sentence in a book. Would it make sense to collect and organize sentences in a book separately? In this context, like so many others, to be able to decide on how to collect content and ultimately to arrange and describe it requires significant technical understanding of how the underlying system functions and has been designed. Herein we find ourselves back in the earlier chapter about preservation intent. These examples illustrate (among other things) just how critical it is to understand how content is produced and to what end one wants to collect it so that what is collected is done so in a coherent and ethical fashion.

Ultimately, the database nature of new media, its inherent indexicality, means that these decisions about structure and order are far more fluid than they are for artifactual physical objects. We need to figure out how to best chunk this data and process it to extract the meaningful information that will make it usable and discoverable now and in the future. At the same time, we need to think through which data should and shouldn't be collected, given how it might ultimately end up being used.

The good news is that things like tweets that are full of extractable metadata are perfect fits for the MPLP state of mind. Recognize that digital media comes with extensive, and often self-describing, structure. Just leave the tweets in the order they come to you, and explain that order so that you and others can understand the scope and context of what it is you have. If you want to collect tweets, you need to set up boundaries for a given collection and then go about getting the data. If it's relatively small, once you've got it, you can create a single record for it. This can work just like the 4chan collection case. Explain a bit of what it is and how it's structured and let them have at it. This leaves open a wide range of potential modes of access, which we will discuss further in the next chapter. The challenging part, then, is more about what one should collect or not collect and how to provide access to it. These points relate back to the discussions of collection development, which projects like Documenting the Now discussed earlier are currently grappling with.

I will now turn to more seemingly banal examples, like those that preceded this exploration of Ferguson tweets. However, throughout the rest of the book, consider how any of the examples I discuss would play out differently if they involve any number of individuals whose digital information can place them at risk through the intersectional layers of oppression that structure and order society. These could include Facebook posts of an undocumented person under threat of deportation, photos from an LGBTQ person's phone that could be used to out or otherwise harass them, or any sliver of personal information on the web that could serve as the basis for any number of forms of harassment. Every aspect of preservation—collecting, managing, arranging, describing, and providing access to collections—needs to engage with the ethical issues that emerge from this kind of consideration. I will further discuss these ethical questions in the next chapter on access.

Multiplicity of Orders, Variants, and Copies

When we take seriously the idea that there is no "first row" in the database as an underlying principle for understanding digital media, much of what we think about sequence and order in arranging and organizing collections goes out the window. While cataloging systems have always had to deal with "shelf order," and archival arrangement and description has long focused on "original order," these ideas are, on a base level, functionally inappropriate for working with digital objects. While it is always true that on some underlying media there is a linear sequence of bits that makes up any given object, our interactions with those objects operate through abstractions.

Librarians, archivists, and museum professionals have yet to fully realize the potential that this affords them. As a default, we can begin from the assumption that there is a multiplicity of orders and potential orders available to us and our users. In the same way that you might re-sort the files and folders on your desktop at any moment based on any given metadata field (alphabetical, chronological, file

size, etc.), we can work to make sure that the tools and systems we develop to organize and provide access to collections preserve that manipulability. This underscores the resonance that comes between the affordances of digital media and the objectives of an MPLP approach to arrangement and description. Take what you are given in the order it comes, and then any transformations and rearrangements can be created without having to move the underlying data or bit stream.

The various ways digital content can be manipulated are liberating. To some extent, we can empower end users to sort and filter collections into what makes the most sense for them. However, it does mean that decisions about how to chunk and organize content into reasonable and coherent sets of information are important. Returning to our Twitter examples, if you develop a strategy to collect and store time-based chunks of tweets, it's going to suggest and privilege temporal frames for working with them. In contrast, collecting all the tweets of an individual user over time and storing them as a collection would privilege a user-centric approach to content. In either case, someone who is using that collection is free to do a chronological sort, filter by keyword, or use any other number of means, but the decisions about how to chunk the information will significantly impact what someone can do with it easily. That is, someone might need to extract a subset of data from several collections and then pull it together to view or interact with it the way they want. This multiplicity of orders is powerful, but it also creates new challenges in making sense of and relating the variants of digital objects that emerge from the way users have come to use digital tools and systems.

The distinction between an original and a copy or between a master file and derivative copies plays a central role in managing collections. Distinctions between these relationships are generally tied up in differences between artifactual and informational conceptions of the identity of objects. While these distinctions do exist, for many analog objects there are still, generally, relatively straightforward relationships between originals, variants, derivatives, and copies. This is not necessarily the case for the ways that we manage digital infor-

mation, and it has significant implications for how we approach arranging and describing digital objects.

Through extensive research on how everyday people manage their personal digital information, researcher Catherine Marshall has demonstrated how the ease of creating copies and derivatives of digital content has resulted in a massive proliferation of variants of objects that each have their own distinct but related significance.[11] As an illustration, consider the ways that individuals manage and work with their digital photograph collections.

The Social Life of a Digital Photograph

I take a digital photo with my phone. My phone stores a JPEG version of the photo in the NAND wafer in the device, and it also embeds a set of technical metadata (the time stamp, a geocode, data about the make and model of my phone, data indicating whether the photo was taken from the front or back camera, and the file names based on the order in which I've taken the photos). I might then quickly edit the photo (change the contrast, or crop or rotate it) right from my phone, which itself might be saved as an additional copy or might overwrite the original.

I might publish the photo to Facebook, where I describe it and (using Facebook's features) tag the face of my wife in it and give it a description. I might also upload it to Instagram, where I would crop it into a square and choose a filter that (for whatever strange reasons) we think makes our photos reflect some ideal notion of how we want to be seen. I also have my phone set up to automatically back up all my photos to Flickr. When the photo is uploaded to Flickr, that site automatically creates derivative copies of the image at varying sizes and resolutions. As variants of the image are rapidly published across these various platforms, they each end up with different titles and captions, dates and times of publication, tags, and additional metadata, and each accrues its own social metadata (likes, favs, comments, etc.). Very quickly, through the everyday practice of working with photos on my phone, there are now dozens of copies

of this image. How would one go about relating and managing these versions of images?

The net result of this situation is that our world of digital objects involves a slew of major and slight variants and derivatives. In Marshall's research, she illustrated situations where an animated music video might exist in variants across a dozen different websites with different metadata and a wide range of other transformations (for example, different kinds of compression, transcoding, introductions). Taking my personal photo example further, as individuals manage this information and ultimately export, back it up, and transfer it to other organizations, these variants will exist in many forms: a directory of all my photos that I back up on an annual basis, a copy of my Facebook archive, or a copy of my Flickr archive. While it is trivial to identify exact copies through comparing fixity information for files, most of these variants would likely fail to register as identical according to a fixity check, as they are, at least slightly, different. To that end, several techniques have been developed in other fields for computationally identifying near copies and variants (visually analyzing photos to detect similarity to other photos, for example).

While it's possible to spend a lot of time and energy sorting out these relationships and deciding which copies should be kept, in keeping with the MPLP principles, it's likely best to hold on to a lot of these variants and stay open to exploring computational methods for better relating and connecting them in the future. If one were acquiring my digital photos for some reason, it could also be reasonable to make calls at the highest level of organization to keep one set and not another, for instance, keeping photos in the Facebook archive and discarding the Flickr backup. Marshall's suggestion is that we come to terms with the fact that we are going to be dealing with copies, or near copies, with significant variance and that we ultimately want to develop approaches to harmonizing those copies. From this perspective, we move to a distributed notion of these objects, focusing less on which version is the best one, or the "master," but more on developing approaches to automate mapping relationships between copies and near copies and creating methods for

describing these aggregated and related clusters of objects. Several emerging techniques for this kind of fuzzy matching based on computational analysis of the rendered images show promise. While the technology isn't here to do this right now, it is enough to maintain the aggregations of copies in forms that are currently usable and await the development of these future methods and techniques.

With the proliferation of interrelated and varied content, there have also emerged new methods to step back and enable various communities to identify and interpret their own materials. I will briefly consider examples of how this can work and the impact it can have on arranging and describing content.

Pushing Description Out to the Contributors or User Communities

Empowering contributors and user communities to describe and catalog objects is becoming increasingly popular. It has the advantage of both representing the content in exactly the terms that a user would use and off-loading the work and labor required to describing the ever-growing amount of content that organizations want to collect. Sharing three very different examples of how this plays out in related but distinct collecting systems (crowd-sourced identification and description of animated GIFs for a museum exhibition, an institutional repository, and a mobile app for oral history collection) will help demonstrate some of the affordances of this technique. As librarians, archivists, and curators move into this work they need to become reflective practitioners of user experience design. In this process we become less the producers of description and more the enablers of its production.

Reaction GIFs as a Form of Gesture

The Graphics Interchange Format, or GIF, created in 1987 by CompuServe, is one of many image formats.[12] But it is one of the few that

has come to have a very specific cultural meaning. GIFs allow for looping animations which, strangely enough, makes these files a form of moving images too. As a result of this feature, *GIF* has culturally become a term that is applied to animated loops, and the reaction GIF has become a cultural form. These are generally animated GIFs that show a body in motion, often from a film or a television show, which people use in online discourse to express a reaction. It might be a short loop of the actress Jennifer Lawrence nodding and sarcastically saying "OK" and giving a thumbs-up, or an animation of Michael Jackson from the music video *Thriller* eating popcorn.

In 2014, Jason Eppink, a curator at the Museum of the Moving Image, created a collection of GIFs to document the cultural function and use of them.[13] His installation and online exhibition, *The Reaction GIF: Moving Image as Gesture*, offers an approach to arranging and describing digital content that unpacks the medium's potential.

In watching how people used reaction GIFs on the social media site Reddit, Eppink realized that there was a significant amount of shared understanding of what these GIFs meant across online communities. Seeing these GIFs as a means by which individuals were inserting a form of gesture into their discourse, he decided to develop a collection of these GIFs and exhibit them in the museum. To decide which GIFs to use, he turned to the online community of Redditors to help identify what, at least at that moment, constituted the canon of GIFs and then to ask the community to describe what they meant. The result was a collection of images and descriptions of what those images meant to users in that community. By asking Redditors to identify the most popular GIFs and then interpret them, Eppink was able to both select relevant GIFs and unpack the meaning of this digital vernacular from these participating Redditors' perspectives.

Eppink used a vernacular/folkloric approach to study these GIFs. He wasn't interested in who authored the GIF but what the GIF meant to the various everyday people who used it online. Similarly, it would be challenging to identify the author of the OK sign you

make with your hand, but it is still significant to study the contextual meaning of that gesture. So while it might be possible to trace back through time and identify when and where the first animated GIF of Michael Jackson eating popcorn in *Thriller* emerged, for the purpose of this collection it mattered more that this particular GIF is so iconic. As such, it is an exemplar of "eating popcorn GIFs," which are often posted in discussion threads where the poster is communicating amusement in watching an argument or some drama unfold in a discussion.[14] So this turning to a community to engage in description and selection is itself a powerful tool for solving some challenges. Also, if you are focused on cultural documentation, then many of the default kinds of metadata (author, date created, publisher, and so on) may not be particularly useful for building or arranging a collection. Further, this cultural meaning frame for understanding collections fits rather naturally with the multiple ways that sociologists, anthropologists, folklorists, and communications scholars approach the study of cultural forms. Taking this approach when one anticipates these kinds of scholars as your users will likely generate better alignment between your approach to arrangement and description and the ways those users think about that content.

An Institutional Repository

More and more institutions of higher education are maintaining repositories. While this might sound like a generic function of an organization, in this case it has come to mean a very specific set of features for managing, preserving, and providing access to the scholarly outputs of the organization. Many of these systems are run by an institution's library. For example, when I finished my dissertation I deposited it in MARS (Mason Archival Repository System), George Mason University's (GMU) institutional repository.

Depositing my dissertation here was not unlike uploading a picture to Flickr. After being given a user account, I logged in, uploaded the PDF of my dissertation, and filled in web forms with the title, department I was graduating from, and my abstract. The system

recorded my dissertation when I uploaded it. I checked a box to make the dissertation immediately available, and then it was up online. You can find it in the College of Education and Human Development section of GMU's Electronic Theses and Dissertations Collection. Where in the past, I imagine, a cataloger would have needed to create a record for my dissertation, the system is now set up in such a way that the work of doing that is handed off to the dissertation's author. Institutional repositories are used for much more than dissertations; many contain items like meeting minutes, podcasts, PowerPoint presentations, research data sets, video recordings, and more.

The strength of this system (largely, that the keys have been handed over to the users) is simultaneously its biggest weakness. It is easy for these systems to become a "roach motel" where people inconsistently upload and inadequately describe digital objects.[15] They tend to work well for something like dissertations, where it is possible to insist that someone cannot graduate without depositing their dissertation. But beyond that, these systems tend to unevenly represent an institution's records. That is, the comprehensiveness of this kind of collection is going to live or die based on how well it incentivizes the participation of its users. When a library hires someone to systematically describe and catalog a collection, it ends up with highly consistent metadata and levels of description. Handing that function over to the individual end user can easily result in spotty and inconsistent data. The same sets of issues come up in very different contexts.

StoryCorps.me: Crowd Sourcing Oral History

Many readers are familiar with StoryCorps, the snippets of oral history interviews shared every week on NPR. Since 2003, StoryCorps has collected more than fifty thousand oral history interviews from listening booths that travel around the country. The interviews are described and stored by StoryCorps staff and archivists and ultimately archived for preservation at the Library of Congress. In 2015 StoryCorps designed and launched StoryCorps.me, a mobile

app that allows people around the world to conduct StoryCorps interviews using their phone, enter metadata for them, and upload them to be included in the archive. As you might imagine, this rapidly expanded the size of the collection. Quickly, StoryCorps had more interviews from the app than they had from more than a decade of collecting interviews from the booths. This case isn't unique. Many organizations are using things like the open-source Omeka collection publishing platform to create crowd-sourced collections. These app-collected interviews, and other crowd-sourced collecting efforts, come with exactly the same potential issues as the materials in an institutional repository. That is, because the metadata for this collection is user generated, it is inevitably not going to be as consistent and comprehensive as the metadata created by trained professionals.

The result of this is that user-experience design, doing iterative testing in the development of interfaces and work flows, becomes critical to the ability of these kinds of systems. This ends up being a kind of social science research project. How do you motivate or incentivize people to participate in these systems? What kinds of metadata fields should be used? Should you use controlled vocabularies and drop-down menus? When should you have a free text field? How many metadata fields can you ask someone to fill out? Do you put in place restrictions on what kinds of files someone can upload, or do you validate files that they upload and force them to resubmit if the information isn't there? How many fields is someone likely to fill out? Which fields should be mandatory and which optional? These are social science and human computer interaction research questions for which we don't have the answers. But owing to the development of these kinds of systems for building digital collections, these questions have become central to librarianship and the work of cultural heritage institutions. These institutions need to invest time, resources, and personnel to be successful at producing comprehensive, consistent, and usable collection interfaces. Design decisions about how to structure user contributions and interactions will leave a lasting mark on the content and structure of these collections.

Linked and Networked Description

Many digital objects index, describe, and annotate each other. Consider, for instance, the links that appear in articles published in the *Drudge Report*. The fact that the *Drudge Report* linked out to those sites tells you something about them. Returning to the metadata in an individual tweet, if you took all the tweets a significant political figure made over time, you end up with not only a coherent set of tweets but also a series of annotations of any URLs mentioned in those tweets. That is, if you take every tweet in that collection that mentions a specific URL and all the tweets from various other collections that mention that URL, you end up with a lot of information that describes, contextualizes, and annotates whatever resource resides at that URL. This linked set of connections becomes a powerful form of context.

The implications of this relate to points in the previous chapter related to collection development. For example, several web archiving projects have used one set of content as a means to identify other content to collect. The British National Library developed TwitterVane, an open-source tool that collects URLs mentioned in tweets that also mention a given term.[16] Similarly, the Internet Archive created a web archive collection using the URLs pulled from the 13 million tweets mentioning the Ferguson hashtag in the protests after Michael Brown's killing. In these cases, one digital collection becomes the basis for scoping another, and the two functionally annotate and serve as context for each other.

Natural language processing techniques, computational methods for identifying patterns in text, are increasingly used to surface relationships between objects and descriptive metadata. Powerful open-source toolkits exist for named entity extraction (an approach for identifying people's names, names of places, dates, and times expressed in several textual ways), and researchers are working on applying these techniques to aid the description of objects. As these techniques are improved, it will be possible for a librarian or an ar-

chivist to run them against a corpus of text or, using computer vision techniques or speech-to-text technologies, against collections of images or audio, and then link, tag, and categorize content based on suggestions provided by these computational techniques.

It is appropriate to frame nearly all-digital objects as data in their own right and as metadata that describes other objects. To this end, we should think of "description" and "the described" as a fuzzy boundary. The future will involve figuring out how to leverage the fact that digital media increasingly reference each other. Figuring out how to surface and document these links, in automated ways, will provide a massive amount of potentially valuable descriptive metadata. It is likely also the only way that we will be able to work at the scale of digital content.

From Cataloger to Data Wrangler

The affordances of digital objects present opportunities to rethink how we arrange and describe them. The database nature of digital information makes some aspects of arrangement much more straightforward. We can enable end users to take on much more agency in filtering and sorting content in ways that are useful for them at a given moment. At the same time, the ways that we go about collecting and chunking that content create privilege in some approaches over others. It remains critical to consider how digital information is organized, but the emphasis is less on the individual objects and more on creating useful aggregations.

Thankfully, the logic of computing insists on varying levels of embedded metadata in digital objects. On one level, all digital objects are self-describing. They come with file names, file extensions, time stamps, and so on. This metadata enables cultural heritage professionals and their users to quickly manipulate and process them. The messiness of digital objects, that is, their variant copies and the rhizome of links and interrelationships, provides considerable grist for sorting out the networked relationships that exist between them. In

this context, establishing the boundaries for digital objects in relation to preservation intent becomes paramount.

We are moving away from a world in which an archivist or a cataloger establishes an order and authors a description to a world where archivists and catalogers leverage, wrangle, and make sense of information flows. This is less about applying descriptions or imposing arrangement and more about surfacing descriptions and clarifying and deciding which order inside digital content to privilege. In many cases, roles are also shifting to enable various kinds of users to describe and organize content. In this space, it becomes more and more critical to take the lessons of the More Product, Less Process approach from archival theory and apply that to practices that enable us to work at higher levels of organization and description and let the lower-level aspects of arrangement and description be covered by embedded metadata and the forms of order and structure that come with all kinds of digital objects to begin with.

- - - - - - - - - - -

Enabling Multimodal Access and Use

GeoCities, the free web hosting service and early online community, was abruptly shut down in 2009. Thankfully, the Internet Archive and a band of rogue archivists that go by the name Archive Team made concerted efforts to archive the site. Archive Team provided bulk access to a terabyte of data of the archived site, and the Internet Archive provided access to the site through their Wayback Machine. The bulk data dump from Archive Team became the basis of a series of projects that created significant and meaningful interfaces to that data. From this raw, bulk dump of data artists created multiple projects: Deleted City, which visualized the content of the site through tree map diagrams and *One Terabyte of the Kilobyte Age*, which reenacted and interpreted pages of the site on Tumblr. This story, which I delve into later in this chapter, is illustrative of key themes for the use of digital collections. Quick bulk access to digital collections can empower users to create other modes of access to them. The future of digital access starts as wholesale bulk access that empowers users and continues through a range of more boutique projects when justified for a particular user community's needs.

Ultimately, preservation is about access in the future. But access today is critical as well. It is difficult to justify collecting and preserving things if they aren't providing value to your stakeholders. While working to provide access to digital content, you can help make sure that the ways you are acquiring, arranging, and providing access to it are useful and intelligible to your users. The sooner you provide access, the sooner you know if the rest of the work you are doing hangs together and makes sense to your users. That is, by getting content up and out there to users, you can start to incorporate user input while refining your approach and focus.

This chapter works through some of the opportunities and challenges in providing access to digital collections. There are simple things anyone can do to immediately start providing access to content at some level. It is critical to think through the legal and ethical issues involved in providing access to collections. These considerations prompt a series of key issues regarding what kinds of restrictions to access make sense in different contexts. With these points in mind, I then work through several examples of methods and approaches for providing access to specific digital collections. Throughout these examples I suggest the importance of a multimodal approach to access. This enables your users to provide feedback on what will make the content the most useful to them. It also opens up opportunities for users to take the lead on designing interfaces to your content for others to use as well.

Together, the examples in this chapter illustrate how access is and will continue to become more and more multimodal. Given many of the inherent affordances of digital information, it makes sense that we will see a variety of assemblages, aggregations, interfaces, and methods for accessing and using digital collections. In this context, you need to think about the *ways* you will provide access to content instead of *the way* you will provide access. This increasingly involves thinking across a spectrum of access modes. One end of this spectrum is wholesale: methods for providing bulk access to collections as data sets and for uniformly providing access to all your content. On the other end of this spectrum is the boutique: highly

curated sets of materials, special custom interfaces, or modes of re-mediating or enhancing content for special use cases.

Given that there are multiple ways one should approach access to a given set of objects, it is now generally a good idea to start with what is easiest or simplest and explore other approaches as time and resources permit. As has been the case throughout the book, the key consideration that informs your decisions about what methods for access make sense in a given context is going to involve sorting out the cost-benefit analysis of an approach to support the needs of your users or stakeholders.

Start Simple and Prioritize Access

When a user in a research library asks to see a book in an obscure language, a librarian will generally bring it out and let them look at it. That librarian may have no idea how to make sense of the text. That does not preclude them from knowing how to provide access to it. In this situation, it is assumed that a researcher requesting such a book needs to come prepared with the skills to make sense of it. At the most basic level, we can provide this kind of access to any digital object we are preserving. Here it is, have at it. Returning to the principle of MPLP described in the last chapter, we should be working to provide this level of access as quickly as possible to any and everything we have acquired. It should take very little time to turn things we acquire into things we provide access to, at least in some minimal form. Providing a base level of access should be a matter of days, weeks, or months, not years.

Once you have acquired an object or collection, you should provide at least a minimal description about it and access that is as open as permitted and ethical. The example of the 4chan archive at Stanford in the last chapter exemplifies this golden minimum. Librarians at Stanford received the files. They created a collection-level record. They determined that they could share them openly over the web. They published the collection/item on the web where anyone

can download a copy of it or verify that their copy of it is authentic from the record Stanford has provided. The collection was appraised, selected, described, and made accessible at the collection level in a matter of hours.

The affordances of digital media open up significant potential for access and use of digital content. Yet our experience with consumer software can get in the way of starting to provide access to digital content. Many librarians and archivists aren't providing access to content until they have a sophisticated system in place that renders the content in an easy-to-use interface. The "user friendly" ideological frame for computing largely interferes with a sophisticated, critical appreciation of computational media.[1] We need to get over the desire to have the kinds of interfaces for everything where one just double clicks on a digital object to have it "just work." Remember, this is part of the problematic assumption of screen essentialism. There is no inherent interface or means of accessing any given digital object. Instead, there are various ways of rendering that content that may or may not matter to a particular user in a particular use case.

This means digital preservation practitioners need to, for starters, be OK with saying, "Here it is, have at it." Even if you don't know how to open a file, your users can explore it in a Hex editor and read embedded metadata in it. At the most basic level, providing on-site access to digital materials should be the default. With that noted, the possibilities for access provided by the open web require a bit more thought.

The Tyranny of the Discovery System

- -

Before getting into issues around access restrictions, I want to first address discovery systems and interfaces. For many working in cultural heritage institutions, the answer to the question of access is whatever their system offers. So if you do a collecting project using Omeka, then Omeka lets you provide access to each item through its

interface. Similarly, if you use DSpace as a repository system, then that comes with an end user interface. By all means, use what you have available to you. However, don't allow these systems to foreclose the best way for you to provide access to your content.

Don't let the functionality of a system drive your decisions about describing and arranging your content. Returning to the example of the 4chan archive, the page for that collection in Stanford's repository looks a lot like an item page, but it is actually a description of the entire collection. Whatever discovery system or interface you use today is temporary. Today's shiny new system or platform is tomorrow's old frustrating system that you will need to migrate out of. In three years or a decade there will be a new system, and you don't want to have made significant long-term decisions based on the features of a current application. To that end, for many kinds of content it is just as simple to publish the content online in directories or very simple HTML pages and then integrate that with whatever systems you might otherwise be using.

In keeping with the idea of multimodal access, if you are provided with a discovery or access system to work from, it should provide your initial baseline and initial mode of access. However, do not think of this as the only way the content will be used. It is simply a means to an end today. With that noted, I'll return to thinking through access opportunities outside any particular system or framework.

The Opportunity and Problem of the Open Web

The web is an amazing access platform. Content published on the web becomes almost immediately globally accessible. It is hard to adequately underscore how massive an impact this has had and is still having on access to cultural heritage material.

An archivist can take a collection of ten thousand word-processing documents, batch convert them to HTML, and upload them to the web with a simple link structure in them so that they are

indexed by search engines. The result is rapid global access and discoverability of content. At that point, someone doing a Google search for an obscure person's name may end up jumping directly to document number 3,587 where that person is mentioned.

This kind of discoverability of content is transformative. This would have been the stuff of science fiction before the web made it a mundane part of our everyday life. However, this discoverability requires us to be considerably more thoughtful than we have been in the past about the effects of immediate access to information. In the past, that individual's name found on one page of a document in an archive would have been accessible only to someone who (1) somehow knew to look in that collection even though the person's name wasn't likely described in the collection's metadata, and (2) then physically went to the archive and looked through the entirety of the collection to find it. The work it took to access something like this had the effect of providing a form of privacy via obscurity. As a result, it is imperative that those managing digital collections become more thoughtful about the ethical and legal issues emerging with this transformational form of access and discoverability.

Ethics, Privacy, Rights, and Restrictions

Slogans like "information wants to be free" feel like they should have an apparent truth to them. However, there are three major reasons that those working to provide access to digital collections simply cannot take this slogan as their mantra: copyright, privacy, and respect for cultural norms. I will briefly describe each of these points and then in examples throughout the rest of the chapter demonstrate of how different approaches to access function to address these legal and ethical issues.

Nearly all work people produce is protected by copyright. I am not a lawyer. This is not a book about copyright. So don't take these brief comments as legal advice. Instead, use my comments here as a prompt to remind yourself to think through these issues and do your

own research or consult legal counsel. Copyright grants a work's creator exclusive rights to distribution of their work. In the United States, libraries follow a set of exemptions laid out in section 108 of the copyright law that deal with preservation and access of collections. These exemptions are woefully out of date for dealing with information, but they are still important.[2] Libraries are also increasingly using fair-use provisions to support their approaches to providing access.[3] In addition, cultural institutions often make agreements with donors or sellers of content that grant distribution rights to the institution. Along with this, the growing movement for making creative work openly usable and reusable through initiatives like Creative Commons licenses has created a wide range of possibilities for collecting, preserving, and providing access to content.

Setting copyright aside, there are ethical issues around privacy at play in making some content broadly available. For example, organizational records might include information about staff members' salaries, Social Security numbers, and bank account information. Any of this private information could be used to harm these individuals. Many forms of research data raise similar ethical issues. For example, medical and social science researchers at institutions of higher education often collect sensitive data on individuals' sexual behaviors or drug use that could be harmful to the research participants if it were to become public knowledge. Similarly, a researcher studying social movements and activists' use of social media could end up collecting data that would be of interest to individuals working to suppress those movements or further oppress those people. Even beyond the realm of personal data, there are ethical issues to consider regarding sensitive information. For example, a zoologist studying an endangered species may collect data on the locations of animals that poachers might use to further hunt a species to extinction. These are just a few examples, but they underscore how disregarding privacy concerns in data could result in real harm.

Cultural heritage institutions have an ethical responsibility to ensure that their commitments to preservation and access align with our shared social responsibility. That requires thinking through

approaches to restricting access to content that considers these kinds of ethical issues. In keeping with the interactive perspective on all the issues in these later chapters of the book, these ethical issues related to access often prompt a return to decisions about what to collect, how to collect it, and how to process those collections. Often the best way to manage ethical issues is to anonymize, redact, or otherwise ensure that information that could be harmful to individuals is simply not collected and retained. If you do in fact have data that could result in real harm, realize that the safest way to protect those it would harm is to destroy it. So any decision to keep sensitive data should come as a result of a deliberate weighing of the potential benefit and harm that could come from keeping it.

Besides privacy, there is another category of related ethical concerns. Cultural and ethnic groups around the world have distinct norms and rules for what can and should be shared in a given situation or setting. This is a particularly significant issue with collections of cultural materials from indigenous communities. These cultural issues have, historically, been largely ignored by colonial powers. For example, there may be digitized objects that only individuals in a family should have access to, or that should be used or viewed only in a particular season or time of year, or that are considered sacred and should be engaged with only in particular ways. Kimberly Christen at Washington State University leads a team that developed and supports Mukurtu, an open-source collection management system focused on returning control of access decisions to indigenous communities.[4] Similarly, initiatives like Traditional Knowledge Labels are attempting to develop ways of making legible these kinds of access restrictions.[5] These examples remind us that access for the sake of access should not be the objective of cultural heritage institutions. Cultural institutions should be resources *to* communities and not harvesters or plunderers of resources *from* communities. History shows us that this has often not been the case. Libraries, archives, and museums have served and by default, in many cases, continue to serve as infrastructures of colonialism and oppression.[6] We need to do better.

While much of the work focused on these cultural norms emerges from working with indigenous communities, the implications of this work are far-reaching. As cultural heritage institutions work to become more socially responsible, it is critical for them to recognize that their existence is often owed directly to the flows of power. As a result of those power structures, a significant portion of library, archive, and museum work in collection development over time has functioned as part of systems of control and oppression. Many public and nonprofit institutions emerged from the personal collections of the wealthy and continue to build collections in continuity with the directions set by their progenitors. So it is important to think about issues around cultural norms alongside issues of individual privacy in a wide range of collection situations. This is especially so when working with initiatives focused on documenting or preserving records from communities that have been or are being oppressed. You can help by systematically incorporating voices and perspectives of the oppressed into every aspect of your work to collect, preserve, and provide access to culture.

These three areas—copyright, privacy, and cultural norms—are general considerations that one should think through in developing plans for how to make any collection accessible. In keeping with the interactive approach to the practice portion of this book, it is worth underscoring that access isn't something to figure out later. You should be thinking about modes of access from the beginning. For each of these legal and ethical issues the most straightforward way to deal with them is to restrict access to content. This could involve managing a dark archive, something to which no access is provided; restricting access to only individuals who visit a reading room; or restricting access to those who create an account and sign an agreement regarding what they will and won't do with the content. However, there are more sophisticated ways to approach the issue of access, in cases where there are significant restrictions and where there aren't. Exploring several examples will help demonstrate these points.

Multimodal Levels of Access and Restrictions

There are increasingly sophisticated ways to provide useful access to aspects of a collection while still respecting the restrictions to access that emerge from copyright, privacy, and cultural norms. The best way to illustrate this is through some concrete examples.

In this section I introduce three collections of digital material: the National Software Reference Library, the Google Books and HathiTrust corpora, and Rhizome's Theresa Duncan CD-ROM collection. The access restrictions in each of these cases have more to do with copyright than privacy or cultural norms, but their approaches are illustrative of methods that could be used for these two areas. Several of these cases illustrate the value of creating and sharing derivative data from collections. This is a point I will further explore in the next section, which focuses on the potential for remediation, derivatives, and enhancements to enable access and use of collections.

Access to a Dark Archive: The National Software Reference Library

Created in 2000, the National Software Reference Library (NSRL), a division of the National Institute of Standards and Technology (NIST) in the US Department of Commerce, contains a massive collection of files from commercial software packages (including Quick-Books, Microsoft Word, AutoCAD, and World of Warcraft).[7] At the time of writing, this included something on the order of 140 million digital files. Most of the software in the collection was purchased. Some of it was donated, so the NSRL does not have the right to distribute the files. For the most part this is commercial software that is being actively sold and used.

This unique collection was created to standardize the practices for identifying software as part of computer forensic investigations. One wants to be able to quickly identify which content on a com-

puter is standard software and which is potentially relevant unique material that should be the focus of an investigation. As discussed earlier in relation to fixity, one of the key properties of digital objects is that it is possible to generate cryptographic hash values (MD5, SHA-1, and so forth) to uniquely identify a file. So, by centralizing a massive library of commercial software, it is possible for the NSRL to provide hash values for all the files it contains, which can then be used by any number of organizations to conclusively identify which software is on any computing device.

While the content in the collection is covered by copyright, the NSRL *can* distribute metadata about the collection. This metadata is useful because it contains key descriptive information (title, publisher, and so on) along with the hash values for each file associated with any individual computer program. Along with the derivative data, the NSRL maintains a copy of the collection for research purposes. While they won't let researchers access the collection on-site, the NSRL accepts queries from researchers to run against the massive corpus of unique files. In this respect, this vetted corpus of unique files has played a key role as a research data set that various computer science methods and approaches have been developed against.

The NSRL is functionally a dark archive. The collection of software files is maintained on an air-gapped network, a completely separate network that isn't connected to computers outside the rooms at NIST where the library is located. That is, not only is it *not* possible for you to access those files, it is also impossible for anyone inside NIST to do so without physically getting inside the space. It's not unlike the Svalbard Global Seed Vault, the global repository of last resort for seeds. By deriving metadata about the collection and publishing and sharing that data, the NSRL's content is widely used. While the actual files are preserved and inaccessible, the derivative data from those files serves an immediate use to several stakeholder communities. Similarly, by allowing for computational analysis of their collection's contents, NIST also provides a valuable way for others to use it. While most readers of this book won't have the kinds of sophisticated infrastructure that NSRL has, there are some

take-aways from this case. Publishing metadata and computationally derived descriptive information about any collection can be quite useful. In particular, the uniqueness of the hash values offers a way for exact duplicates from across various collections to be identified.

Nonconsumptive Use: HathiTrust and Google Ngram

HathiTrust is a partnership of more than 120 research institutions and libraries that provides online access to millions of digitized works. In particular, it contains more than 7 million digitized books. The partnership originates through the Google Books digitization project in which Google partnered with libraries to digitize books in their collections. Much of the work digitized in this process is still under copyright, and as such cannot be broadly and openly shared. However, within the network of HathiTrust partners it is possible to make use of copyrighted works in the collection within the provisions of copyright law. This has largely been called "nonconsumptive use," a slightly confusing term generally meaning computational analysis of texts as a data set as opposed to more straightforward reading of material. Much like the NSRL collection, HathiTrust runs a research center that enables researchers to computationally analyze and data mine the entire corpus of books for research purposes. It also runs initiatives to identify orphan works in the collection and clear the rights for those works to make them openly available. This effort provides significant added value in further opening up access to works whose copyright status is difficult to determine.

One example of the derivative data that has been particularly useful for many research contexts is the corpus of n-grams and the n-gram viewer. Google Ngram uses a remediated and processed subset of the corpus of books digitized through the Google Books project as a basis for anyone to study historical trends in word usage in the corpus. Through this interface you can study social and cultural changes as they manifest in the texts of books over time. You can also download the underlying data. The data set that powers the n-gram viewer does contain all the words in the books, but it gives

the frequency at which those words appear, not the actual stories. For this reason, the digital data shared is information about the works and not the copyrighted material itself.

Remote Virtual Machines: The Theresa Duncan CD-ROMs

In the mid- to late 1990s, designer Theresa Duncan released a trilogy of interactive storytelling games for the Mac operating system (*Chop Suey* in 1995, *Smarty* in 1996, and *Zero Zero* in 1997). These games are interesting both as exemplars in the history of interactive story-telling and as the kinds of work women have been taking the lead on. Surfacing the history of the leadership of women in video game development is important as a counter to video game cultures that often erase, ignore, or disregard women's contributions to games and games culture. Over time, even if you have a copy of Duncan's games, it has become increasingly difficult to play them, as sourcing an old machine or setting up emulation or virtualization systems to play them is rather challenging.

Rhizome took on the task of preserving and providing access to these works.[8] Using the open-source bwFLA Emulation as a service platform, they set up a system where anyone can visit their site and connect to a virtual machine that runs the required operating system and includes a copy of each of the games to play. It is actually a quite remarkable experience; you click the link and it generally takes a few moments for you to see a copy of an old Mac OS system load up in your web browser. The same kind of access is provided for the Salman Rushdie archived laptops at Emory described earlier.

Significantly, this is not actually distributing copies of the game. Instead, a user is remotely accessing a copy of the game running on a server hosted by Amazon. The users are given access to the game environment, but the actual files of the game are running on a remote computer. While a user could create screen shots of things they see on the screen, they cannot copy the actual underlying files of the game to access them later. They get to interact with the game but only as long as it is served to them from the remote computer. While this

isn't necessarily a core requirement for these particular works, this kind of remote-access approach to virtualized or emulated computing environments offers significant potential for providing access while still not openly distributing content that can be further distributed.

Remediation, Derivatives, and Enhancements

- -

When I talk about "access" in this book, I generally mean providing digital information to potential users. With that noted, many cultural heritage institutions are increasingly entering into relationships with users that are much richer and more complex, resulting in diverse outcomes of use, reuse, and remediation of content. The remainder of this chapter explores examples that demonstrate some of these emerging and evolving multimodal access ecosystems.

In some cases, these interactions are enabling users to develop new methods of providing access to collection materials. Many new forms of digital scholarship are taking the form of interfaces to digital collections. This complicates the general model of the relationship between the users and providers of collections, in that scholars are increasingly producing derivative forms of collections that then have their own users and audiences who make use of these for various purposes. In many of these cases, the cultural heritage institution is offering bulk access to information "wholesale," and the scholars are then doing most of the work to make that information useful to audiences.

In other cases, cultural heritage institutions are investing considerable time and resources enhancing these collections for use. Earlier discussions of crowd sourcing in this book offer related points for consideration on the coproduction of acquisition, arrangement, and description of collections, but many of these cases demonstrate how this work is related to emerging evolutions in access. Along with providing more straightforward access to collection items, cultural heritage institutions have facilitated the production of interpretations and derivative resources. This includes anything from critical

bibliographies, to exhibitions and exhibition catalogs, to documentary and critical editions. These enhancements to objects and sources enable deeper modes of engaging with and providing access to materials. As opposed to the "wholesale" model mentioned above, this "boutique" approach requires substantial justification for the investment of time and resources into creating these kinds of derivative or enhanced forms of content.

These points are best illustrated through discussion of five examples: interfaces to GeoCities, bulk access to digitized newspapers, facial recognition for developing an interface to archival records, remediation of public domain ebooks, and the creation of resources to make collections useful to K–12 teachers. Together these examples demonstrate various levels of involvement and the different kinds of ecosystems that are emerging around use and reuse of digital collections. Looking across them you can map out the increasingly diverse methods and approaches that institutions have to consider when thinking about access to digital content.

Multiple Points of Entry: Archives of GeoCities

GeoCities was both a free web hosting service and an early online community. Drawing on the cities metaphor, each user selected which city their website would be located in, which then served as a key element in navigating the site. Some of this was geographic and other parts were topical. Launched in 1994 and bought by Yahoo! in 1999, the US section of the site was shut down in 2009. When the site shut down, it had more than 38 million pages of content.

Given the prominent place GeoCities had in web history, its shutdown prompted efforts to preserve it. Much of the site had been archived over time by the Internet Archive through its ongoing regular web archiving activities. The Internet Archive also engaged in extensive focused archiving of the site when it was close to being shut down. At the same time, a grassroots movement to archive the site led by archivist Jason Scott, Archive Team, and other groups worked to copy parts of the site. One year after the site had been

shut down, Archive Team published a torrent file (a means of peer-to-peer file sharing) that included nearly a terabyte of data of the archived site.[9]

Archive Team made a single bulk dump of the data, which led several new projects to create significant and meaningful interfaces for that data. Two derivative artworks created from publishing this data dump demonstrate how users of digital collections are increasingly moving into roles that are a hybrid of interface development and the creation of interpretations.

The Deleted City: The artist Richard Vijgen created a piece called *The Deleted City*, which interprets and presents an interface to the data.[10] *The Deleted City* uses a touch-screen interface to explore the site's content. It also uses a tree map interface, where the size of the different areas of GeoCities is visually represented based on the number of files they contain. Created as a piece of art in its own right, it has been exhibited as an installation in galleries and is now also available online. The resulting work provides file-level access to the contents of the archived site in an easily understood and navigable form. This work of art is a very useful way to explore and understand the content.

One Terabyte of the Kilobyte Age: Digital folklorists Olia Lialina and Dragan Espenschied created *One Terabyte of Kilobyte Age*, another work derived from the GeoCities data set, but one that is anchored in a very different approach. A "reenactment" of GeoCities, *One Terabyte of Kilobyte Age* interprets and provides access to the contents of the archive.

One Terabyte of the Kilobyte Age takes individual pages from GeoCities and generates an authentic form of rendering of those pages in old browsers and old operating systems at the screen resolution that would then have been common. After getting to this level of screen-rendered authenticity, screen captures of the pages are taken, which are then published to the project's Tumblr. By turning the pages into images and publishing them to a Tumblr, the project disseminates them into the social media feeds of different users of this social network. Many of those Tumblr users then reshare the im-

ages in their feeds. A few images of GeoCities sites are published to the Tumblr feed every hour. At this point more than ninety thousand images have been published through this project. The project functions as its own creative work, but it is also a way of publishing and making accessible content from the archive to share the collection more broadly.

GifCities: The Internet Archive offers other ways to interact with archived copies of the site. Anyone can use the Wayback Machine, the Internet Archive's general-purpose method for getting access to individual archived websites based on their URL. In addition, the Internet Archive created a custom search interface to the collection called GifCities. GifCities allows users to search by keyword through all of the animated GIFs archived from the site. Part of the digital vernacular of GeoCities was its abundant early web animated GIFs. The Internet Archive team realized that providing a specialized way to search and explore those GIFs would likely generate new and additional interest in the collection. The launch of the GifCities search interface did result in considerable attention to the collection in various tech blogs and the tech press. While those GIFs were always there for anyone to find, creating a custom search interface earned new user interest.

Through these three examples we can see several patterns emerging. By providing bulk access to an archived copy of the data, Archive Team created an opportunity for different artists to run with the contents of the collection and create works that stand on their own as creative projects. These works also exist somewhere on a continuum of functioning as interfaces to the archived data and as forms of exhibition and publication of interpretations of that data. At the same time, the Internet Archive's approach to developing an additional interface (GifCities) to some of the data they had in their archive spurred additional use and engagement with their archive. This multiplicity of modes of access—spanning from bulk data down to item-level interfaces—is all driven by the embedded structure and metadata that are inherent in born-digital objects.

The Bulk Data Your Users Want: National Digital Newspaper Program Data

The National Digital Newspaper Program (NDNP) at the US Library of Congress publishes a massive collection of digitized US newspaper pages online through the Chronicling America website. At the time of writing, this includes more than 11.5 million digitized pages. This online collection is the result of a rather unique and distributed approach to collection development. The National Endowment for the Humanities funds digitization of newspaper pages through grants to cultural heritage institutions around the United States that have microfilm copies of significant runs of newspapers from their area. The grant funding for these projects supports both the digitization and the process by which subject matter experts help make informed selections of which newspapers in a region are particularly significant to prioritize for digitization. The microfilm is digitized to standards set forth by the Library of Congress, and then the Library of Congress archives copies of this data and publishes it online through the Chronicling America website.

The Chronicling America website is an amazing resource for researchers. Scholars can browse through the collection, but because the pages have been run through optical character recognition (OCR), researchers can also do keyword searches through the entire corpus. Full-text search continues to be an amazingly transformative means of providing access to collection materials. From there, users can read the individual digitized pages with their search terms highlighted. The site provides additional modes of access to the collection: an application programing interface (API) that allows programmers to interact with the collection information, methods to get bulk access to the digitized pages, and bulk downloads of the OCR data. Through the API developers and researchers can write custom queries into the corpus of data.

In practice, the API has turned out to be less widely used than some of these other formats. In contrast, the bulk data dumps of the OCR have been extensively used. David Brunton, one of the lead

developers on the site, offered a few explanations for this that are broadly relevant to access to collections as data sets.[11] The lessons learned through this project offer insights for which multimodal access methods likely make the most sense to prioritize for particular uses. Using the API requires a somewhat sophisticated understanding of web scripting. Most users of the data are not web developers, and they don't have considerable access to web development resources. Instead, most scholars interested in the bulk data are humanities researchers who have limited experience with programing. As a result, bulk downloading the entirety of the images of the collection, or even a selection of the images, would provide those users with such a massive amount of data that they couldn't really work with it in very meaningful ways. It is also worth noting that there aren't many approaches and methods for working with the images themselves computationally as research objects, so this kind of access doesn't readily connect with methods that users might take.

In contrast, the bulk OCR data is relatively small. Instead of the large image files, the bulk OCR data just contains the much smaller text files for each image. This allows a user to work with the OCR text on a modestly high-end laptop. Along with that, there are numerous free and open-source tools for computationally working with textual data. As a result, OCR—created for search purposes and thus noisy and error prone—is still the most used of the various methods of accessing bulk data.

As has been the case in many of the examples of access discussed so far, many of the scholars working with this data have produced interfaces to interact with and explore parts of the collection. For example, the Viral Texts project from Northeastern University has studied and mapped networks of reprinting in nineteenth-century newspapers and magazines.[12] Through this work, the project has produced both traditional scholarly publications, like journal articles, as well as online interfaces to texts that repeatedly appear in different newspapers with links to their sources. Similarly, historians at Virginia Tech used the NDNP data to map and analyze press coverage of the 1918 influenza outbreak. Their work has, again, produced

scholarly publications, derivative data sets, and online interfaces to that data.[13]

Here, a pattern has emerged: providing forms of bulk data access to collections enables the creation of additional, derivative forms of data. Importantly, the OCR was itself a form of derivative data from the collection. In this case, because that form of data was a better fit with the resources and tools that the potential users had ready to hand, it was critical for the Library of Congress to meet these potential users where they and their tools could work best and offer up that kind of data.

We are moving into an increasingly complex dialogue with users that will be grounded in ongoing development of new methods and approaches for working computationally with digital objects. For example, taking the case of newspapers further, recently a team of humanities scholars led by librarian Elizabeth Lorang at the University of Nebraska developed approaches for identifying poetic content in this corpus.[14] This has required using computer vision techniques to analyze the visual structure of the pages. Thus bulk access to the image files is a crucial part of enabling this kind of work. Of course, this work is possible only because of (1) the development of computer vision tools to do this kind of analysis and (2) the further development of computing tools that make it relatively easy to do this kind of more computationally intensive research. These two developments will likely continue to drive the ongoing dialogue between the kinds of access that institutions can offer and the ability of different user communities to make use of those methods. As technologies continue to advance, users will be able to develop additional methods to work with and make use of our collections.

A key point here is that access to content won't ever be finished. New techniques and methods for working with digital objects will require a continual rethinking of which kinds of slices and derivative sets of data might be useful, and those new forms will likely result in additional new interfaces and modes for further engagement and access.

Inverting Control Relationships: The Real Face of White Australia

In the early twentieth century Australia established a series of laws, called the White Australia Policy, that were focused on limiting immigration of non-Europeans to the country. These racist policies weren't repealed until the 1950s through the 1970s. The National Archives of Australia has extensive documentation of how and when these immigrant groups were controlled and oppressed. Through the Invisible Australians project, historians Kate Bagnall and Tim Sherratt have set out to turn these documents of control into a means of surfacing the stories and narratives of the oppressed people they were created to control.[15] This work offers considerable potential for modeling how cultural heritage institutions might further develop and cultivate relationships with their users to develop modes of access and use for their collections.

The primary output of this work is an interface that presents a wall of faces under the title "The Real Face of White Australia." Users can click on any of the faces to see the document each face was extracted from, the bulk of which come from the National Archives of Australia's digitized online collections. Sherratt and Bagnall identified a series from the archives, downloaded images of the digitized documents, and then used facial recognition software to identify the faces that were embedded in pictures attached to these documents. From this page, a user can scroll down through a seemingly never-ending wall of portraits of men, women, and children who were documented for the purpose of control by the government. Where looking at the documents themselves reinforces the narrative of dominance and control, extracting just the faces of those who were oppressed functions to surface their lives.

Sherratt and Bagnall's work has received considerable international acclaim and resulted in substantive engagement with these records and with an underappreciated aspect of the history of Australia. In this case, the work was possible because of the depth of subject-matter expertise that Bagnall brought to understanding the

collection and the technical chops and ingenuity of Sherratt. It is worth underscoring that by making digital collections available online, cultural heritage institutions create the possibility for this kind of use and reuse. Given the significance of these possibilities, cultural heritage institutions would be wise to more explicitly seek out and support uses and reuses of collections instead of simply waiting for potential users to do so on their own. To this end, it is worth considering ways that institutions could spur this kind of use, such as competitions, residencies for artists and digital historians, and hackathons where users can work with subject-matter experts and developers working in cultural heritage institutions.

When It's Worth Getting Out the Tweezers: Remediated Public Domain Ebooks

Most of the examples thus far have fallen into the "wholesale" category of work on the part of the cultural heritage institutions. The last two examples fall more into the "boutique" category. These are situations where cultural heritage institutions get much more in the weeds to remediate or add value to digital content to meet key needs for users.

There are millions of digitized public domain books. You can find them in several sources and formats. You can browse and search through Google Books and Ngram, or you can read digitized works online in HathiTrust and the Internet Archive. All kinds of researchers use these tools, but this isn't really the kind of thing people do when they want a fun or relaxing read. So if someone wants to read a digital copy of *Frankenstein* a little each night before they go to bed, they don't want a hard-to-read scan of it. If they want to read it through an e-reader, they likely want a well-formatted EPUB file. The additional advantage of EPUBs is that they are also far more accessible for the blind and visually impaired. The problem with this functionality is that it involves far more work than simply digitizing the book.

You can find EPUBs for a variety of classic books from Project Gutenberg, a volunteer network that has been collecting and

publishing digital text copies of classic public domain works since 1971. Still, navigating those copies and getting them into your reading device can be complicated. Someone needs to get a fully correct copy of the text of the work, and it needs to be formatted so that it's as appealing as a physical book. It even needs cover art. The book essentially needs to be republished, with much of the work that is entailed in the traditional publishing process.

In addition, curation activities make it easy for users to find what they want. If a reader is accessing the book for pleasure, she doesn't need to see hundreds of editions and variations on the work. Ease of navigation, across different reading devices, would be of primary importance.

Addressing the needs of such a reader requires a network of partners. The New York Public Library and the Digital Public Library of America are working on a project called Library Simplified. Library Simplified has launched a freely available app that provides access to (in many cases) republished public domain ebooks right alongside licensed in copyright ebooks that are checked out through the same application. In regard to the public domain content, this has meant finding particularly high quality public domain copies of works. For example, Standard Ebooks is a volunteer effort that carefully republishes works with attention to inclusions of artwork, proofing, and markup and encoding. At the same time, the Library Simplified project developed computational tools to help wrangle the data from some fifty thousand titles from Project Gutenberg to duplicate them and generate covers. The continued use of these books is going to depend on more and more engagement across these various initiatives to get particularly high quality books that can be bundled, shared, and delivered in the ways that users most want them.

Adding Value: Teaching with Primary Sources

Cultural heritage collections have a wide range of potential users. In many cases, the users are researchers. Many of the conventions for description, arrangement, and access are designed around the

imagined needs of these users. As the last example demonstrated, making content useful and usable to broader audiences can require further investment of resources. Another audience of interest to cultural heritage institutions is K–12 teachers. Indeed, the collections of cultural heritage institutions are full of material that could be used by teachers who work in fields that use primary sources. Historical sources are the most obvious, but a wide range of sources are also relevant for studying languages and literature and the sciences. With that noted, it requires considerable work to make these sources useful for teachers.

One example of this kind of work is that done by the Library of Congress through its Teaching with Primary Sources program.[16] This program curates resources for K–12 teachers that are focused on topics widely covered in K–12 curricula. Each of these sets of digital items comes with short essays that contextualize the items, and offers suggestions for how the items might best be used in the classroom. Along with that, each set includes URLs where teachers can find the items as well as PDF copies of reproductions of the items that are easy for the teachers to print on standard-sized paper and use in their classrooms. The materials that are assembled in this fashion have been developed in dialogue with practicing teachers to make sure that they are a good fit for the ongoing needs of classroom teachers. The program also runs professional development workshops for teachers to learn how best to teach with these sources and provides additional professional development materials.

These points are of general use to those who want to make collections useful and used by K–12 teachers. However, they also demonstrate how identifying particular user groups and understanding their needs as they engage with content can lead to much more time-intensive investment in working with smaller numbers of items. For teachers, a large quantity of objects is far less useful than a smaller, highly curated thematic set of resources that come with ideas for how to use them to explore particular concepts. Ultimately, understanding and continuing to engage with representatives of specific user communities will likely offer similar insights into what kinds of

work might be undertaken to meet their needs. Here it is worth emphasizing that cultural heritage collections are not an end in their own right. They are instrumental in supporting the achievement of a wide range of public and institutional goods. The more time we spend figuring out what kinds of impact our collections can have on things that people care about, the easier it will be for us to focus resources on amplifying, documenting, and ultimately communicating the impact and outcomes collections have on issues people care about.

Access and Progressive Enhancement

The purpose of preservation is enabling access. In many cases, the need for access is immediate. As the examples in this chapter have demonstrated, the menu of options and considerations for how to do access is growing longer and becoming increasingly complex. However, there are some overarching principles and points to get started.

First off, prioritize making access happen. Don't spend too much time thinking about every potential way of making something accessible before you go ahead and start providing access. The perfect is the enemy of the good, so don't wait to make access happen. At the very least, provide access under restricted terms or methods. If you have content that you can't or shouldn't be providing access to, it is worth second-guessing whether you should really have it at all. If it is not to be used, then what is it for?

Second, prioritize understanding the lives of the individuals who are documented in your collections. How old are your collections? Are the individuals featured in it alive? Are there copyright considerations? What about privacy? Make sure you are always thinking about the lives of the people who are tied up in whatever collections you are working with and that you understand the legal issues surrounding providing access to a given set of materials. These points surface the types of restrictions you should be thinking about implementing. We want to make sure we aren't doing anyone any harm, but in keeping with professional archival and library values, we need

to be particularly concerned about further harming oppressed peoples who have, repeatedly, been taken advantage of by cultural heritage institutions and are also the most likely to suffer potential harm from data about them being misused. Therefore, it is critical to think through the various methods that one can use to restrict access to content. It may make sense to weed out and remove content that has limited value but could result in significant harm. It might be preferable to restrict access to a reading room, or to those with an institutional account.

Third, realize that what you do for access now is just a start and not the end. You can put up some quick bulk data dump, and then go back later and work up item-level interfaces to materials. You can provide access to items with minimal records and then later, time permitting, provide enhanced and more detailed records. Set in place plans for watching how people are using collections. Explore possible partnerships with your users to enable them to create ways to access your collections. Or, as the Internet Archive case with GifCities demonstrates, you can have a long-running standard way of providing access to content (like the Wayback Machine) and still pull out a special subset of content and offer up some additional experimental interface to it.

Fourth, some of the best and most compelling interfaces and modes of access to your collections may be things developed by your users. As evident in cases like Invisible Australians, *One Terabyte of the Kilobyte Age*, and Viral Texts, increasingly, the results of scholarly and artistic use of collections are themselves interfaces and means of access into those collections. This opens up a significant and still emergent area for work. How can libraries, archives, and museums become better at helping facilitate the production of these modes of interacting with collections? Furthermore, what roles can libraries, archives, and museums take on to help steward, collect, preserve, and provide access to derivative data sets and points of access to the collections? If some of the most useful interfaces to collections are being created by their users, then the institutions have a

clear vested interest in helping to ensure that those interfaces are brought into the fold to persist into the future as well.

Fifth, one of the most powerful ways of further enabling access is coming from the development of derivative data sets. As several examples demonstrated, providing a bulk form of access or a data dump led scholars and artists to develop very creative means of interfacing with and exploring the collection. Beyond those forms of bulk access, some of the most useful forms of data have been derivative ones. While we can't use the software in the NSRL, the published hash values are important to stakeholders and a means to uniquely identify software files. Similarly, while the full Google Books data can't be shared because of copyright, the n-grams and the n-gram viewer have quickly become a powerful way to study trends over time.

Sixth, realize that some of the most powerful ways to make your content accessible to particular audiences may involve extensive work on small numbers of objects to make them useful to that audience. A million digitized books is great for a researcher, but when you want to curl up and read some literature before going to bed, a highly curated set of exquisitely reformatted and published EPUBs is likely far more useful. Similarly, millions of digitized historical images might be attractive to a professional researcher, but a K–12 teacher's needs are much better met with a curated subset of objects with prompts and ideas for how to use them. There are times when high-touch approaches to small subsets of materials can pay significant dividends in meeting the needs of specific user groups, so it's a good idea to identify these contexts and users.

The possibilities for digital access are exciting and emergent. The good news in all of this is that there are very simple things we can do for starters, and from there we can connect more with various user groups and stakeholders to figure out the right way to invest limited resources to provide access for various types of content. As we derive data from collections, as others make use of them and produce variants and other kinds of copies, we notice that critical

features from the preservation tradition have been the most essential in ensuring long-term access. While conserving artifacts and making perfect informational copies of works is what we usually think of as the professional work of preservation, it is the folkloric, or vernacular, methods of sharing and retelling and reformatting and copying that have been the most long-standing forces of preservation in human history. It's important that we not forget this as we let our collections out into the world to be used, reused, and remixed.

Tools for Looking Forward

D igital preservation is not an exact science. It is a craft in which experts must reflexively deploy and refine their judgment to appraise digital content and implement strategies for minimizing risk of loss. At least, that is the case I have sought to make in this book.

The craft of digital preservation is anchored in the past. It builds off the records, files, and works of those who came before us and those who designed and set up the systems that enable the creation, transmission, and rendering of their work. At the same time, the craft of digital preservation is also the work of a futurist. We must look to the past trends in the ebb and flow of the development of digital media and hedge our bets on how digital technologies of the future will play out.

One of the most challenging aspects of writing practical things about digital tools and technologies is how the quick rate of technological change can make the work seem dated. I hope that in focusing on a way of approaching and making decisions about objects that this book can have a long shelf life. However, I understand that it's possible that significant shifts in underlying digital technologies

might result in some very different results for particular situations in the future. So to that end, I'm going to close the book by discussing and appraising technologies, trends, and sociotechnical forces that are relevant to digital preservation planning. My hope is that this can offer insights into a few near-term technology trends and shifts that may be relevant to digital preservation but also, more broadly, demonstrate tools for thinking through the potential impact of any technology trend.

Emerging Technologies and Technological Misdirections

There are numerous emerging technologies and tech trends that are relevant to thinking through the future of digital preservation. I will briefly review two such trends: emerging user interface paradigms and the shifting rates of increase in storage capacity. After discussing these two trends, I will visit trends that I see as misdirections. For each of these technologies, the details about them are potentially relevant, but, more significantly, the thought process for considering them illustrates how to consider and evaluate signals and trends in technology as a digital preservation practitioner. Take this section of the book less as a set of predictions and more as an example of the practice of predicting that you as a digital preservation practitioner need to engage in.

After consideration of near-term emerging technology trends, I will zoom out and offer a few broader observations about challenges in charting the future of digital technologies for work in cultural heritage institutions.

Changing Interface Logics

Since their wide-scale rollout into the market with iPhones, touch interfaces have quickly transitioned to be the primary interface by

which users around the globe interact with computers. This transition is an excellent opportunity to check our assumptions about the future use of digital content. If the trend continues, we could move into a situation where things like keyboards just aren't part of the default setup for computing environments. In that case, various kinds of digital content that assumed their use would need to be adapted to be made usable. In many cases, tablet devices are building in virtual keyboards that offer a vision of what might come: more and more layers of virtualized interfaces to technologies.

The changes that touch-based computing bring may be the first of a series of novel interface paradigms. Virtual reality (VR) devices, like the Oculus and the HTC Vive, are moving what had been decades of the imagination into a viable consumer technology. What opportunities will there be for providing access to content in a VR environment? At the same time, what sorts of ethical considerations might come into play around placing someone in a more embodied and direct experience with content?

In some ways, the most conceptually challenging of the new computing environment interface modes is voice. Tools like Amazon Echo and Google Home are now starting to show up in houses around the country and are offering entirely nonvisual interfaces to computing systems. What would it mean to make digital collections usable and available through voice-based interfaces? Each of these new interfaces is going to be both a context in which we need to think about collecting and preserving novel forms of born-digital content and a context in which we need to think about how to port historical digital content forward to make it accessible, usable, and used. In the case of voice technology, this opens significant questions regarding how "always on" technologies that record sound around them are collecting and managing that information. Along with that, content in these systems prompts a return to consideration of the sustainability factors of digital formats. If there ends up being critical content that is uniquely tied to the features of any of these new interface platforms, then their increasingly proprietary nature

becomes problematic. These changing interface logics present numerous challenges, but there are also trends in the development of basic digital storage that present other challenges.

The Kryder Rate Has Been Slowing Down

Over the last thirty years we have become accustomed to the idea that every few years we should be able to buy significantly larger volumes of digital storage for lower and lower prices. Our experience as consumers has been that if you bought a new computer every five or six years, that new computer would come with a dramatic increase in storage capacity. I clearly remember at one point getting a computer that had eight gigabytes of storage and saying, "How would I ever fill that up?" Of course I did. We all did. With more and more storage space, more and more larger files became possible. The pace of nearly exponentially dropping costs of storage is explained in Kryder's Law. Named for the chief technology officer of Seagate, the concept focuses on the idea that one could expect drives to store 40 percent more data in the same amount of physical space every subsequent year as a result of advances in storage technology.[1]

For a number of years this rate of change has stalled out. The core take-away from this shift is that "storage will be a lot less free than it used to be."[2] Importantly, the pace of growth for the creation of digital content has not begun to slow down. The result is that in the future the costs of storage are likely going to take up more and more of the resources and budgets of institutions engaging in digital preservation activities.[3] With that noted, if the Kryder rate continues to level off, this is likely to affect the kinds of content that is produced and could also open up the possibility of developing more longer-lived or otherwise differently architected digital storage media[4]—a point that I will return to later in this conclusion.

The take-away from this trend is that storage costs likely will grow for cultural heritage institutions that actually get serious about digital preservation. It's not entirely clear what the impacts of this

will be, but it may mean that institutions will become more selective about what they collect and commit to preserve for the long haul and large institutions will continue to explore investing in hierarchical storage systems that use a wide range of storage media to keep their costs down.

Discussion of these two specific technology trends (new interfaces and changes in the trajectory of storage media) offers models for unpacking potential impacts that other trends in the overall tech landscape could have on our work. With that noted, I want to spend a bit of time talking through some of the traps that can come with looking too hard to the future for the answers to the problems of today.

The Trap of Technological Solutionism

There will never be an app for digital preservation. On this point, I return to the hope I alluded to in the introduction for a single super system that could "just solve" digital preservation. Similarly, there will be no app for more pressing challenges facing society, like social justice, economic equity, civil rights, poverty, or a better environment. However, the rapid pace at which computing has changed our lives sometimes makes it seem like some app could drop tomorrow that would "solve" long-standing social, political, and economic issues. Don't bet on linked data, blockchains, QR codes, bitcoin, or artificial intelligence to offer or suggest new ways to solve our problems. Similarly, don't wait until the next fancy new open-source repository system is finished to get started doing digital preservation. Technologies will not save you from needing to get your metaphorical digital boxes off the floor before the flood comes.

In keeping with much of the discourse of computing in contemporary society, there is a push toward technological solutionism that seeks to "solve" a problem like digital preservation. I've suggested that there isn't a problem so much as there are myriad local problems contingent on what different communities value.

One of the biggest problems in digital preservation is that there is a persistent belief by many that the problem at hand is technical. Or that digital preservation is a problem that can be solved. I'm borrowing the term *technological solutionism* from critic Evgeny Morozov, who himself borrowed the term *solutionism* from architecture. As Morozov describes it, "Solutionism presumes rather than investigates the problem it is trying to solve, reaching for the answer before the questions have been fully asked."[5] Stated otherwise, digital preservation, or ensuring long-term access to digital information, is not so much a straightforward problem of keeping digital stuff around but a complex and multifaceted problem about what matters about all this digital stuff in different current and future contexts.

The technological solutionism of computing in contemporary society can easily seduce and delude us into thinking that there could be some kind of "preserve button." Or that we could right click on the folder titled "American Culture" on the metaphorical desktop of the world and click "Preserve as" My hope is that this book has demonstrated the danger that comes with this techno-fantasy-illusion. Ultimately, the future of access to digital information is, as was the case with preservation throughout history, a question of resources. Who will we give the resources to for making decisions about the future of our past? Do we value cultural memory institutions enough to support and sustain them in this work? To what extent are we being stewards of our natural world and resources to enable a future in which preservation, of even our own species, is viable? I will focus more on these questions in the remainder of the chapter, but before that I want to drill down a bit more into some key questions about predicting the future of digital technologies.

Remember Who Is in Control

What I personally want for the future of digital technology is largely irrelevant. Our society provides and provisions resources for imagining our technological future not to our communities, or our teachers,

librarians, archivists, historians, sociologists, or scientists. All of us work in the shadows of two casts of characters who are empowered to dream of a future and manifest it as reality through the application of resources.

The defense industry and Silicon Valley are the two institutions that get to really imagine the future and have the resources to manifest their visions of possible worlds and technologies in the realities. The web, data mining, facial recognition, cryptography, data storage systems: all of these systems and infrastructures come to us from the minds and the largess of flows of venture capital into Silicon Valley and federal spending from the US government into military R&D. These points are true for shaping the future in the United States and abroad. Without radical and seemingly unlikely changes in how we allocate global resources, this is unlikely to change.

The result is that archivists, historians, humanists, and all other sectors of civil society aren't granted the resources to steer any of the fundamental decisions about what kind of future technology is worth bringing into reality. It's a bit bleak, but I think it's best to see things more clearly for what they are. This has some pragmatic implications for our work. Our remit in the social order as it exists is to imagine how to take the tools created to surveil and control and see if we can find ways to bend them to protect and preserve. It's essential that we do not go into this work blind. The tools of digital technology are not here to emancipate us. They are tools created on behalf of the power structures of our society and are intended to bring about their vision of a future.

It is important to remember that new technologies don't just happen. Computers from twenty years ago aren't inherently obsolete. We don't advance along straightforward trajectories into an objectively more efficient future. Every efficiency assumes its own priorities. Digital rights management is a sort of "terminator gene" that, not unlike the way that Monsanto produces crops that can no longer reproduce, builds technologies on the assumption of planned obsolescence and creates disruptive innovations that are tied up in an ongoing struggle many have begun describing as "late capitalism."

The Problem of Cultural Institutions in the Era of Neoliberalism

"Do we need libraries in the age of Google?" is the kind of absurd question that is possible only in a society that has been seduced by the siren's calls of late capitalism. How is it culturally possible that this question is asked? The concept that a for-profit company founded less than twenty years ago could entice people to question the social, civic, and economic function that more than 100,000 libraries provide to people across the United States alone exemplifies a growing sickness in the zeitgeist. No. Ad revenue for search will not create a national infrastructure for collecting, preserving, and providing access to knowledge, wisdom, and lifelong learning.

I don't mean to pick on or blame Google here. The problem is just as much our own lack of belief in our institutions as it is our belief in the idea that the success of the development of computing technology can result in a complete rewiring of society. Silicon Valley's notions of disruptive innovation occupy so much of our cultural imagination in large part because they have an ergonomic fit with a long-standing social impulse to divest from social, civic, and public goods.[6] This technological utopianism comes at the same time as we experience the long-running history of neoliberalism.

Under the logic of neoliberalism, nearly all aspects of society are imbued with the logic of the marketplace. States find themselves with fewer and fewer resources to maintain libraries and archives. At the same time, companies have swooped in to digitize their collections, often public records, as long as they are granted limited-term monopolies on digitizing only the content they choose and providing access to that content only to individuals who pay for subscriptions.[7] One of the biggest threats to the sustainability of digital information now and into the future is the defunding and underfunding of our cultural and civic institutions. To this end, one of the biggest things we can do to support digital preservation is to demonstrate the value and relevance of our work to the communities we serve.[8] We can't take

for granted that society will continue to believe that cultural heritage institutions are public goods worth supporting and that we need to develop our institutions' capacities to demonstrate their value.

It's also worth emphasizing how unsustainably inequitable the labor of cultural heritage workers has become. As resources become increasingly scarce and jobs dry up, there are fewer and fewer positions available. These positions often pay less and less to earnest and eager young archivists, librarians, and museum professionals. This is particularly problematic in that these areas of work that have historically been largely gendered feminine, and under the patriarchal norms of our culture, these roles have already been underpaid and undervalued. These problems become all the more manifold as we move further and further into the "gig economy" dreamed up and made real by companies like Uber, Airbnb, and TaskRabbit. As some of the most galling examples in this space, some cultural heritage institutions have begun contracting out to penitentiary systems for cultural heritage work. While the concept of providing opportunities to learn to do cultural heritage work to the incarcerated seems potentially promising as a path to meaningful personal development and career opportunities, given that those careers themselves would require advanced degrees, it's more clear that this trend results from the perfect storm of neoliberalism. Instead of finding pathways for people to make their way into well-paid careers in libraries, archives, and museums, our society has established pathways from communities to prisons that provide cheap labor and further undermine the future of a professional cultural heritage workforce.

The problems of neoliberalism and the gig economy make it all the more difficult for the cultural heritage workforce to grow to better reflect the diversity of our communities. There is a clear and expressed desire to get the staffs of cultural heritage institutions to better reflect the diversity of the communities they serve. However, given the apparent need for early-career professionals, often with multiple advanced degrees, to float through a series of unpaid internships and compete nationally for low-paying, term-limited contract work to get onto the career ladder for these professions, we are left

in a situation where only the most privileged can afford to work in cultural heritage. In this context, we are faced with problems that can be resolved only by working to better establish the resource foundations for our institutions and by looking for ways to better integrate our communities more directly into the communities we serve.

I should stress that I don't believe the state of things I've described is actually an intentionally built social system doing what it has been designed to do. Instead, I see this as the playing out of a series of ideological frames that are not particularly sophisticated or well developed. It's bleak, but I think it's better to be honest with ourselves than to be deluded. Those of us who have succeeded in institutions of higher education and increasingly also in libraries and archives must not convince ourselves that we did so because we worked hard. I'm sure we did. But hard work is not enough. It's a responsibility for those of us who find ourselves in the lifeboats of cultural heritage institution careers to be thinking about what we can and should do to help those trying to get in. There is always a hustle, and we have a duty to do what we can to make the increasingly oppressive systems we function in as humane as we can. We have a duty and a responsibility to figure out how to imbue our institutions and our fields with an ethic of care.[9] We need to swim against the tide of our times to create spaces where people who work in cultural heritage institutions are provided with adequate pay as well as the time and space required to live full lives. The tide, as it were, is an important metaphor for our next consideration. The bleakness of neoliberalism can look somewhat tame in the face of the challenges it has brought about for us to contend with regarding our natural environment.

Cultural Heritage Institutions in the Anthropocene
- -

The twentieth century brought with it something far more novel than the emergence of digital media. It brought about the ability for humanity to radically alter our world to the point that it could be-

come completely inhospitable to us. We have entered a new age, the Anthropocene. It's not entirely clear whether this is going to be an era, an epoch, or an event.[10] Will we come to recognize the power of technology and science and become stewards of our fragile, pale blue dot? Or, will we haphazardly continue along a collision course toward our own potential near extinction? Only time will tell, but in general, the outlook does not look so good.

Anthropogenic global climate change is happening. The science is settled. In the next half century we are going to see dramatic changes to our global environment, and the results of this will have sweeping impacts on all sectors of society, cultural heritage institutions included. For context, just in the United States, more than half of the major cities are less than ten feet above sea level.[11] Many cultural heritage institutions may be literally under water in the next century. This is an issue that librarians, archivists, and museum professionals are responding to proactively through initiatives like Archivists Respond to Climate Change and Keeping History above Water.[12] It's worth noting that the National Parks Service has also issued guidance on scenario planning for historical sites, which is a useful tool for any cultural heritage institution to use to plan for continuing your mission in the face of a changing environment.[13] Throughout all of this work, it remains clear that we are likely to see more and more natural disasters occur around the world, which makes it all the more critical for cultural heritage institutions to be developing plans for how to respond to disasters in their communities and ideally how to lend a hand in disasters that occur in others.

In this context, it becomes increasingly important for cultural heritage institutions to explore ways to become more environmentally sustainable. The revolving cast of ever sleeker new computing gadgets in the privileged minority world is predicated on deeply problematic labor conditions in the majority world, the exploitation of natural resources, and environmentally and socially problematic factories. Beyond that, it's not just the problems of producing computing technologies but also the problems of where they end up when they have been quickly discarded. E-waste is having significant

detrimental effects on human health in countries like China and India.[14] In this context, it is important for digital preservation practitioners to commit to establishing green practices. This can and should involve thinking about the carbon footprints of equipment such as servers, and the ways that institutions can become better at engaging in practices to reduce e-waste. When we consider the heating and cooling costs both in terms of carbon footprint and the cost of electricity, we might want to make different decisions about storage media. Indeed, several cultural heritage institutions are beginning to explore these issues.[15] Along with this change, assuming that the Kryder rate does continue to level off, there could well be opportunities to focus on investing in longer-lived storage systems that could be more efficient in terms of energy consumption and result in less e-waste. In this space, digital humanities efforts like the minimal computing that looks to ways to use more sustainable computing technologies and systems become sites of significant value for the future of digital preservation.[16]

Sites of Hope in a Broken World

I want to conclude on the subject that gives me hope. I think we have been largely misled about where innovation occurs in our world. While wealth and power are stacked up to offer a small set of privileged folks to design our future, a very different cast of characters has been keeping our futures afloat for quite some time. In the essay "Rethinking Repair," Steven Jackson asks us to "take erosion, breakdown, and decay, rather than novelty, growth, and progress, as our starting points in thinking through the nature, use, and effects of information technology and new media."[17] This line of thinking leads us to see the capacity of human civilization to absorb and respond to dramatic changes as the site of innovation. Through discussion of the ship-breaking industry in Bangladesh, Jackson demonstrates how a source of global waste and detritus of abandoned ships becomes a

resource that is broken down to its parts and circulated back into the global economy.

In this context, it's not the continual forces of "disruptive innovation" that we need to be focused on. Those are the very forces that have brought the world to the brink. In contrast, we should refocus our attention on the forces of maintenance and repair that emerge in the wake of these so-called innovators. Indeed a community of scholars and practitioners has emerged around the idea of recentering maintenance in our understanding of the future.[18] Cultural heritage institutions could stand to benefit considerably from a recentering of this mindset in our culture. However, with that noted, we have nearly as much to gain by focusing on recentering this in our own conceptions of our institutions' roles and functions. All too often the ideologies that underlie digital technologies begin to rub off on our thinking about the work of digital preservation. Central to our understanding of the future of cultural heritage institutions must be the realization that preservation, digital or otherwise, is about committing financial resources and empowering current and future generations of professional librarians, archivists, and museum professionals to build and maintain the social and civic infrastructure roles that our institutions serve to the world. We can't predict the future, but we can invest in it.

Your Role in the Relay Race

Martha Anderson, formerly the managing director of the Library of Congress National Digital Information Infrastructure and Preservation Program, whom I was lucky to have as a mentor and a guide in developing my craft, described digital preservation as a relay race. Digital preservation is not about a particular system, or a series of preservation actions. It is about preparing content and collections for the first in a great chain of hand-offs. We cannot predict what the future digital mediums and interfaces will be, or how they will

work, but we can select materials from today, work with communities to articulate aspects of them that matter for particular use cases, make perfect copies of them, and then work to hedge our bets on digital technology trends to try and make the next hand-off as smoothly as possible. That is what it means to practice the craft of digital preservation.

There is no end for digital preservation. The best one can hope for is to be one link in an unbroken chain of memory. Given the challenges our world faces, I think those links to our past, those connections to facts, and the decisions we make about whose stories matter enough to constitute our collective social memory are now more important than ever. I hope that this book can serve in some small way as a useful guide to those of you who want to help maintain and repair that chain.

Notes

Introduction: Beyond Digital Hype and Digital Anxiety

1. Cook, "'Imperative of Challenging Absolutes.'"

Chapter One: Preservation's Divergent Lineages

1. For an exploration of the relationship between affordances of objects and agency in interpretation and use, see Eco, *Kant and the Platypus*, 54.

2. See International Council of Museums, Committee for Conservation, "Conservator-Restorer."

3. My distinction between *informational* and *artifactual* mirrors distinctions between *allographic* and *autographic* that Matthew Kirschenbaum makes in *Mechanisms*. In presenting the terms *allographic* and *autographic* to students, I have found them to be generally confusing, so I've shifted to using terms that I think are a bit more straightforward.

4. As a nuance here, the first press of a print is often more accurate then subsequent presses, and there are indeed distinctive and interpretive acts that one can make in creating a photograph from a negative.

5. This example is drawn from Rinehart and Ippolito, *Re-collection*, 32–33. Beyond this specific point, their entire book is full of valuable

examples of how new media artworks have been challenging assumptions in the conservation of art for a century.

6. Tillett, "Conceptual Model."

7. The Shakespeare examples discussed here are all drawn from Werner, "Material Book Culture."

8. My descriptions of folklore are largely informed and shaped by McNeill, *Folklore Rules*.

9. Michael Tomasello, in *The Cultural Origins of Human Cognition* (p. 5), describes the folkloric aspects of sociocultural memory as the "cultural ratchet," a social mechanism that allows ideas and concepts developed by individuals to be disseminated to others through a shared understanding of others as people like one's self.

10. *Scientific American*, "Wonderful Invention," 2.

11. Jean-Marie Guyau, "Memory and Phonograph," 1880, quoted in Kittler, *Gramophone*, 33. These examples are central to the argument Friedrich Kittler develops as part of media archeology in *Gramaphone, Film, Typewriter* and also play a central role in Lisa Gitelman's *Always Already New: Media, History, and the Data of Culture*.

12. For an exploration of the intersections between new media and the preservation of folklore, see Saylor, "Computing Culture."

13. A description of this meeting can be found in Sharpless, "History of Oral History."

14. See Brylawski et al., "ARSC Guide."

15. To date, Smigel, Goldstein, and Aldrich, *Documenting Dance*, remains a fantastic resource for understanding performing arts documentation.

16. See Bird, *Multitextuality*.

17. For further discussion of these points, see chapter 2 in Bearman, *Archival Methods*.

18. See Association for Documentary Editing, "About Documentary Editing."

19. The history of the original *Thesaurus Graecae Linguae* is briefly described in the context of the more recent work to extend and further develop the same vision; see Thesaurus Linguae Graecae Project, "Thesaurus Linguae Graecae—History."

20. Public historian Ian Tyrrell used the same rhetoric often used regarding digitization and the web to describe microfilm in the 1930s. In his words, microfilm "democratized access to primary sources by the 1960s

and so put a premium on original research and monographic approaches." Tyrrell, *Historians in Public.*

21. See Office of Communications and Library of Congress Office of Communications, "Hyperspectral Imaging."

22. Further information on the Archimedes Palimpsest project can be found on the project's website. Archimedes Palimpsest Project, "About the Archimedes Palimpsest."

23. I happen to know these examples particularly well, as my wife and I were married in front of this particular butterfly garden.

Chapter Two: Understanding Digital Objects

1. For an elaboration of the various things in an Atari game, see Bogost, *Alien Phenomenology.*

2. The argument here on the materiality of digital objects is a short version of many of the points from the first two chapters of Kirschenbaum, *Mechanisms.*

3. Manovich, "Database as a Genre of New Media."

4. Manovich expands on this focus on database logic in *The Language of New Media.*

5. For an extensive history of the development of the card catalog, see Krajewski, *Paper Machines.*

6. Montfort and Bogost, *Racing the Beam,* 2.

7. This table and much of this analysis draw from Lee, "Digital Curation as Communication Mediation."

8. The term *screen essentialism* was coined by Nick Montfort in "Continuous Paper: MLA."

9. Gitelman, *Paper Knowledge,* 114.

10. Sterne, *MP3,* 2.

11. Thacker, "Protocol Is as Protocol Does," xii. See also Chun, *Control and Freedom,* for further exploration of the ways that underlying Internet protocols function as part of systems of control and surveillance.

12. See Fino-Radin, "Rhizome Artbase."

13. See Manovich, *Software Takes Command.*

14. For a critical exploration of the differences between the aesthetic visions of Apple commercials and *The Matrix,* see Nakamura, *Digitizing Race.*

15. Kirschenbaum, "Software, It's a Thing."

Chapter Three: Challenges and Opportunities of Digital Preservation

1. For further exploration of the connections between archeological media labs, see Emerson, "Archives, Materiality, and the 'Agency of the Machine.'"

2. My discussion of the Larson papers presents results from Reside, "'No Day but Today.'"

3. For a more detailed forensic walk-through of this disk, see Kirschenbaum, *Mechanisms*, 114–42.

4. This example is drawn from previous writing I did on representations of monuments and memorials in video games; see Owens, "Pixelated Commemorations."

5. This example comes from Owens, "Pixelated Commemorations."

Chapter Four: The Craft of Digital Preservation

1. Dooley, "Archival Advantage."

2. Greene and Meissner, "More Product, Less Process."

3. For more on community archives see Caswell, "Assessing the Use of Community Archives."

4. For an overview of themes in many of these policies, see Sheldon, "Analysis of Current Digital Preservation Policies."

5. For a good guide to the OAIS see Lavoie, "*Open Archival Information System (OAIS) Reference Model*. For context on using the TRAC audit standards see Houghton, "Trustworthiness." For the NDSA (National Digital Stewardship Alliance) levels see Phillips et al., "NDSA Levels of Digital Preservation."

6. For a sampling of six additional models see Bailey, "I Review 6 Digital Preservation Models." For further examples and even more diagrams see LeFurgy, "Life Cycle Models for Digital Stewardship."

7. Rudersdorf, "Proof Is in the Standards Pudding."

8. Bettivia, "Encoding Power."

Chapter Five: Preservation Intent and Collection Development

1. See Dappert and Farquhar, "Significance Is in the Eye of the Stakeholder."

2. See Yeo, "'Nothing Is the Same.'"

3. Web, Pearson, and Koerben, "'Oh, You Wanted Us to Preserve That?!'"

4. For further information on the approach to processing and providing access to the Rushdie papers and laptops, see Carroll et al., "Comprehensive Approach to Born-Digital Archives."

5. For more on Sagan's writing practices see Owens, "Sagan's Thinking and Writing Process."

6. For an exploration of the kinds of access and discovery modes that would be possible using this kind of full text information extracted from the files see Owens, "Mecha-Archivists."

7. For more detail on how VHP processes born-digital collections, see Owens, "Personal Stories, Storage Media, and Veterans History."

8. Shulgin, *Form Art*.

9. See Fino-Radin, "Rhizome ArtBase" and Fino-Radin, "Web Browser as Aesthetic Framework."

10. Hedstrom et al., "'The Old Version Flickers More.'"

11. Whalen, "Close Enough."

12. Fino-Radin, "Take a Picture, It'll Last Longer"

13. For more on this project see Contaxis, "Grateful Med."

14. For more discussion of the challenges in preserving virtual worlds like World of Warcraft and Second Life, see McDonough et al., "Preserving Virtual Worlds Final Report."

15. See Lowood, "Memento Mundi."

16. This project is described in detail in Chan and Cope, "Collecting the Present."

17. Zinn, "Secrecy, Archives, and the Public Interest."

18. For more on this see Jules, "Documenting the Now."

Chapter Six: Managing Copies and Formats

1. Bearman, *Archival Methods*, ch. 2.

2. Reich and Rosenthal, "Distributed Digital Preservation."

3. For further information on fixity, I highly recommend Stefan et al., "Checking Your Digital Content."

4. Kruse and Heiser, *Computer Forensics*, 89.

5. Swan, Grimes, and Owens, *State of Small and Rural Libraries*, 7.

6. For further information about each of these services, see their

respective websites: http://preservica.com/, http://www.exlibrisgroup.com/products/rosetta-digital-asset-management-and-preservation/, http://www.dspacedirect.org/, and http://www.archivesdirect.org/.

7. Owens, "Open Source Software and Digital Preservation."

8. Skinner and Halbert, "MetaArchive Cooperative."

9. Owens, "What Do You Mean by Archive?"

10. These are described in more detail in Arms and Fleischhauer, "Digital Formats."

11. See University of Michigan Libraries, "Deep Blue Preservation and Format Support."

12. See Dietrich et al., "How to Party Like It's 1999."

13. For an example of this approach, see Owens, "Mecha-Archivists."

Chapter Seven: Arranging and Describing Digital Objects

1. Pearce-Moses, "Original Order."

2. Greene and Meissner, "More Product, Less Process."

3. Ibid.

4. Owens, "Creepypastas, Memes, Lolspeak & Boards."

5. I want to thank Bergis Jules and Ed Summers, who discussed various potential tweets I could include that they had come across through their work with Ferguson tweets and suggested these. Aside from this specific input, I remain grateful for all I've learned from both of them about digital preservation and its intersectional considerations.

6. Note, in this case I have redacted part of where Rajai's email address was displayed. While this is presented as publicly accessible information, I didn't think it was acceptable to publish it in a book. This point further demonstrates the extent to which rather personal information can be embedded in publicly published digital objects. Further, I have published this tweet with explicit permission from Rajai. While this is a public tweet, he is not a media figure, and I believe it is important to have that permission.

7. Molloy, "Palestinians Tweet Tear Gas Advice to Protesters in Ferguson."

8. *St. Louis Post-Dispatch*, "2015 Pulitzer Prize–Winning Photographs."

9. Hunn, "Subject of Iconic Photo Speaks."

10. Bell, "Ferguson Protester."

11. Marshall, "Digital Copies."

12. For more on the history of animated GIFs see Eppink, "Brief History of the GIF."

13. For more about this collection, see Owens, "Exhibiting .Gifs."

14. For context on this phenomenon see Know Your Meme, "Popcorn GIFs."

15. One of the best pieces on the extensive limitations and challenges of establishing and running digital repositories remains Salo's "Innkeeper at the Roach Motel."

16. For discussion of the TwitterVane project and related work see Milligan, Ruest, and Lin, "Content Selection and Curation for Web Archiving."

Chapter Eight: Enabling Multimodal Access and Use

1. On this point, see chapter 2 of Emerson, *Reading Writing Interfaces.*

2. For a review of issues with section 108 and digital objects see *The Section 108 Study Group Report.* The report is now nearly a decade old, but it is still relevant as there have yet to be any substantial revisions to the law.

3. For a practical and useful introduction to fair use for libraries, see Adler et al., "Code of Best Practices."

4. See Christen, "Archival Challenges."

5. See Anderson and Christen, "'Chuck a Copyright on It.'"

6. See Drake, "Expanding #ArchivesForBlackLives"; Zinn, "Secrecy, Archives, and the Public Interest"; and Hagan, "Archival Captive—The American Indian."

7. For much more detail on how the NSRL works see Owens, "Life-Saving."

8. For more details on this project see Espenschied et al., "(Re-) Publication of Preserved, Interactive Content."

9. See Scott, "Archiveteam! The Geocities Torrent."

10. See Rhizome, "Deleted Cities by Richard Vijgen."

11. See Brunton, "Using Data from Historic Newspapers."

12. For more on work from the Viral Texts team see Cordell and Mullen, "'Fugitive Verses.'"

13. See Fraistat, *Shared Horizons.*

14. Lorang et al., "Developing an Image-Based Classifier."

15. See Bagnall, "Invisible Australians"; and Sherratt, "Real Face of White Australia."

16. To see the kinds of resources this program develops see http://loc .gov/teachers/.

Conclusions: Tools for Looking Forward

1. Walter, "Kryder's Law."

2. Rosenthal, "Storage Will Be a Lot Less Free than It Used to Be."

3. Rosenthal et al., "The Economics of Long-Term Digital Storage."

4. Adams, Miller, and Rosenthal, "Using Storage Class Memory for Archives with DAWN, a Durable Array of Wimpy Nodes."

5. Morozov, *To Save Everything*, 5.

6. See Vaidhyanathan, *The Googlization of Everything* for an extensive exploration of these issues.

7. Kriesberg, "Changing Landscape of Digital Access."

8. For an excellent exploration of the concept of relevance in cultural heritage institutions, see Simon, *Art of Relevance*.

9. Bethany Nowviskie, "On Capacity and Care."

10. Grinspoon, *Earth in Human Hands*.

11. Benjamin Strauss, "What Does U.S. Look Like?"

12. For more on these initiatives and opportunities to get involved, see Tansey, "Archival Adaptation to Climate Change."

13. Rose and Star, *Using Scenarios to Explore Climate Change*.

14. Ongondo, Williams, and Cherrett, "How Are WEEE Doing?"

15. Rosenthal et al., "Green Bytes."

16. Global Digital Humanities Working Group, "Minimal Computing."

17. Jackson, "Rethinking Repair," 221.

18. Russell and Vinsel, "Hail the Maintainers."

Bibliography

- -

Adams, Ian F., Ethan L. Miller, and David S. H. Rosenthal. "Using Storage Class Memory for Archives with DAWN, a Durable Array of Wimpy Nodes." Technical Report UCSC-SSRC-11-07. Storage Systems Research Center, University of California, Santa Cruz, October 2011.

Adler, Prudence S., Patricia Aufderheide, Brandon Butler, and Peter Jaszi. "Code of Best Practices in Fair Use for Academic and Research Libraries." Association of Research Libraries, January 2012. http://www.arl .org/storage/documents/publications/code-of-best-practices-fair-use .pdf.

Anderson, Jane, and Kimberly Christen. "'Chuck a Copyright on It': Dilemmas of Digital Return and the Possibilities for Traditional Knowledge Licenses and Labels." *Museum Anthropology Review* 7, nos. 1–2 (2013): 105–126.

Archimedes Palimpsest Project. "About the Archimedes Palimpsest." Accessed February 3, 2017. http://archimedespalimpsest.org/about/.

Arms, Caroline, and Carl Fleischhauer. "Digital Formats: Factors for Sustainability, Functionality, and Quality." Paper presented at the Society for Imaging Science and Technology Archiving Conference, Washington, DC, 2005. http://memory.loc.gov/ammem/techdocs/digform/Formats_ IST05_paper.pdf.

Association for Documentary Editing. "About Documentary Editing." Association for Documentary Editing. Accessed February 3, 2017. http://www.documentaryediting.org/wordpress/?page_id=482.

Bagnall, Kate. "Invisible Australians." *Asian Currents*, April/May (2012): 14–15.

Bailey, Jefferson. "I Review 6 Digital Preservation Models So You Don't Have To." Jefferson Bailey, April 26, 2014. http://www.jeffersonbailey.com/i-review-6-digital-preservation-models-so-you-dont-have-to/.

Bearman, David. *Archival Methods*. Archives and Museum Informatics Technical Report, vol. 3, no. 1. Pittsburgh, PA: Archives & Museum Informatics, 1989.

Bell, Kim. "Ferguson Protester Who Threw Back Tear Gas Canister in Iconic Photo Is Charged." *St. Louis Post-Dispatch*, August 26, 2015. http://www.stltoday.com/news/local/crime-and-courts/ferguson-protester-who-threw-back-tear-gas-cannister-in-iconic/article_437076f9-a6a2-5f03-a2fb-d612611a504f.html.

Bettivia, Rhiannon. "Encoding Power: The Scripting of Archival Structures in Digital Spaces Using the Open Archival Information System (OAIS) Reference Mode." PhD diss., University of Illinois at Urbana-Champaign, 2016.

Bird, Graeme D. *Multitextuality in the Homeric Iliad: The Witness of the Ptolemaic Papyri*. Hellenic Studies 43. Washington, DC: Center for Hellenic Studies, 2010.

Bogost, Ian. *Alien Phenomenology, or, What It's Like to Be a Thing*. Posthumanities 20. Minneapolis: University of Minnesota Press, 2012.

Brunton, David. "Using Data from Historic Newspapers." *Signal* (blog), September 5, 2017. https://blogs.loc.gov/thesignal/2017/09/using-data-from-historic-newspapers/.

Brylawski, Sam, Maya Lerman, Robin Pike, and Kathlin Smith. "ARSC Guide to Audio Preservation." CLIR Publication. Washington, DC, 2015. http://cmsimpact.org/wp-content/uploads/2016/08/ARSC-Audio-Preservation.pdf.

Carroll, Laura, Erika Farr, Peter Hornsby, and Ben Ranker. "A Comprehensive Approach to Born-Digital Archives." *Archivaria* 72 (Fall 2011): 61–92.

Caswell, Michelle. "Assessing the Use of Community Archives US IMLS RE-31-16-0117-16." Institute of Museum and Library Services, 2016. https://www.imls.gov/grants/awarded/re-31-16-0117-16.

Chan, Sebastian, and Aaron Cope. "Collecting the Present: Digital Code and Collections." Presentation at MW2014: Museums and the Web 2014 annual conference, Baltimore, MD, April 2–5, 2014. http://mw2014 .museumsandtheweb.com/paper/collecting-the-present-digital-code -and-collections/.

Christen, Kimberly. "Archival Challenges and Digital Solutions in Aboriginal Australia." *SAA Archaeological Recorder* 8, no. 2 (2008): 21–24.

Chun, Wendy Hui Kyong. *Control and Freedom: Power and Paranoia in the Age of Fiber Optics*. Cambridge, MA: MIT Press, 2005.

Contaxis, Nicole. "Grateful Med: Personal Computing and User-Friendly Design." *Circulating Now* (blog), April 28, 2016. https://circulatingnow .nlm.nih.gov/2016/04/28/grateful-med-personal-computing-and-user -friendly-design/.

Cook, Terry. "'The Imperative of Challenging Absolutes' in Graduate Archival Education Programs." *American Archivist* 63, no. 2: 380–391.

Cordell, Ryan, and Abby Mullen. "'Fugitive Verses': The Circulation of Poems in Nineteenth-Century American Newspapers." *American Periodicals* 27, no. 1 (2017). http://viraltexts.org/2016/04/08/fugitive-verses/.

Dappert, Angela, and Adam Farquhar. "Significance Is in the Eye of the Stakeholder." In *Research and Advanced Technology for Digital Libraries*, edited by Maristella Agosti, José Borbinha, Sarantos Kapidakis, Christos Papatheodorou, and Giannis Tsakonas, 297–308. Lecture Notes in Computer Science 5714. Berlin: Springer, 2009. http://link .springer.com/chapter/10.1007/978-3-642-04346-8_29.

Dietrich, Dianne, Julia Kim, Morgan McKeehan, and Alison Rhonemus. "How to Party Like It's 1999: Emulation for Everyone." *Code4Lib Journal*, no. 32 (April 25, 2016). http://journal.code4lib.org/articles /11386.

Dooley, Jackie. "The Archival Advantage: Integrating Archival Expertise into Management of Born-Digital Library Materials." Dublin, OH: OCLC Research, 2015. http://www.oclc.org/content/dam/research/publications /2015/oclcresearch-archival-advantage-2015.pdf.

Drake, Jarrett M. "Expanding #ArchivesForBlackLives to Traditional Archival Repositories." *On Archivy*, June 27, 2016. https://medium.com/on -archivy/expanding-archivesforblacklives-to-traditional-archival -repositories-b88641e2daf6#.6w6jkmgul.

Eco, Umberto. *Kant and the Platypus: Essays on Language and Cognition*. Translated by Alastair McEwen. New York: Harcourt Brace, 2000.

Emerson, Lori. "Archives, Materiality, and the 'Agency of the Machine': An Interview with Wolfgang Ernst." *Signal* (blog), February 8, 2013. //blogs .loc.gov/thesignal/2013/02/archives-materiality-and-agency-of-the -machine-an-interview-with-wolfgang-ernst/.

———. *Reading Writing Interfaces: From the Digital to the Bookbound.* Minneapolis: University of Minnesota Press, 2014.

Eppink, Jason. "A Brief History of the GIF (So Far)." *Journal of Visual Culture* 13, no. 3 (2014): 298–306. doi:10.1177/1470412914553365.

Espenschied, Dragan, Isgandar Valizada, Oleg Stobbe, Thomas Liebetraut, and Klaus Rechert. "(Re-)Publication of Preserved, Interactive Content—Theresa Duncan CD-ROMs: Visionary Videogames for Girls." In *Proceedings of the 12th International Conference on Digital Preservation,* 233–234. Chapel Hill: School of Information and Library Science, University of North Carolina at Chapel Hill, 2015. http://phaidra.univie.ac .at/o:429524.

Fino-Radin, Ben. "Rhizome ArtBase: Preserving Born Digital Works of Art." Digital Preservation 2012 meeting, Washington, DC, July 24–26, 2012. http://digitalpreservation.gov/meetings/documents/ndiipp12/Digital Culture_fino-radin_DP12.pdf.

———. "Take a Picture, It'll Last Longer . . ." Ben Fino-Radin's blog, August 28, 2012. http://notepad.benfinoradin.info/2012/08/28/take-a-pi cture/.

———. "The Web Browser as Aesthetic Framework: Why Digital Art Today Looks Different." *Creators,* May 8, 2012. https://creators.vice.com/en _us/article/digart-the-web-browser-as-aesthetic-framework-why -digital-art-today-looks-different.

Fraistat, Neil. *Shared Horizons: Data, BioMedicine, and the Digital Humanities.* Final Performance Report. College Park, MD: Digital Repository, University of Maryland, August 30, 2013. http://drum.lib.umd.edu /handle/1903/14721.

Gitelman, Lisa. *Always Already New: Media, History, and the Data of Culture.* Cambridge, MA: MIT Press, 2006.

———. *Paper Knowledge: Toward a Media History of Documents.* Durham, NC: Duke University Press, 2014.

Global Digital Humanities Working Group. "Minimal Computing." Global Outlook::Digital Humanities. Accessed March 13, 2018. www.global outlookdh.org/minimal-computing/.

Greene, Mark, and Dennis Meissner. "More Product, Less Process: Revamping Traditional Archival Processing." *American Archivist* 68, no. 2 (2005): 208–263.

Grinspoon, David. *Earth in Human Hands: Shaping Our Planet's Future.* New York: Grand Central, 2016.

Hagan, William. "Archival Captive—The American Indian." *American Archivist* 41, no. 2 (1978): 135–142.

Hedstrom, Margaret, Christopher Lee, Judith Olson, and Clifford Lampe. "'The Old Version Flickers More': Digital Preservation from the User's Perspective." *American Archivist* 69, no. 1 (2006): 159–187.

Houghton, Bernadette. "Trustworthiness: Self-Assessment of an Institutional Repository against ISO 16363-2012." *D-Lib Magazine* 21, nos. 3–4 (2015). doi:10.1045/march2015-houghton.

Hunn, David. "Subject of Iconic Photo Speaks of Anger, Excitement." *St. Louis Post-Dispatch*, August 24, 2014. http://www.stltoday.com/news/local/crime-and-courts/subject-of-iconic-photo-speaks-of-anger-excitement/article_3076e398-2c7b-5706-9856-784c997d0a52.html.

International Council of Museums, Committee for Conservation. "The Conservator-Restorer: A Definition of the Profession," 1984. http://www.icom-cc.org/47/history-of-icom-cc/definition-of-profession-1984.

Jackson, Steven J. "Rethinking Repair." *Media Technologies*, September 2014.

Jules, Bergis. "Documenting the Now: #Ferguson in the Archives." *On Archivy*, April 8, 2015. https://medium.com/on-archivy/documenting-the-now-ferguson-in-the-archives-adcdbe1d5788.

Kirschenbaum, Matthew. *Mechanisms: New Media and the Forensic Imagination.* Cambridge, MA: MIT Press, 2008.

———. "Software, It's a Thing." *Medium*, July 25, 2014. https://medium.com/@mkirschenbaum/software-its-a-thing-a550448d0ed3.

Kittler, Friedrich A. *Gramophone, Film, Typewriter.* Translated by Michael Wutz and Geoffrey Winthrop-Young. Stanford, CA: Stanford University Press, 1999.

Know Your Meme. "Popcorn GIFs." Know Your Meme, 2016. Accessed March 25, 2018. http://knowyourmeme.com/memes/popcorn-gifs.

Krajewski, Markus. *Paper Machines: About Cards & Catalogs, 1548–1929.* History and Foundations of Information Science. Cambridge, MA: MIT Press, 2011.

Kriesberg, Adam M. "The Changing Landscape of Digital Access: Public-Private Partnerships in US State and Territorial Archives." PhD diss., University of Michigan, May 2015.

Kruse, Warren G., and Jay G. Heiser. *Computer Forensics: Incident Response Essentials*. Boston: Addison-Wesley Professional Education, 2002.

Lavoie, Brian F. *The Open Archival Information System (OAIS) Reference Model: Introductory Guide*. DPC Technology Watch Report. Great Britain: Digital Preservation Coalition, 2014. http://www.dpconline.org/docman/technology-watch-reports/1359-dpctw14-02/file.

Lee, Christopher. "Digital Curation as Communication Mediation." In *Handbook of Technical Communication*, edited by Alexander Mehler and Laurent Romary, 507–530. Boston, MA: Walter de Gruyter, 2012.

LeFurgy, Bill. "Life Cycle Models for Digital Stewardship." *Signal* (blog), February 21, 2012. http://blogs.loc.gov/thesignal/2012/02/life-cycle-models-for-digital-stewardship/.

Lorang, Elizabeth M., Leen-Kiat Soh, Maanas Varma Datla, and Spencer Kulwicki. "Developing an Image-Based Classifier for Detecting Poetic Content in Historic Newspaper Collections." *D-Lib Magazine* 21, nos. 7–8 (2015). http://digitalcommons.unl.edu/libraryscience/340/.

Lowood, Henry. "Memento Mundi: Are Virtual Worlds History?" *California Digital Library*, October 5, 2009. http://escholarship.org/uc/item/2gs3p6jx.

Manovich, Lev. "Database as a Genre of New Media." *AI & Society*, 1997. http://vv.arts.ucla.edu/AI_Society/manovich.html.

———. *The Language of New Media*. Cambridge, MA: MIT Press, 2002.

———. *Software Takes Command: Extending the Language of New Media*. International Texts in Critical Media Aesthetics 5. New York: Bloomsbury, 2013.

Marshall, Catherine C. "Digital Copies and a Distributed Notion of Reference in Personal Archives." In *Digital Media: Technological and Social Challenges of the Interactive World*, edited by Megan Alicia Winget and William Aspray, 89–115. Lanham, MD: Scarecrow, 2011.

McDonough, Jerome, Robert Olendorf, Matthew Kirschenbaum, Kari Kraus, Doug Reside, Rachel Donahue, Andrew Phelps, Christopher Egert, Henry Lowood, and Susan Rojo. "Preserving Virtual Worlds Final Report." August 31, 2010.

McNeill, Lynne S. *Folklore Rules: A Fun, Quick, and Useful Introduction to the Field of Academic Folklore Studies*. Logan: University Press of Colorado, 2013.

Milligan, Ian, Nick Ruest, and Jimmy Lin. "Content Selection and Curation for Web Archiving: The Gatekeepers vs. the Masses." In *Digital Libraries (JCDL), 2016 IEEE/ACM Conference on Digital Libraries*, 107–110, 2016. http://ieeexplore.ieee.org/abstract/document/7559571/.

Mir, Rebecca, and Trevor Owens. "Modeling Indigenous Peoples: Unpacking Ideology in *Sid Meier's Colonization*." In *Playing with the Past: Digital Games and the Simulation of History*, edited by Matthew Wilhelm Kappell and Andrew B. R. Elliott, 91–106. New York: Bloomsbury, 2013.

Molloy, Mark. "Palestinians Tweet Tear Gas Advice to Protesters in Ferguson." *Telegraph*, August 15, 2014. http://www.telegraph.co.uk/news/worldnews/northamerica/usa/11036190/Palestinians-tweet-tear-gas-advice-to-protesters-in-Ferguson.html.

Montfort, Nick. "Continuous Paper: MLA." Presented at the Modern Language Association convention, Philadelphia, December 28, 2004. http://nickm.com/writing/essays/continuous_paper_mla.html.

Montfort, Nick, and Ian Bogost. *Racing the Beam: The Atari Video Computer System*. Platform Studies. Cambridge, MA: MIT Press, 2009.

Morozov, Evgeny. *To Save Everything, Click Here: The Folly of Technological Solutionism*. New York: Public Affairs, 2013.

Nakamura, Lisa. *Digitizing Race: Visual Cultures of the Internet*. Electronic Mediations 23. Minneapolis: University of Minnesota Press, 2008.

Nowviskie, Bethany. "On Capacity and Care." Keynote address, National Endowment for the Humanities digital humanities project directors' meeting. Washington, DC, September 2015.

Office of Communications, and Library of Congress Office of Communications. "Hyperspectral Imaging by Library of Congress Reveals Change Made by Thomas Jefferson in Original Declaration of Independence Draft." Press release. Washington, DC, July 2, 2010. www.loc.gov/item/prn-10-161/analysis-reveals-changes-in-declaration-of-independence/2010-07-02/.

Ongondo, F. O., Ian D. Williams, and Tom Cherrett, "How Are WEEE Doing? A Global Review of the Management of Electrical and Electronic Wastes." *Waste Management* 31, no. 4 (2011): 714–730.

Owens, Trevor. "Creepypastas, Memes, Lolspeak & Boards: The Scope of a Digital Culture Web Archive." *Folklife Today* (blog), September 26, 2014. //blogs.loc.gov/folklife/2014/09/scoping-a-digital-culture-web-archive/.

———. "Exhibiting .Gifs: An Interview with Curator Jason Eppink." *Signal* (blog), June 2, 2014. http://blogs.loc.gov/digitalpreservation/2014/06/exhibiting-gifs-an-interview-with-curator-jason-eppink/.

———. "Life-Saving: The National Software Reference Library." *Signal* (blog), May 4, 2012. http://blogs.loc.gov/thesignal/2012/05/life-saving-the-national-software-reference-library/.

———. "Mecha-Archivists: Envisioning the Role of Software in the Future of Archives." Trevor Owens: User Centered Digital History, May 27, 2014. http://www.trevorowens.org/2014/05/mecha-archivists-envisioning-the-role-of-software-in-the-future-of-archives/.

———. "Open Source Software and Digital Preservation: An Interview with Bram van Der Werf of the Open Planets Foundation." *Signal* (blog), April 4, 2012. http://blogs.loc.gov/thesignal/2012/04/open-source-software-and-digital-preservation-an-interview-with-bram-van-der-werf-of-the-open-planets-foundation/.

———. "Personal Stories, Storage Media, and Veterans History: An Interview with Andrew Cassidy-Amstutz." *Signal* (blog), March 6, 2014. http://blogs.loc.gov/thesignal/2014/03/personal-stories-storage-media-and-veterans-history-an-interview-with-andrew-cassidy-amstutz/.

———. "Pixelated Commemorations: 4 In Game Monuments and Memorials." Play the Past, June 18, 2014. http://www.playthepast.org/?p=4811.

———. "Sagan's Thinking and Writing Process." In *Finding Our Place in the Cosmos: From Galileo to Sagan and Beyond*. Washington, DC: Library of Congress, 2014. https://www.loc.gov/collections/finding-our-place-in-the-cosmos-with-carl-sagan/articles-and-essays/carl-sagan-and-the-tradition-of-science/sagans-thinking-and-writing-process/.

———. "What Do You Mean by Archive? Genres of Usage for Digital Preservers." *Signal* (blog), February 27, 2014. http://blogs.loc.gov/thesignal/2014/02/what-do-you-mean-by-archive-genres-of-usage-for-digital-preservers/.

Pearce-Moses, Richard. "Original Order." Glossary. Society of American Archivists. Accessed March 25, 2018. https://www2.archivists.org/glossary/terms/o/original-order.

Phillips, Megan, Jefferson Bailey, Andrea Goethals, and Trevor Owens. "The NDSA Levels of Digital Preservation: An Explanation and Uses." Presentation at the IS&T Archiving Conference, Washington, DC, April 2–5, 2013. http://www.digitalpreservation.gov/documents/NDSA_Levels _Archiving_2013.pdf.

Reich, Victoria, and D. Rosenthal. "Distributed Digital Preservation: Lots of Copies Keep Stuff Safe." In *Proceedings Indo-US Workshop on International Trends in Digital Preservation*, March 24–25, 2009. https:// lockss.org/locksswiki/files/ReichIndiaFinal.pdf.

Reside, Doug. "'No Day but Today': A Look at Jonathan Larson's Word Files." *New York Public Library Blog*, April 22, 2011. http://www.nypl .org/blog/2011/04/22/no-day-today-look-jonathan-larsons-word-files.

Rhizome. "Deleted Cities by Richard Vijgen." *ArtBase*, 2011. http://rhizome .org/art/artbase/artwork/deleted-cities/.

Rinehart, Richard, and Jon Ippolito, eds. *Re-collection: Art, New Media, and Social Memory*. Leonardo. Cambridge, MA: MIT Press, 2014.

Rose, Matthew, and Jonathan Star. *Using Scenarios to Explore Climate Change: A Handbook for Practitioners*. N.p.: National Park Service, U.S. Department of the Interior, 2013.

Rosenthal, David. "Storage Will Be a Lot Less Free than It Used to Be." *DSHR's Blog*, October 1, 2012. https://blog.dshr.org/2012/10/storage -will-be-lot-less-free-than-it.html.

Rosenthal, David, Kris Carpenter, and Krishna Kant. "Green Bytes: Sustainable Approaches to Digital Stewardship." Panel discussion moderated by Joshua Sternfeld, Library of Congress Digital Preservation 2013 Meeting, July 23–25, 2013, Alexandria, VA.

Rosenthal, David, Daniel C. Rosenthal, Ethan L. Miller, Ian F. Adams, Mark W. Storer, and Erez Zadok. "The Economics of Long-Term Digital Storage." Paper presented at The Memory of the World in the Digital Age: Digitization and Preservation UNESCO Conference. Vancouver, Canada, September 26–28, 2012.

Rudersdorf, Amy. "Proof Is in the Standards Pudding." June 21, 2016. AVP blog. https://www.weareavp.com/the-proof-is-in-the-standards -pudding/.

Russell, Andrew, and Lee Vinsel, "Hail the Maintainers." *Aeon*, April 7, 2017. https://aeon.co/essays/innovation-is-overvalued-maintenance- often-matters-more.

Salo, Dorothea. "Innkeeper at the Roach Motel." *Library Trends* 57, no. 2 (2008): 98–123.

Saylor, Nicole. "Computing Culture in the AFC Archive." *Folklife Today*, January 8, 2014. https://blogs.loc.gov/folklife/2014/01/computing-cul ture-in-the-afc-archive/.

Scientific American. "A Wonderful Invention—Speech Capable of Indefinite Repetition from Automatic Records," November 17, 1877.

Scott, Jason. "Archiveteam! The Geocities Torrent." *ASCII by Jason Scott* (blog), October 27, 2010. http://ascii.textfiles.com/archives/2720.

Section 108 Study Group. *The Section 108 Study Group Report.* Washing-ton, DC: The Library of Congress, 2008. http://www.section108.gov /docs/Sec108StudyGroupReport.pdf.

Sharpless, Rebecca. "The History of Oral History." In *History of Oral His-tory: Foundations and Methodology*, edited by Lois E. Myers and Re-becca Sharpless, 9–32. Lanham, MD: AltaMira, 2007.

Sheldon, Madeline. "Analysis of Current Digital Preservation Policies: Ar-chives, Libraries, and Museums." Library of Congress, *Signal* (blog), August 13, 2013. https://blogs.loc.gov/thesignal/2013/08/analysis-of -current-digital-preservation-policies-archives-libraries-and-museums/.

Sherratt, Tim. "The Real Face of White Australia." Tim Sherratt, *Discon-tents* (blog), September 21, 2011. http://discontents.com.au/the-real -face-of-white-australia/.

Shulgin, Alexei. *Form Art.* Rhizome (digital library), 1997. http://rhizome .org/art/artbase/artwork/form-art/.

Simon, Nina. *The Art of Relevance.* Santa Cruz, CA: Museum 2.0, 2016.

Skinner, Katherine, and Martin Halbert. "The MetaArchive Cooperative: A Collaborative Approach to Distributed Digital Preservation." *Library Trends* 57, no. 3 (2009): 371–392.

Smigel, Libby, Martha Goldstein, and Elizabeth Aldrich. *Documenting Dance: A Practical Guide.* N.p.: Dance Heritage Coalition, 2006. http:// www.danceheritage.org/DocumentingDance.pdf.

St. Louis Post-Dispatch. "The 2015 Pulitzer Prize–Winning Photographs from the Post-Dispatch." *St. Louis Post-Dispatch*, April 20, 2015. http:// www.stltoday.com/news/local/metro/the-pulitzer-prize-winning -photographs-from-the-post-dispatch/collection_7a5793c3-9a55 -534c-b84a-a27d6d08ef5f.html.

Stefan, Paula De, Carl Fleischhauer, Andrea Goethals, Michael Kjörling, Nick Krabbenhoeft, Chris Lacinak, Jane Mandelbaum, et al. "Checking

Your Digital Content: What Is Fixity, and When Should I Be Checking It?" Washington, DC: National Digital Stewardship Alliance, 2014. http://hdl.loc.gov/loc.gdc/lcpub.2013655117.1.

Sterne, Jonathan. *MP3: The Meaning of a Format.* Sign, Storage, Transmission. Durham, NC: Duke University Press, 2012.

Strauss, Benjamin. "What Does U.S. Look Like with 10 Feet of Sea Level Rise?" Climate Central, May 13, 2014. http://www.climatecentral.org/news/us-with-10-feet-of-sea-level-rise-17428.

Swan, Deanne W., Justin Grimes, and Timothy Owens. *The State of Small and Rural Libraries in the United States.* Research Brief No. 5. Washington, DC: Institute of Museum and Library Services, September 2013. http://citeseerx.ist.psu.edu/viewdoc/download?doi=10.1.1.396.2562&rep=rep1&type=pdf.

Tansey, Eira. "Archival Adaptation to Climate Change." *Sustainability: Science, Practice & Policy* 11, no. 2 (2015): 45–56.

Thacker, Eugene. "Protocol Is as Protocol Does." In *Protocol: How Control Exists after Decentralization,* edited by Alexander R. Galloway, xi–xxiii. Cambridge, MA: MIT Press, 2006.

Thesaurus Linguae Graecae Project. "Thesaurus Linguae Graecae—History." Accessed February 3, 2017. https://www.tlg.uci.edu/about/history.php.

Tillett, Barbara. "A Conceptual Model for the Bibliographic Universe." *Technicalities* 25, no. 5 (September 2003). http://www.loc.gov/cds/downloads/FRBR.PDF.

Tomasello, Michael. *The Cultural Origins of Human Cognition.* Boston, MA: Harvard University Press, 2009.

Tyrrell, Ian R. *Historians in Public: The Practice of American History, 1890–1970.* Chicago: University of Chicago Press, 2005. http://www.loc.gov/catdir/toc/ecip058/2005003459.html.

University of Michigan Libraries. "Deep Blue Preservation and Format Support," March 9, 2011. https://deepblue.lib.umich.edu/static/about/deepbluepreservation.html.

Vaidhyanathan, Siva. *The Googlization of Everything.* Berkeley: University of California Press, 2012.

Walter, Chip. "Kryder's Law." *Scientific American,* September 2005, 32–33.

Web, Colin, David Pearson, and Paul Koerben. "'Oh, You Wanted Us to Preserve That?!' Statements of Preservation Intent for the National Library of Australia's Digital Collections." *D-Lib Magazine* 19, nos. 1–2 (2013). doi:10.1045/january2013-webb.

Werner, Sarah. "Where Material Book Culture Meets Digital Humanities." *Journal of Digital Humanities* 1, no. 3 (2012). http://journalofdigitalhu manities.org/1-3/where-material-book-culture-meets-digital-humanities -by-sarah-werner/.

Whalen, Zach. "Close Enough." Presentation at the Modern Language As- sociation, Seattle, WA, January 8, 2012. http://www.zachwhalen.net /posts/mla-2012-close-enough/.

Yeo, Geoffrey. "'Nothing Is the Same as Something Else': Significant Prop- erties and Notions of Identity and Originality." *Archival Science* 10, no. 2 (2010): 85–116.

Zinn, Howard. "Secrecy, Archives, and the Public Interest." *Midwestern Archivist* 2, no. 2 (1977): 14–26.

Index